THE SARTORIALIST
CLOSER
SCOTT SCHUMAN

PENGUIN BOOKS

PENGUIN BOOKS

Published by the Penguin Group
Penguin Books Ltd, 80 Strand, London WC2R 0RL, England
Penguin Group (USA) Inc., 375 Hudson Street, New York, New York 10014, USA
Penguin Group (Canada), 90 Eglinton Avenue East, Suite 700, Toronto, Ontario,
Canada M4P 2Y3
(a division of Pearson Penguin Canada Inc.)
Penguin Ireland, 25 St Stephen's Green, Dublin 2, Ireland (a division of Penguin
Books Ltd)
Penguin Group (Australia), 250 Camberwell Road, Camberwell, Victoria 3124,
Australia (a division of Pearson Australia Group Pty Ltd)
Penguin Books India Pvt Ltd, 11 Community Centre, Panchsheel Park, New Delhi –
110 017, India
Penguin Group (NZ), 67 Apollo Drive, Rosedale, Auckland 0632, New Zealand
(a division of Pearson New Zealand Ltd)
Penguin Books (South Africa) (Pty) Ltd, Block D, Rosebank Office Park, 181 Jan
Smuts Avenue, Parktown North, Gauteng 2193, South Africa
Penguin Books Ltd, Registered Offices: 80 Strand, London WC2R 0RL, England
www.penguin.com

First published 2012
001

Copyright © Scott Schuman, 2012

Designed by Stefanie Posavec

Printed and bound in Italy by Graphicom srl

A CIP catalogue record for this book is available from the British Library

978-0-143-12318-7

This book is dedicated to the quiet strength of my mother, Joan Schuman.

I named this book *Closer* for two very simple reasons.

First, I've always felt like an outsider. As a straight boy growing up in the Midwest with an equal interest in fashion and football, it was difficult for me to fit in anywhere.

I developed a sense of isolation and distance from people. This didn't affect me in a negative way – I actually became more curious about people. I wasn't interested in knowing the facts about them, but in creating my own vision of how I thought they might be. This emotional distance was at the core of my development as a photographer.

My interest is never to report on what people are wearing but in capturing my romantic take on what I have seen on the street.

However, in the process of shooting thousands of people for my blog over the last seven years, I have found the imaginary wall between me and my subjects dissolving.

I find myself wanting to understand these individuals better. The result is the introduction of more tightly composed portraits that bring me closer to the true essence of the person while still capturing them as stylish subjects.

Secondly, I feel I'm finally getting closer to the type of character diversity I originally dreamed of when I created The Sartorialist. In this book you'll find cowboys, nomads, fashionistas, photographers, shepherds, ballers, house painters, and bartenders (just to name a few) alongside everyday New Yorkers, Parisians, Venetians, Phoenicians, Milanese, Tokyoites and Turkish (just to name a few).

Even though I traveled thousands of miles in pursuit of the images in this book I still feel like I'm at the beginning of this journey. I hope you will continue to take this trip along with me.

Scott Schuman, The Sartorialist

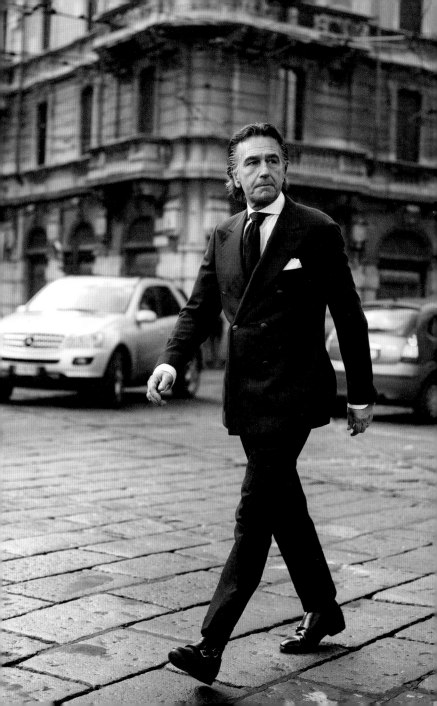

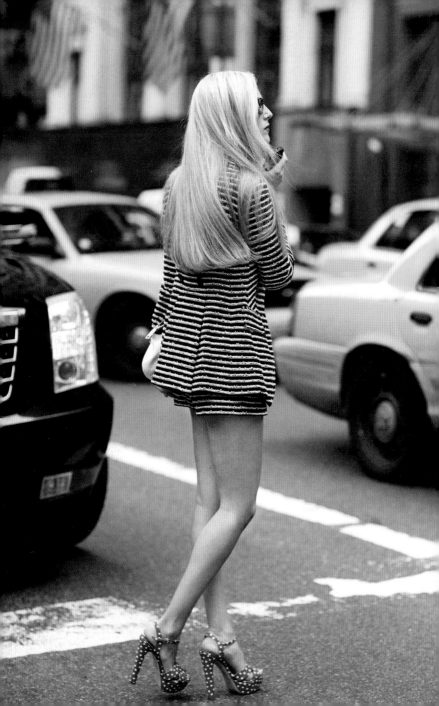

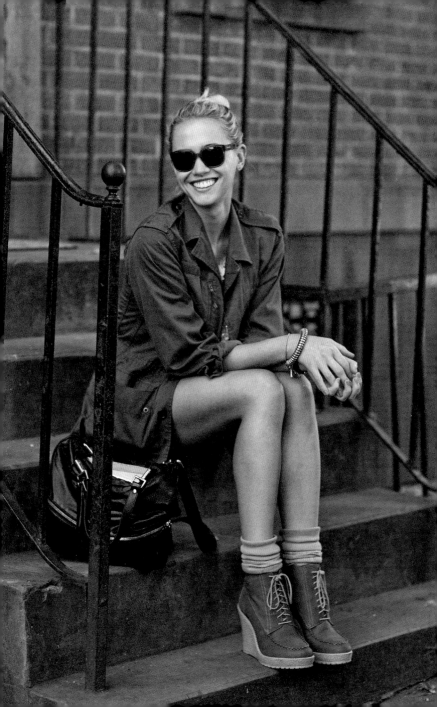

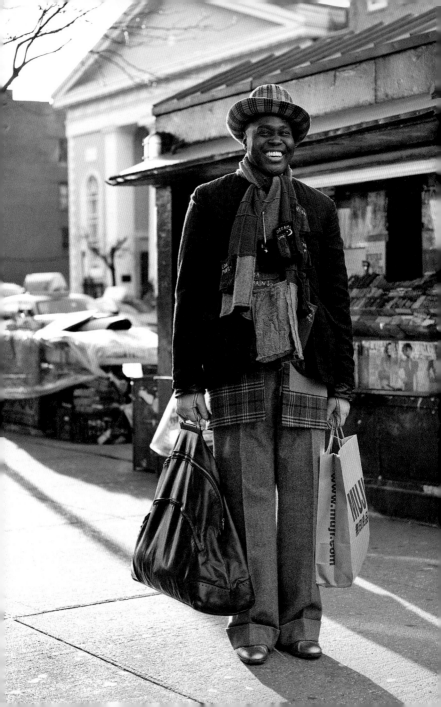

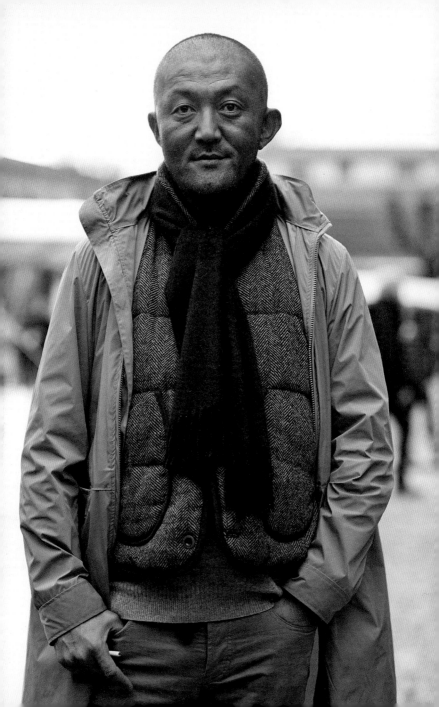

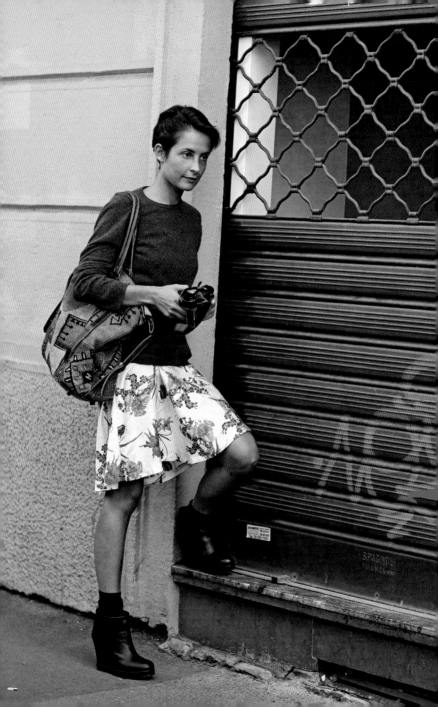

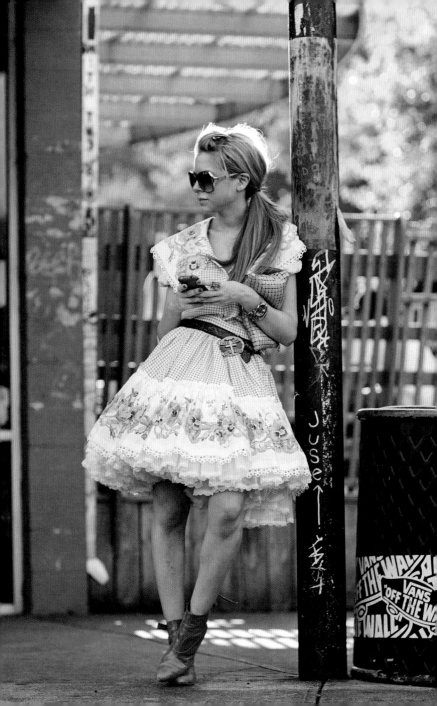

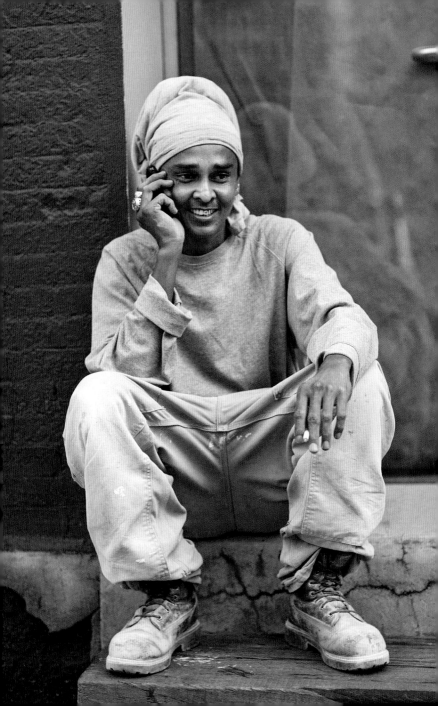

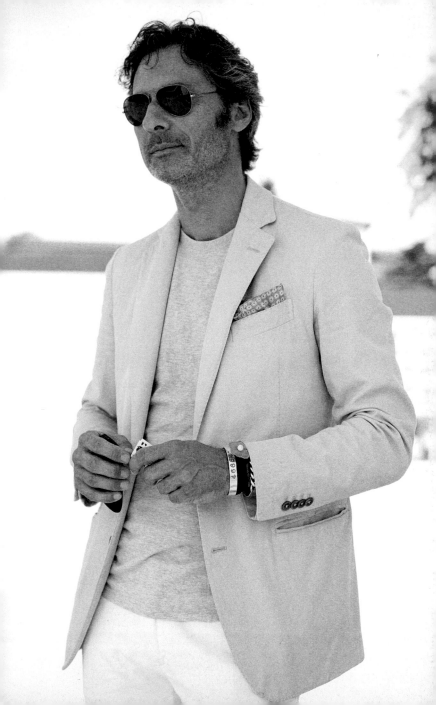

Route 45, Pennsylvania

This young Mennonite girl and her family were selling blueberries by the side of the road deep in the Pennsylvania countryside.

This image is inspiring to me because it is an honest, simple portrait of a young girl that captures many visual clues about her and the Mennonite life.

But it's also an image full of fashion inspiration.

Look at her contrasting floral printed dress and apron, both soiled from long hours working in the fields. Her forearms, tanned to just above the elbow. Her stance is strong, bare feet planted firmly on the ground and hands defensively crossed in front of her.

Unlike her younger siblings she seems old enough to know that she and I are from two different cultures, not so different as to be frightening but different enough to be cautious. Notice that in the group photo on the next page this young lady is the only child not looking directly at the camera. She's looking at her mother, questioning how to handle this encounter with a stranger.

This meeting stayed with me for several days afterwards. It solidified my drive to step off the sidewalks of the world's fashion capitals and onto the back roads of America and abroad.

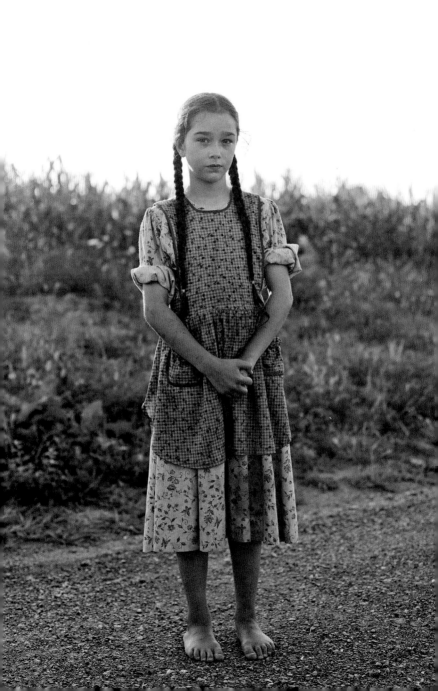

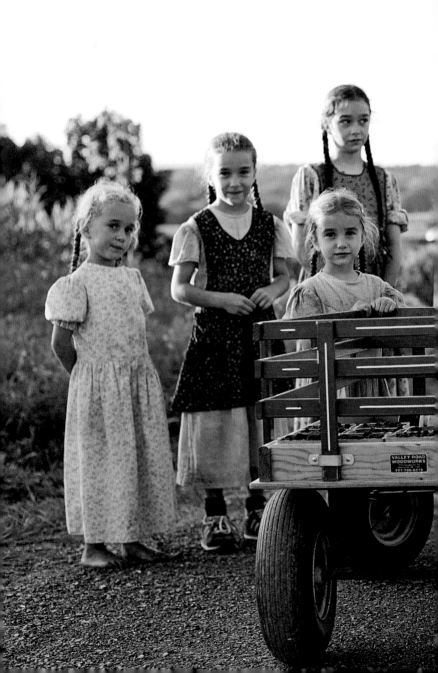

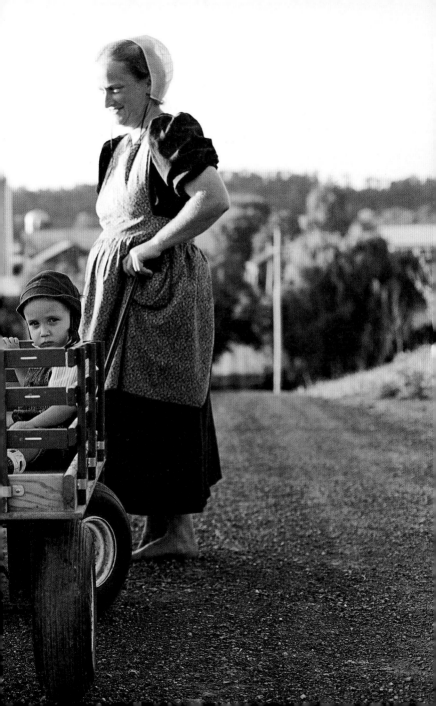

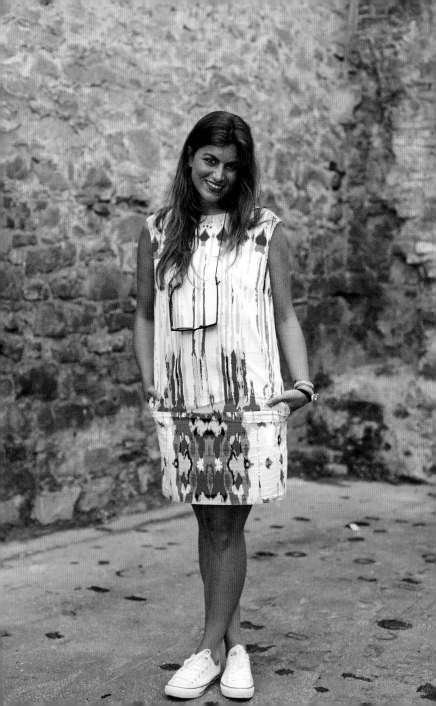

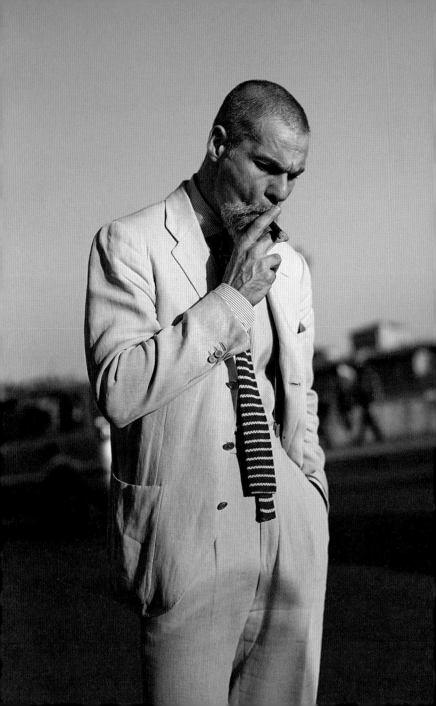

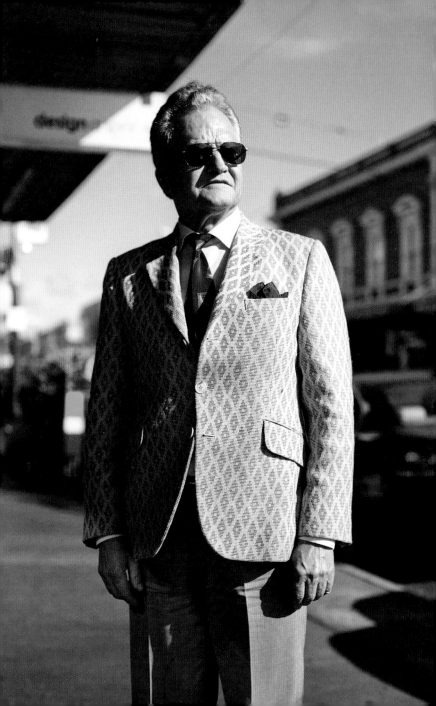

On the Street . . . Via Augusta, Barcelona

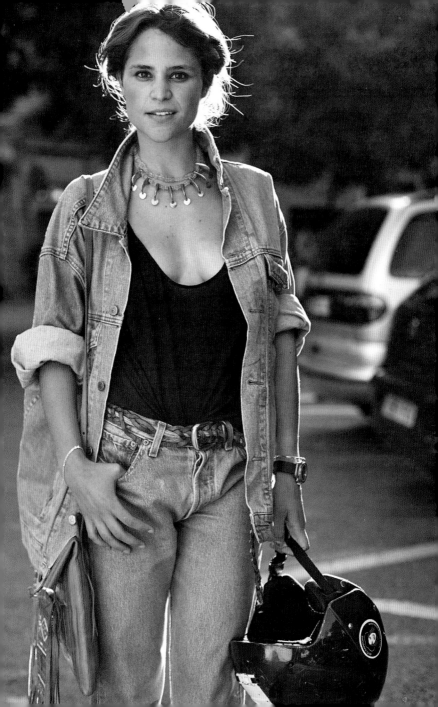

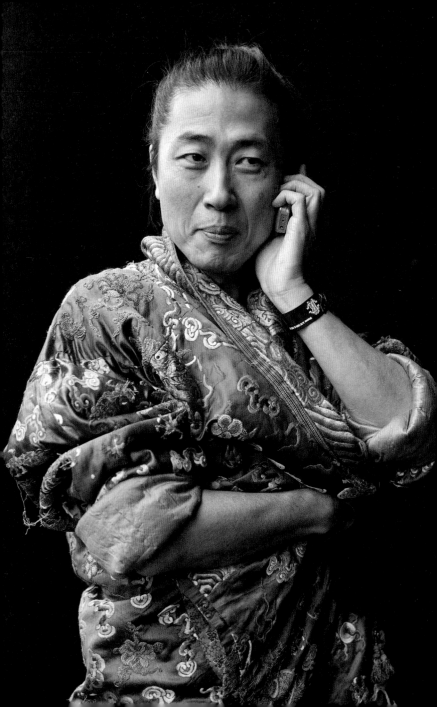

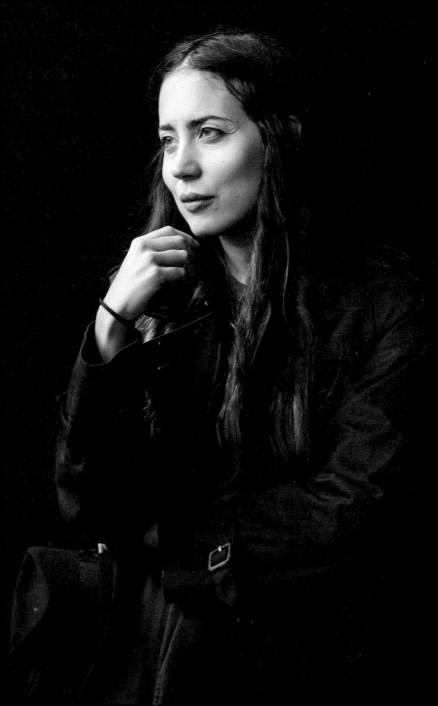

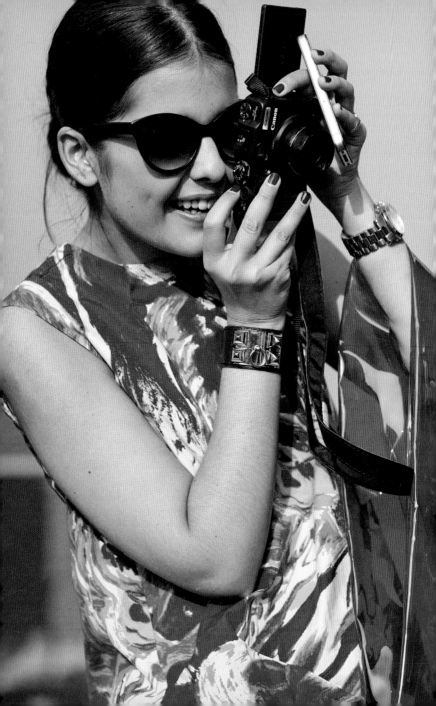

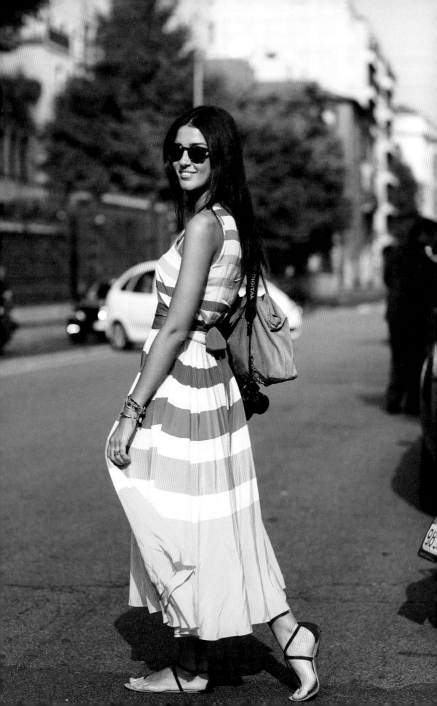

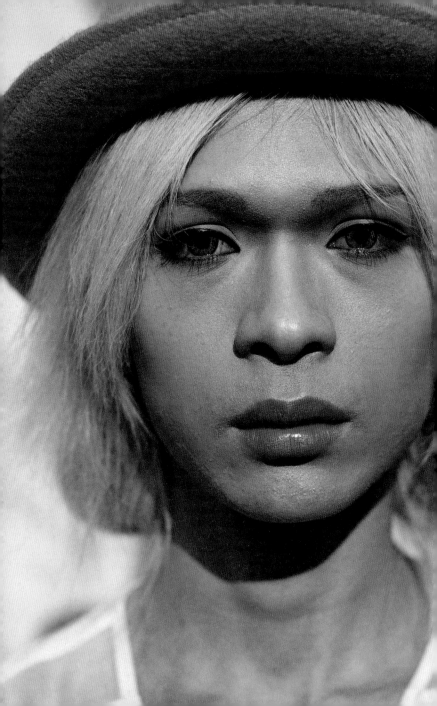

Alessandro Squarzi

Like many people before me I've often cited Fred Astaire or Cary Grant as my style icons. The way their clothing fit was perfection and the artistry of how they put their clothes together is the very reason they're still such style references today.

However, if I have to be totally honest, they've had no real effect on how I dress every day. Not because they're from a different time period but because we have such different body types. How many times have I bought a horizontal navy-striped cashmere knit hoping to look just a little like Cary Grant in *To Catch a Thief* and yet found myself in front of the mirror at home realizing I look more like Charlie Brown?

I think it's important to find a person with a similar body shape to yours as your style inspiration.

For me it's Alessandro Squarzi, a fashion executive living in Milan. We are built in a very similar manner and when I see him looking great (which is often) I really pay attention to the subtleties that make the look work. Things like which fabric weights he chooses and which he avoids (or should avoid), scale of prints and patterns, the proportion of a pant length or if a sweater hits at his waist or hip. Is his jacket nipped in at his waist or more at the ribcage? Unfortunately for him his mistakes are often to my benefit. Let's just say we both have to be careful with double-breasted jackets.

I know it's not easy, but taking the time to find a fashion role model based more on body type than number of Oscar nominations will put you on the right track.

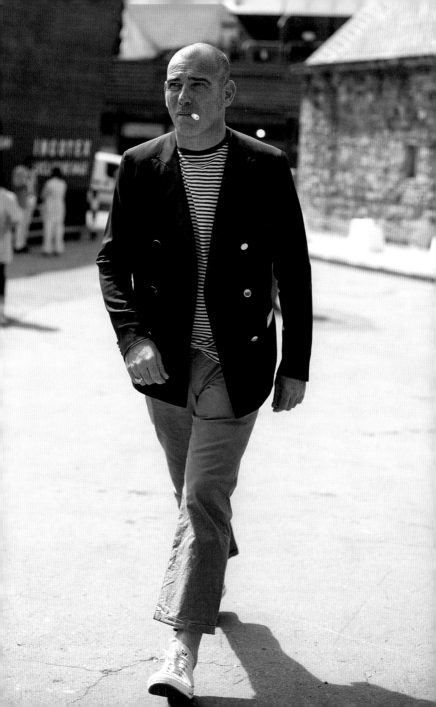

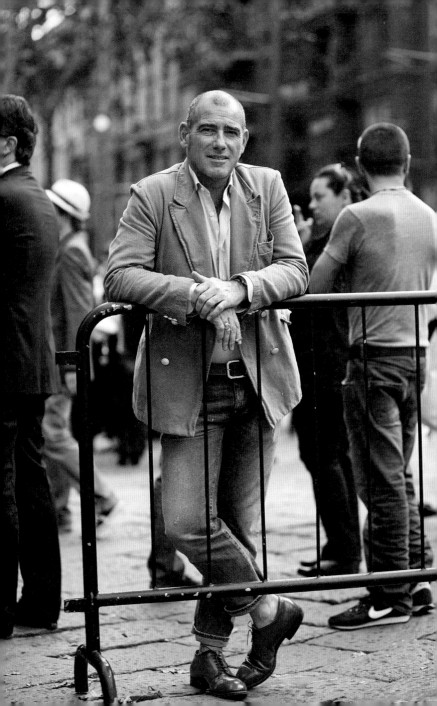

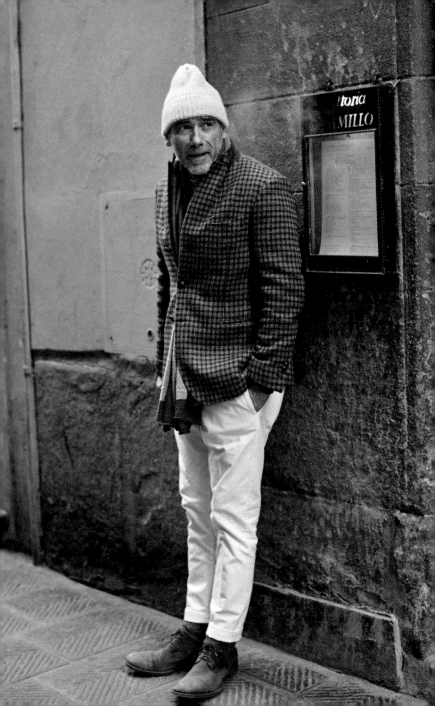

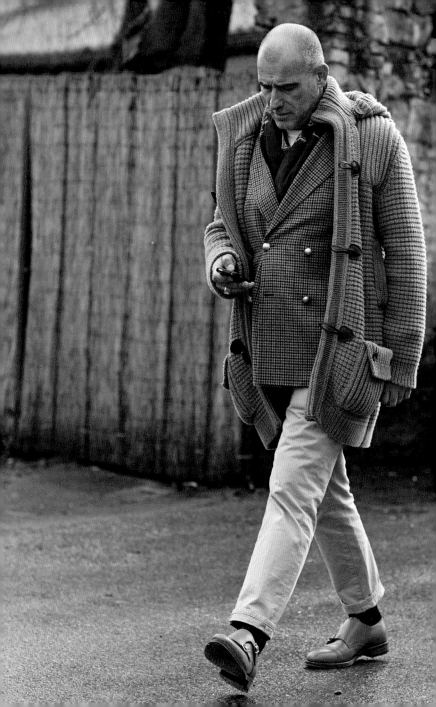

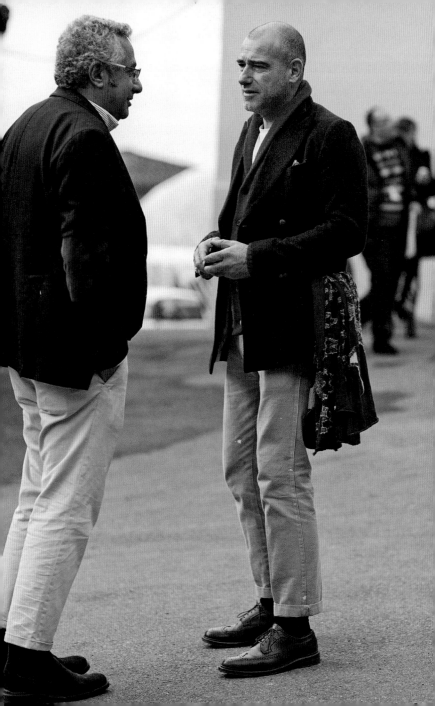

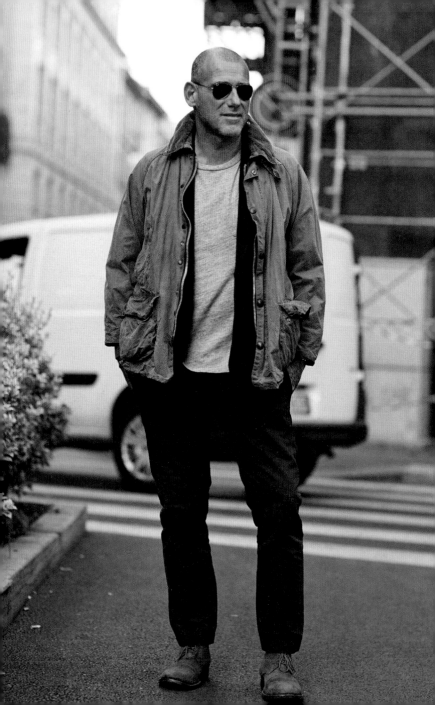

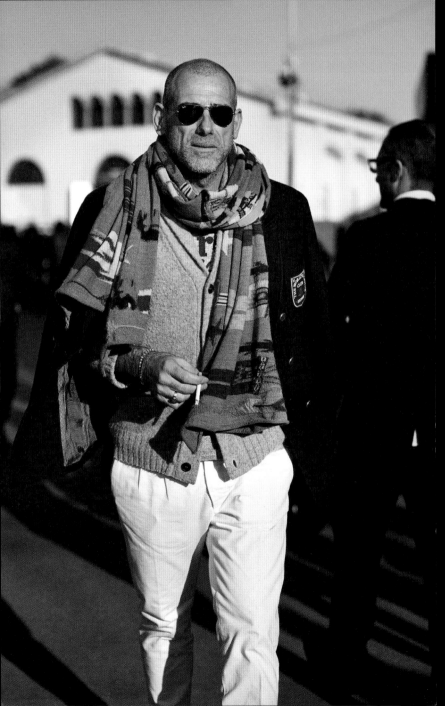

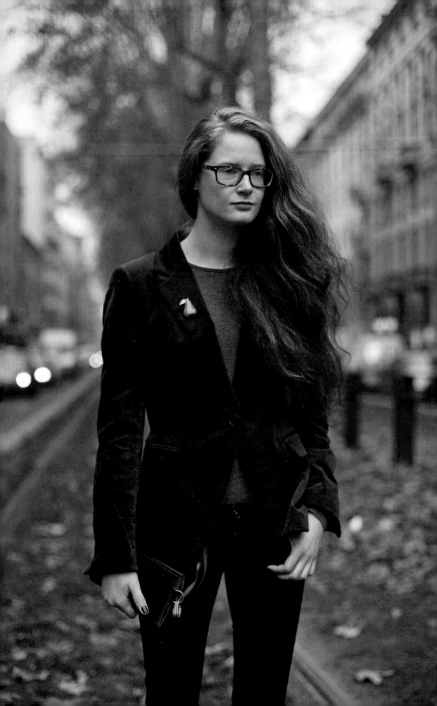

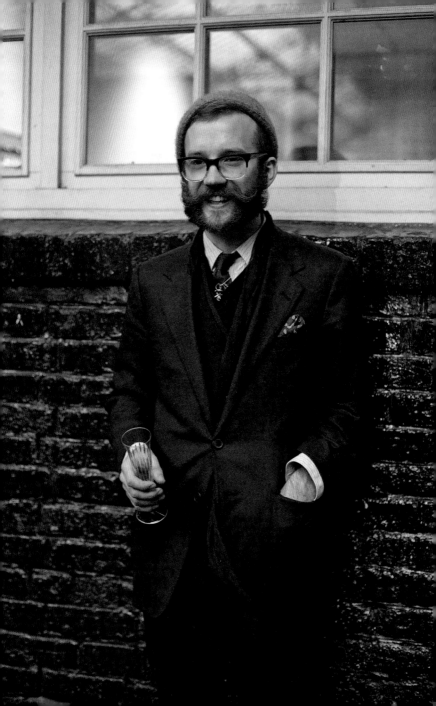

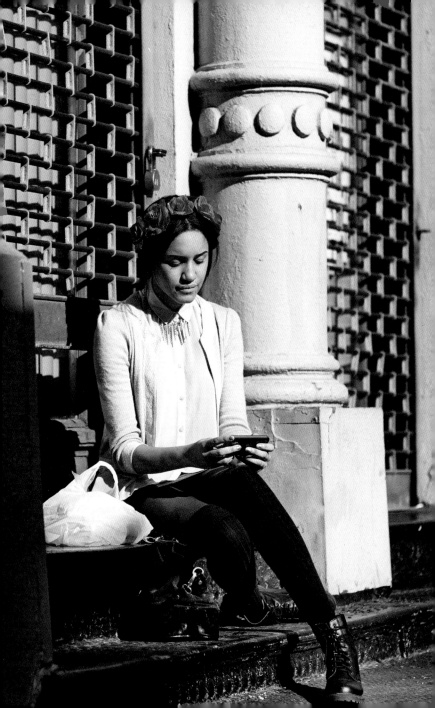

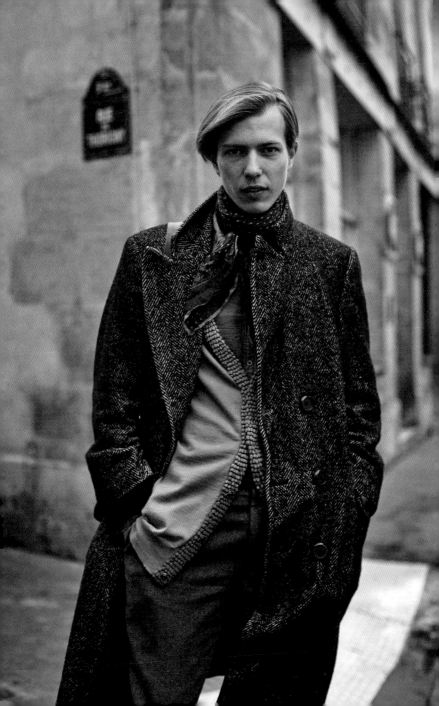

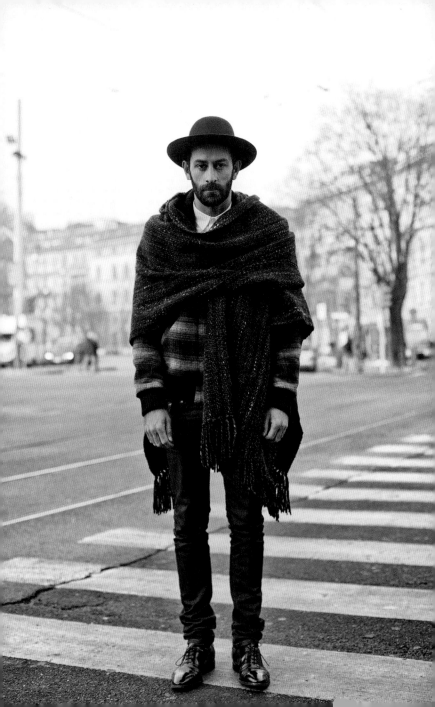

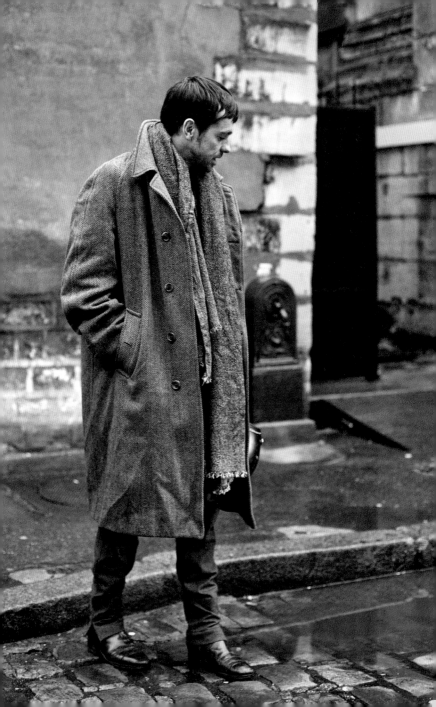

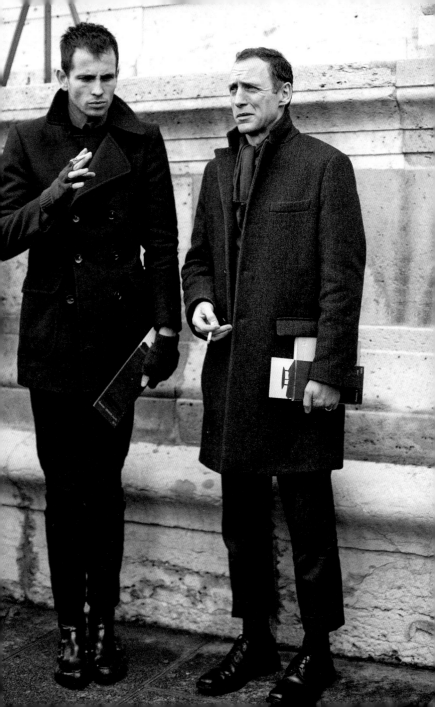

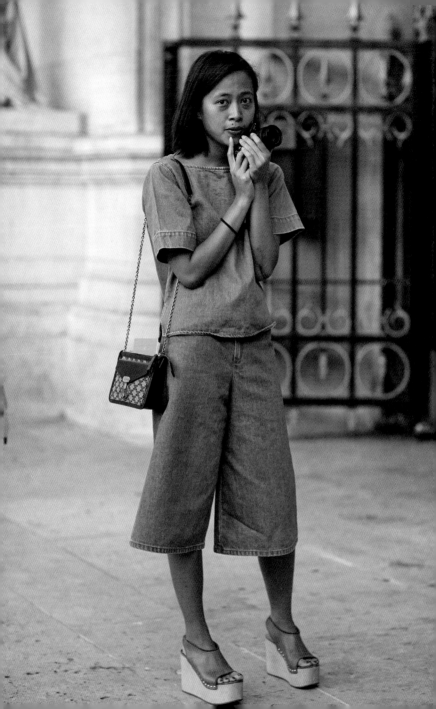

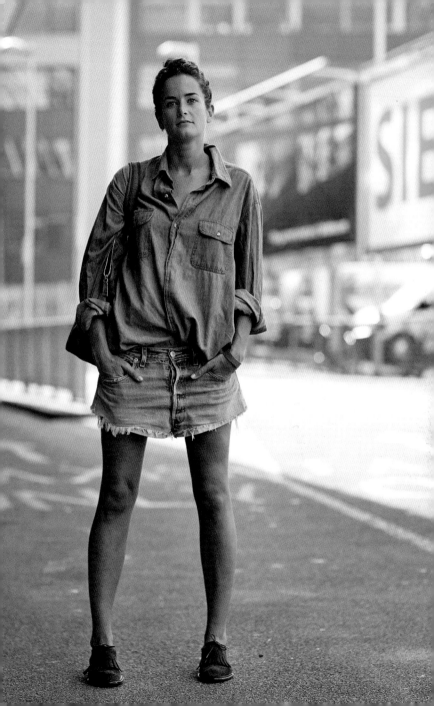

On the Street . . . Doyers Street, New York

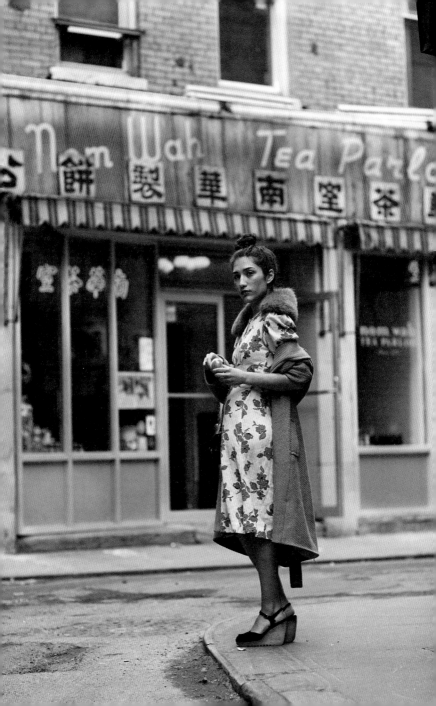

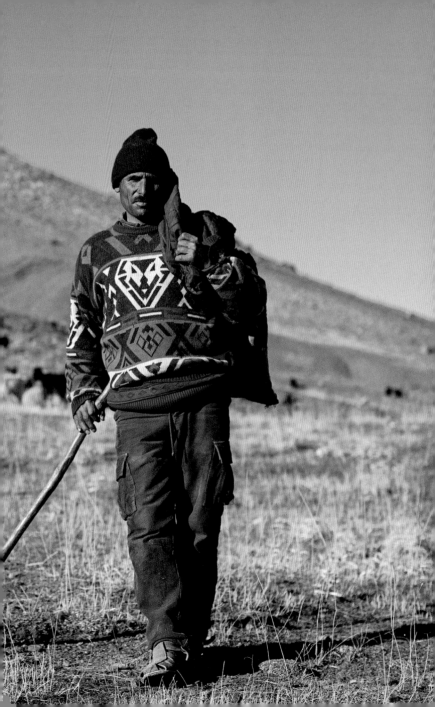

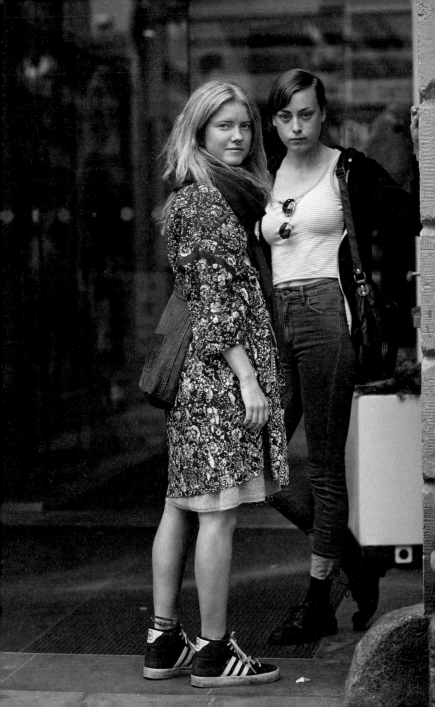

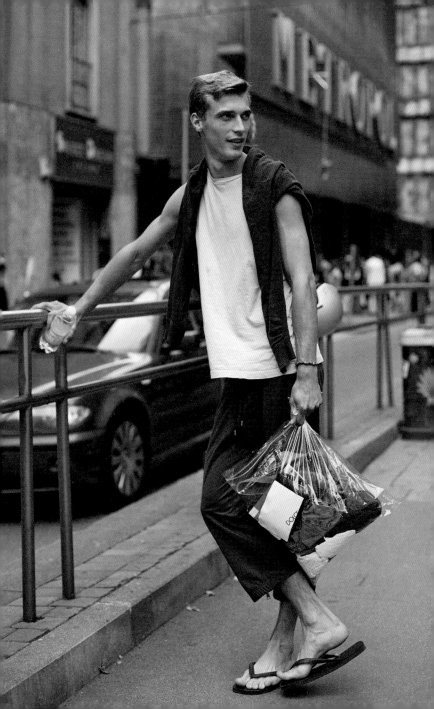

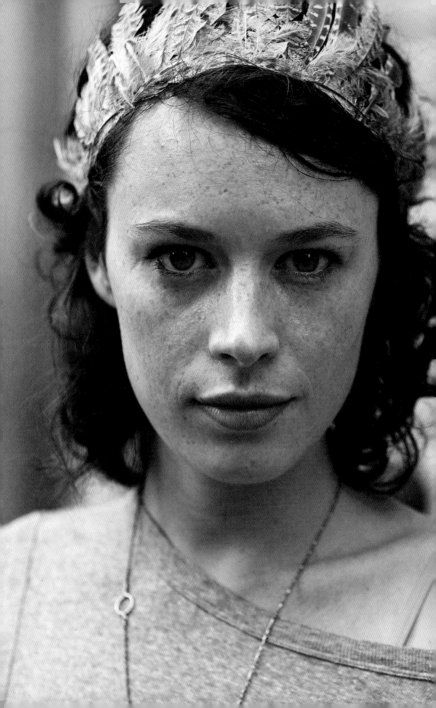

Rome

In November 2010 I was shooting an ad campaign for OVS in Rome. It rained every day, all day. Somehow we made it through by shielding the models under tarps, umbrellas, ancient archways, anything to give the appearance of a sun-filled Roman afternoon.

For the last shot of the last day I had found a hidden little square to shoot the last young lady. The background would be a little *pizzicheria* (dime store), with a beautifully aged ochre facade and a classic old-school bike outside. The type of coincidental beauty that is so common in Italy.

Of course the rain still didn't let up and everyone on set was getting very restless. We finally broke down and photographed her holding an umbrella. Once I knew we had the shot I called it a wrap and sent everyone back to the trailers. I stayed behind in the exact same spot reviewing images with the digital tech when suddenly the sun broke through the clouds and offered us a perfect Italian sunset. The gentleman from the *pizzicheria* came out to take a look at the long lost sun. And that's when, with my camera still in hand, I quickly snapped one of my favorite images of that year.

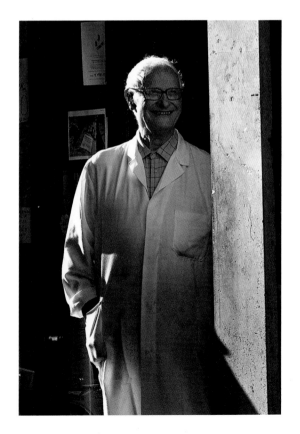

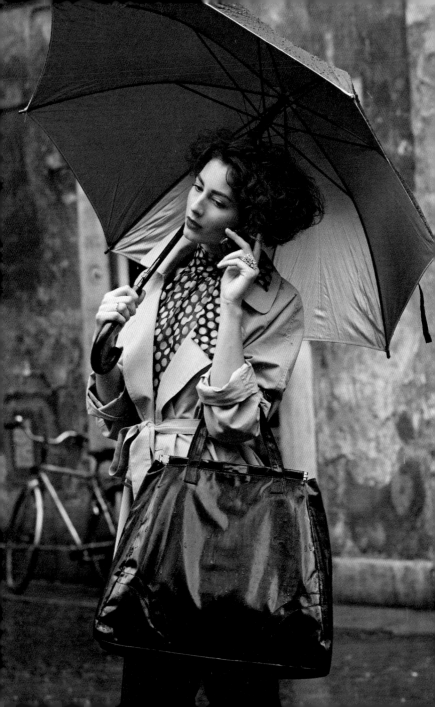

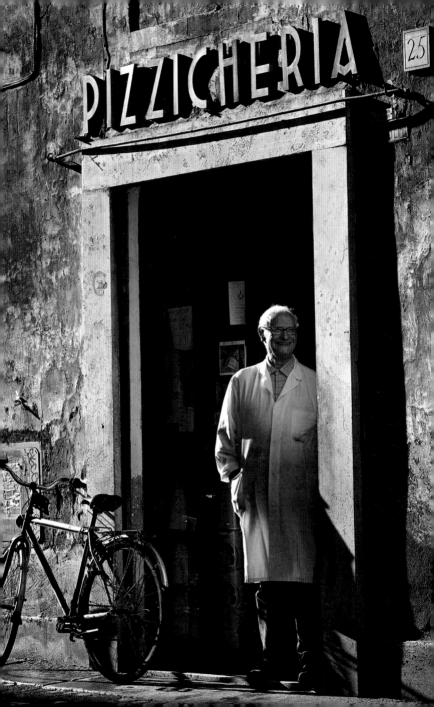

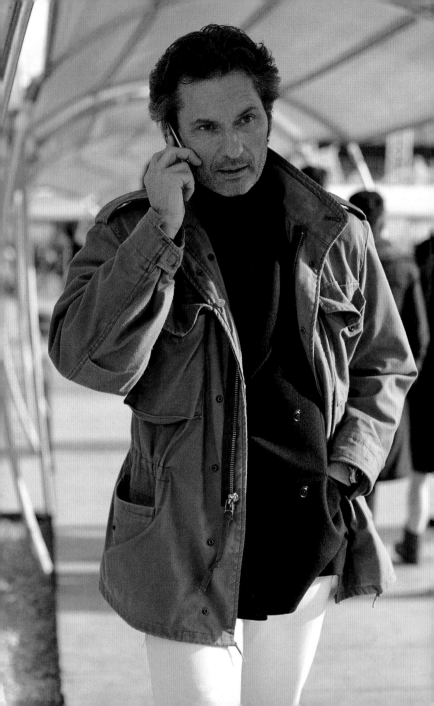

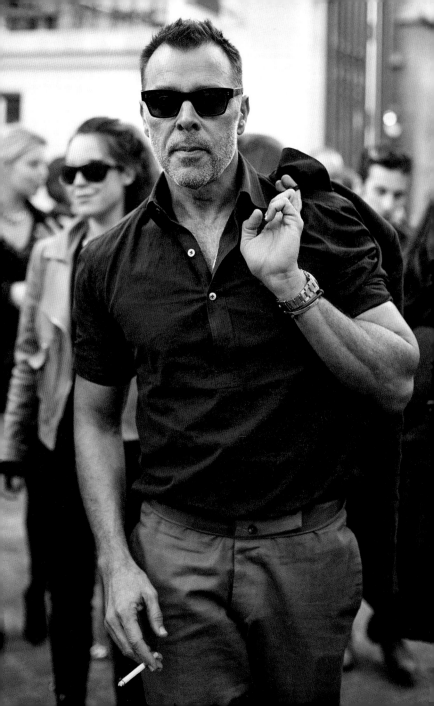

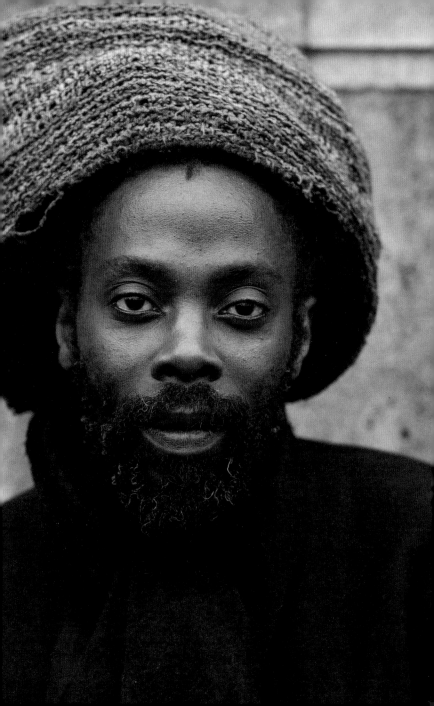

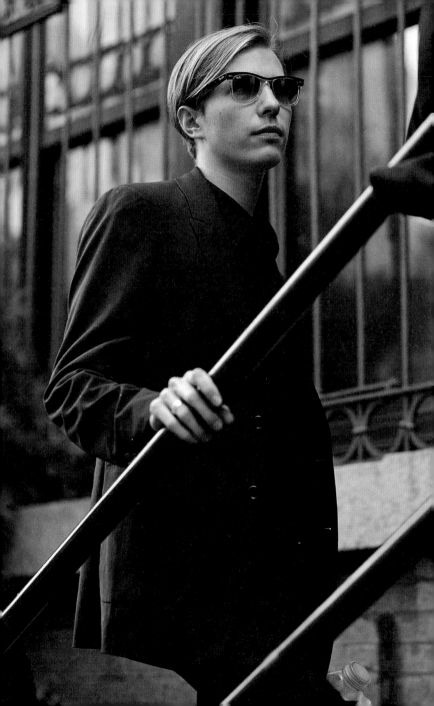

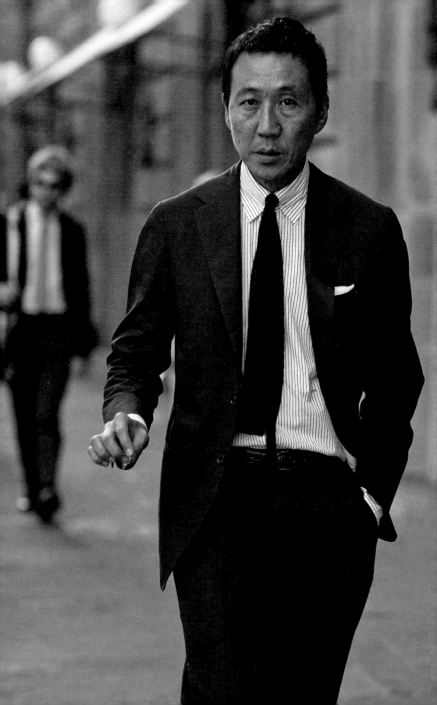

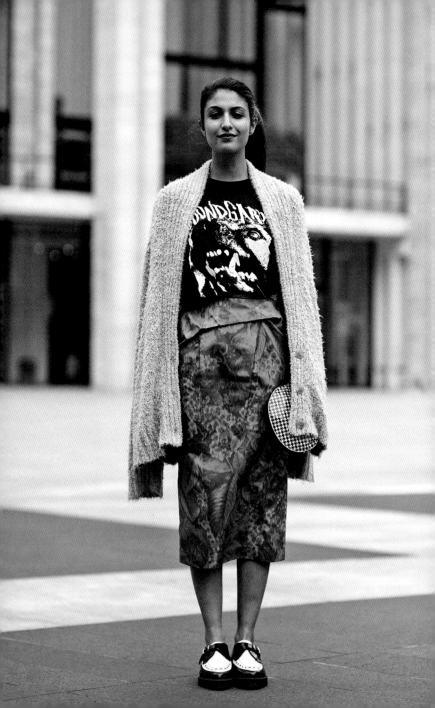

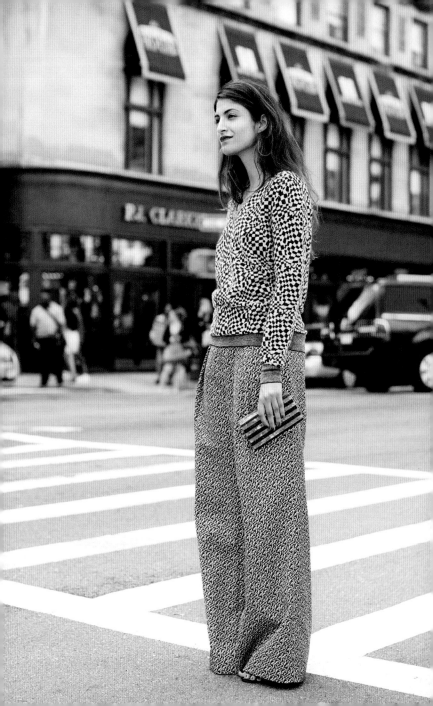

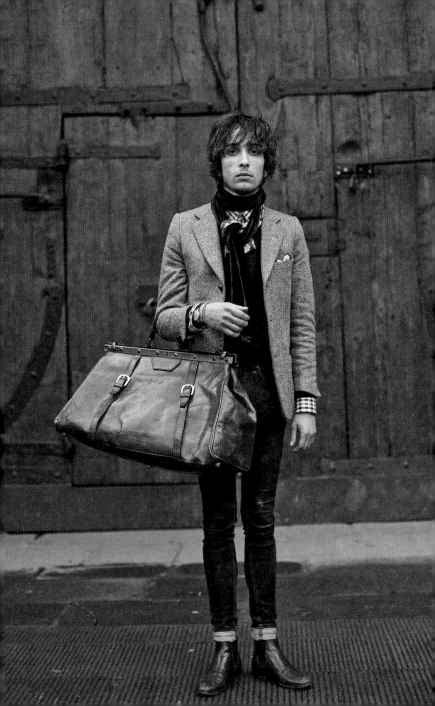

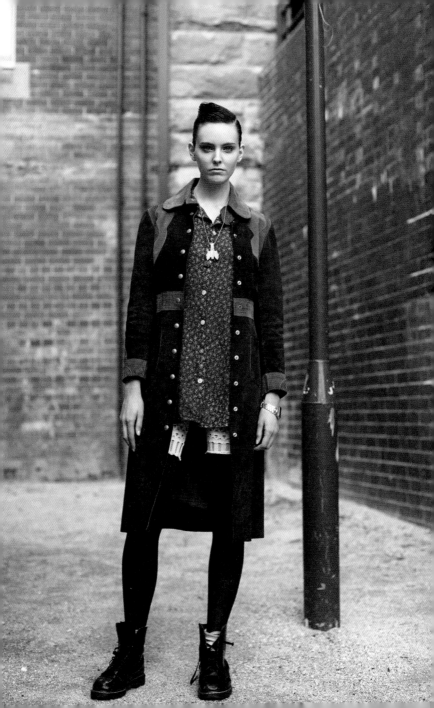

On the Street . . . Greene Street, New York

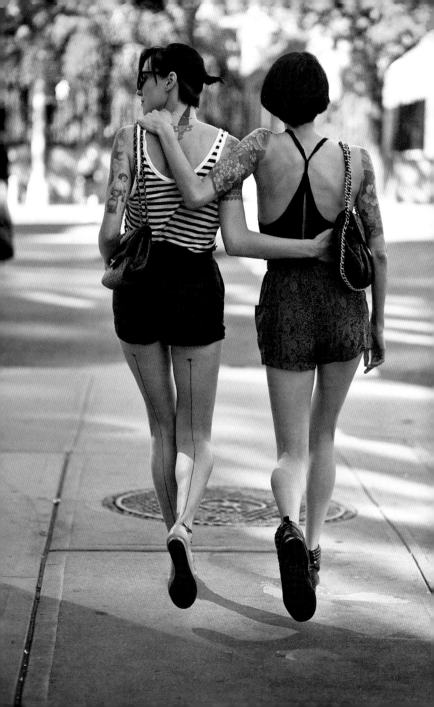

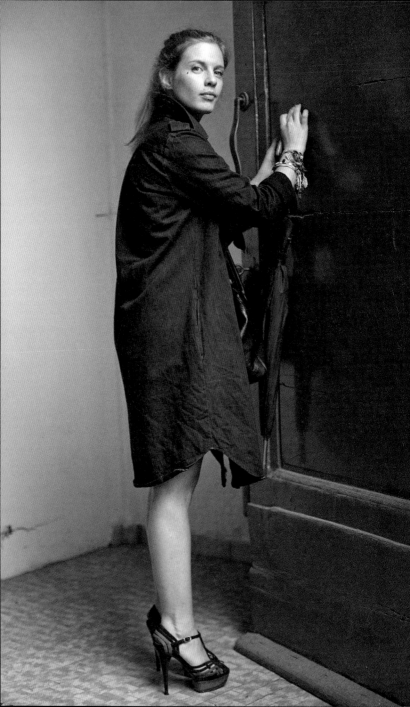

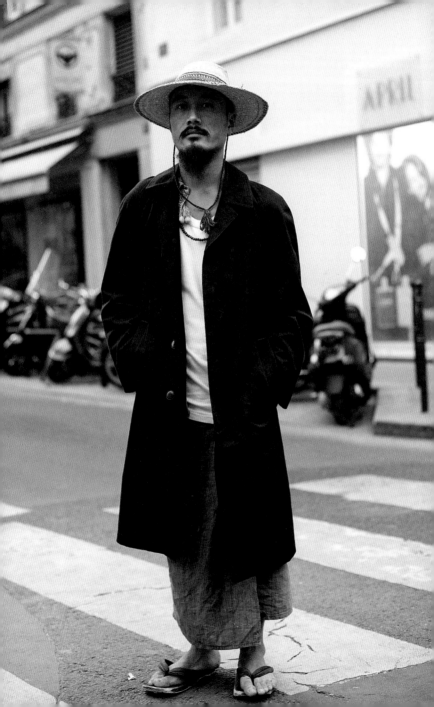

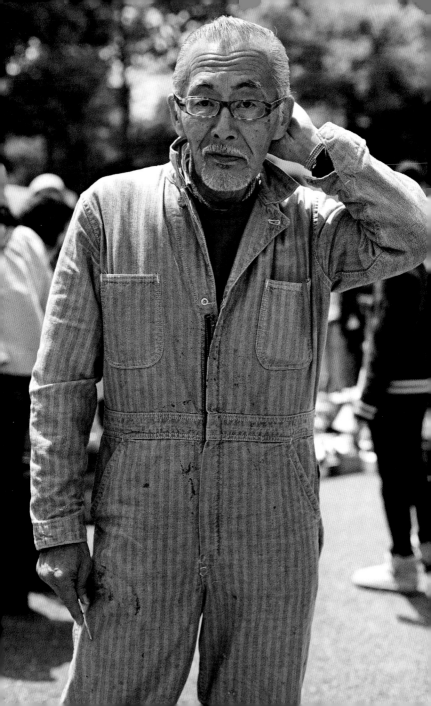

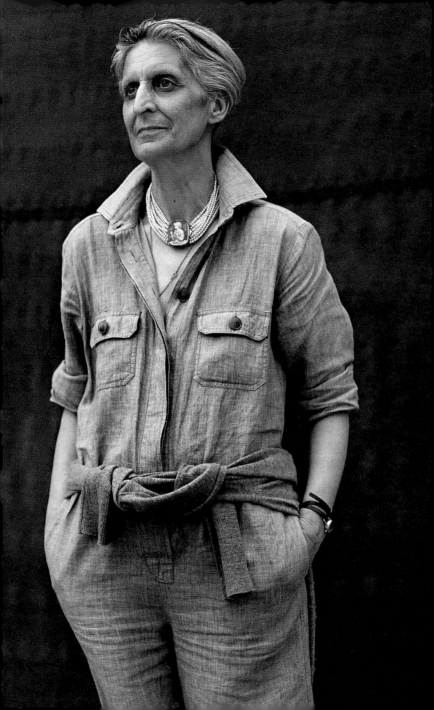

Art of the Trench

One iconic item, the Burberry Trench, shot on one hundred different people. That's the assignment that Burberry offered me in 2009.

The idea was to shoot individuals during my travels around the world, capturing their unique interpretation of the classic Burberry trench.

This project would launch the Burberry 'Art of the Trench' website and their pioneering entrance into social media. Following the launch anyone would be able to submit photos of themselves on the website, sharing their own vision of a Burberry trench.

The result was a groundbreaking success. Never had such a major fashion house exposed themselves to the new concept of user-generated content. The audience engagement and the media attention were astounding.

Equally astounding was the amount of artistic freedom I was given during the project. Occasionally I would email a few images to Burberry HQ and my only feedback was to try and gain an even wider diversity of individuals for the project. Never once did they ask for 'It girls', celebrities or socialites.

What I learned from this experience is that the most powerful brands, like Burberry (often with the most to lose), often take the biggest risks. And therefore reap the biggest rewards.

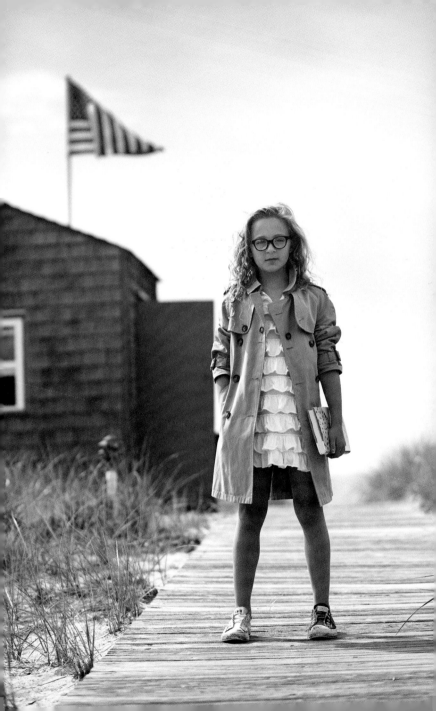

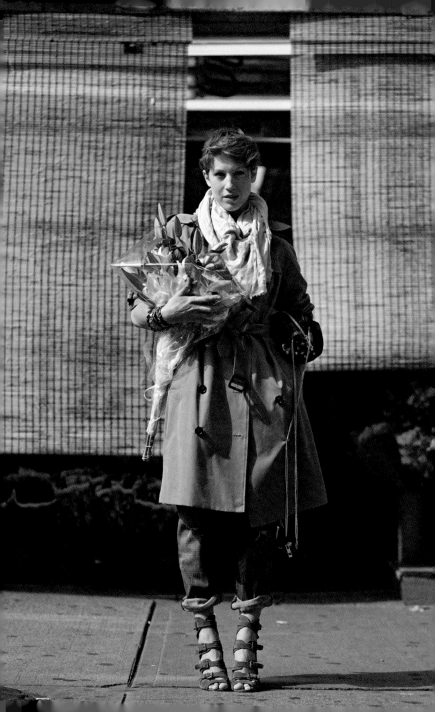

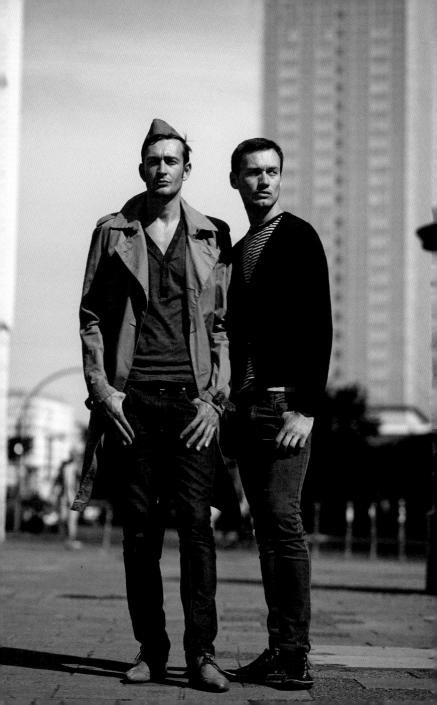

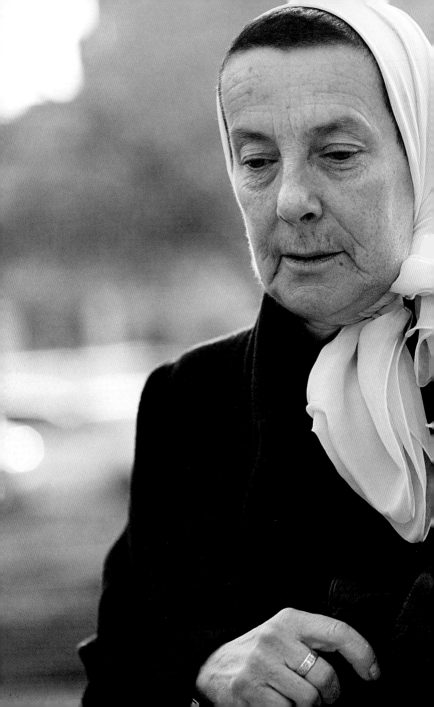

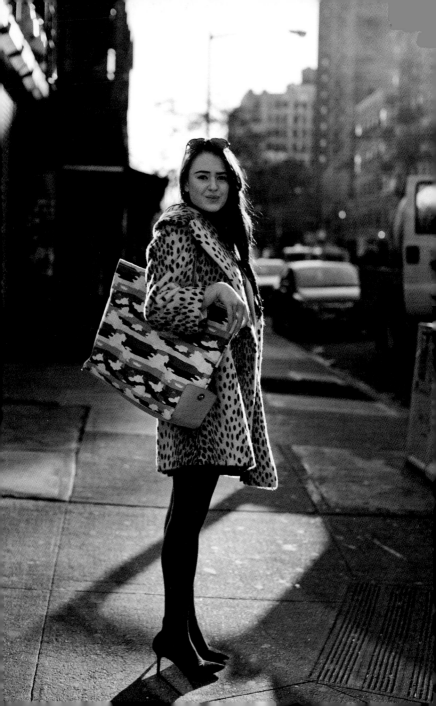

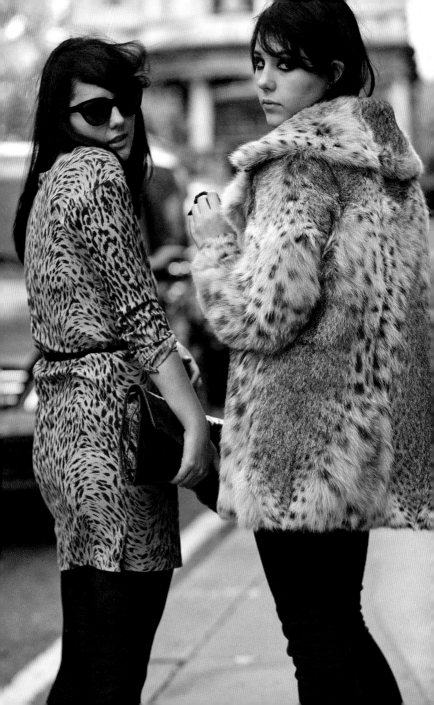

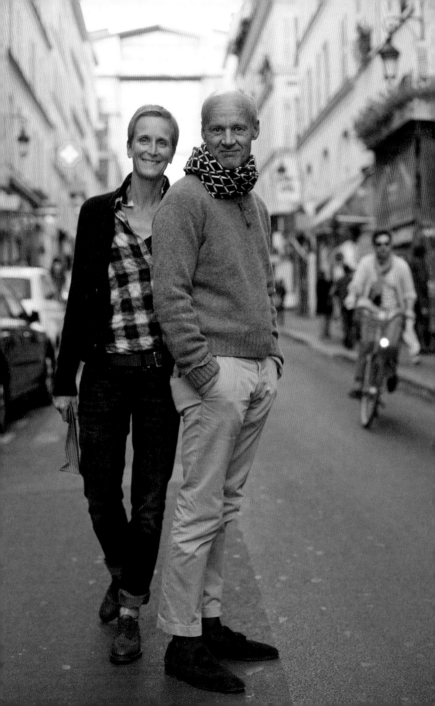

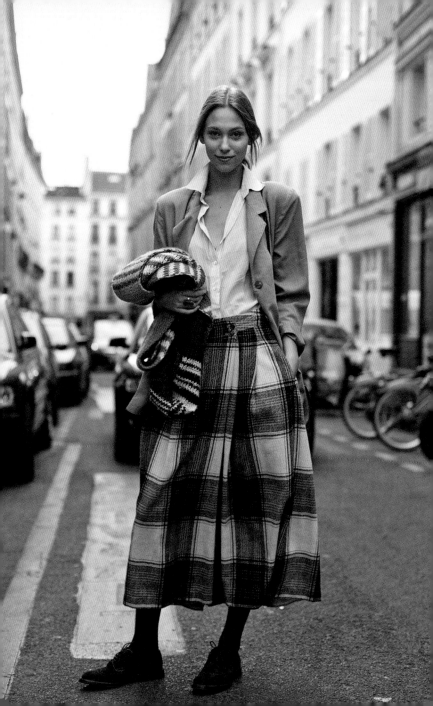

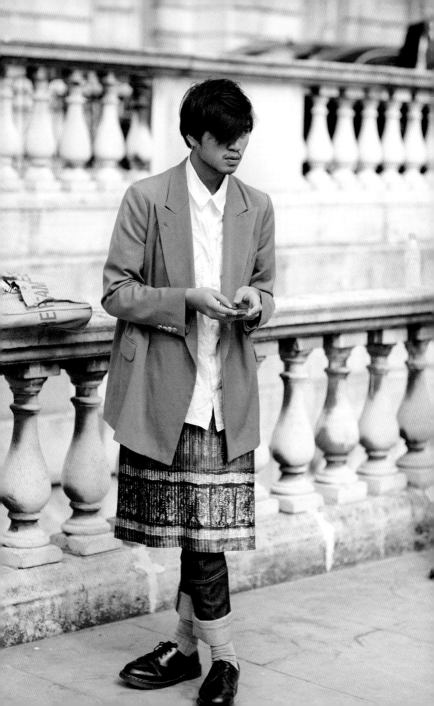

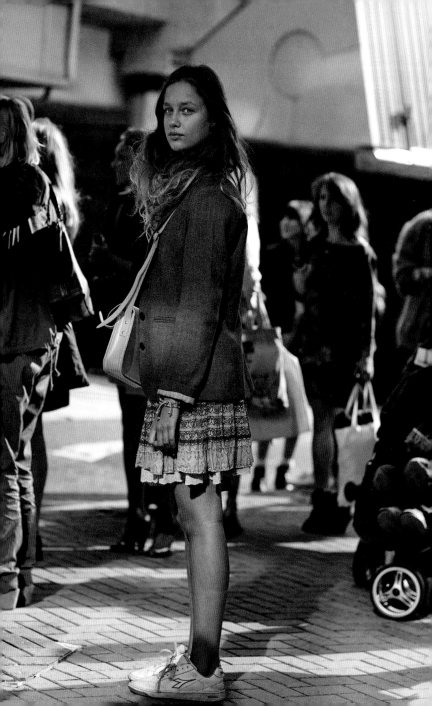

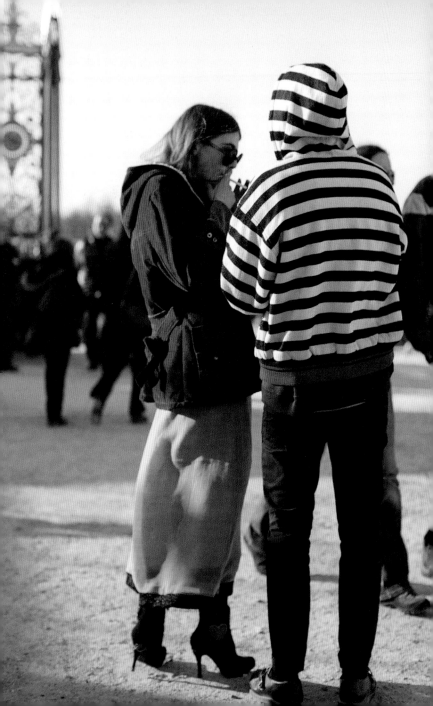

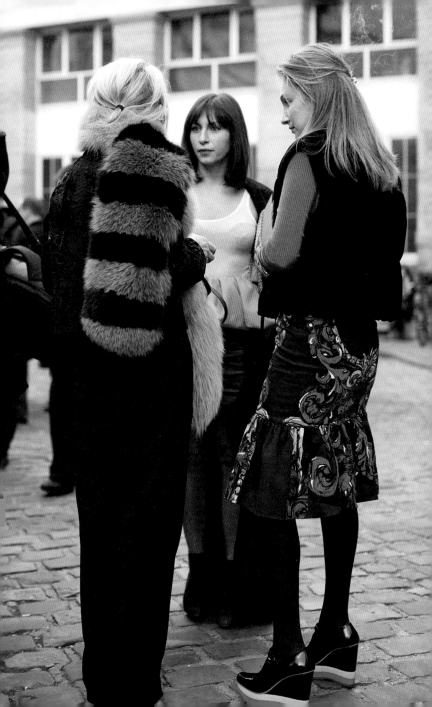

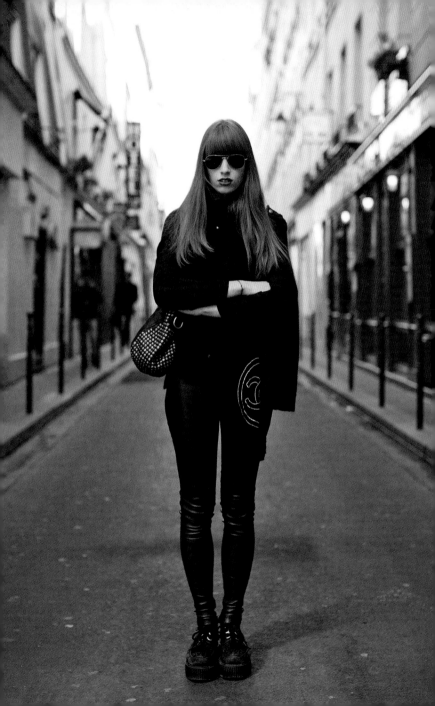

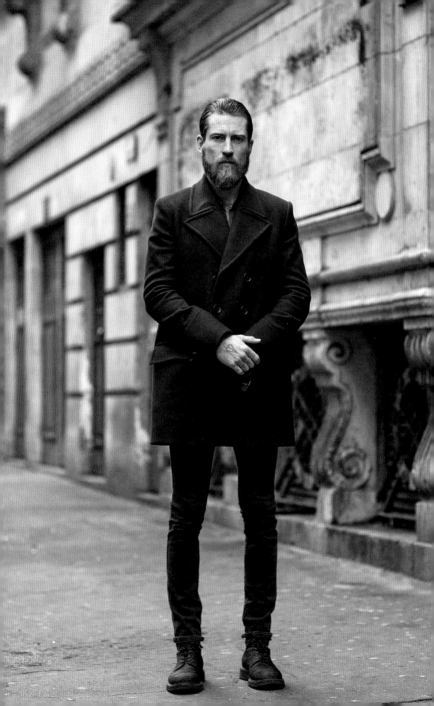

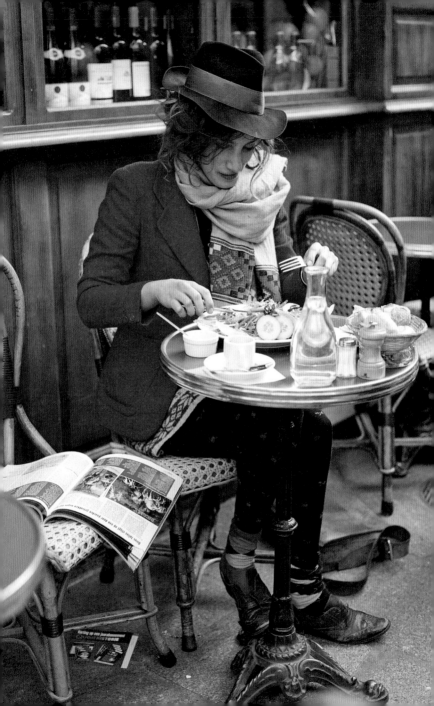

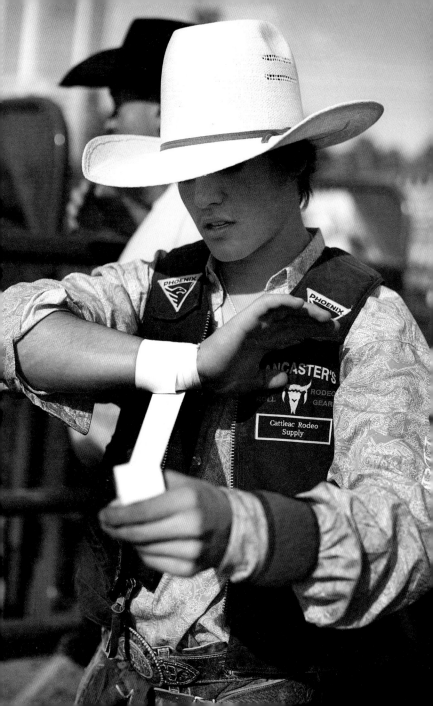

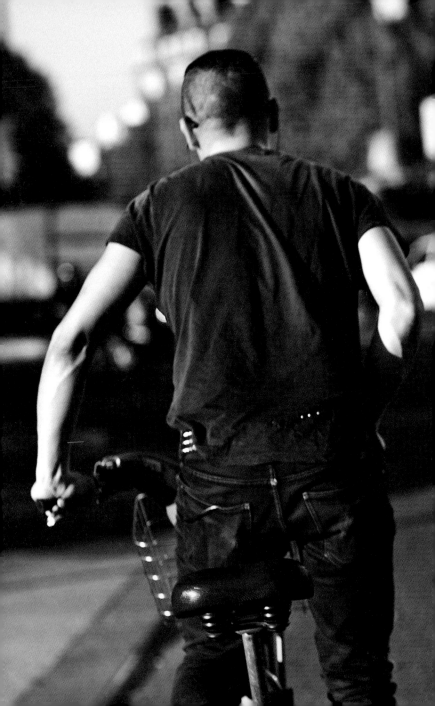

Wear the clothes you have

Leather has the most beautiful way of aging: it cracks, it creases, it scuffs, it darkens over time.

I remember showing Garance a photograph of a pair of Luciano Barbera's gloves. They had aged beautifully. I told her that I wished one of my multiple pairs of gloves would eventually age as perfectly as his.

She replied with one of the most simple but insightful truths about style: 'If you want your clothes to age with that kind of grace then wear the clothes you have and stop always buying new ones!!' . . . so true.

It's pretty funny that we buy pre-washed, pre-ripped, pre-faded clothes. Yet we can achieve that look ourselves with a couture-ish level of uniqueness that store bought pre-aging will never, ever duplicate.

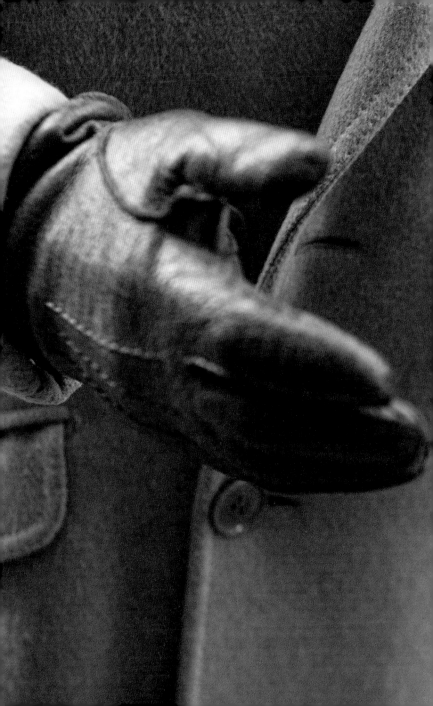

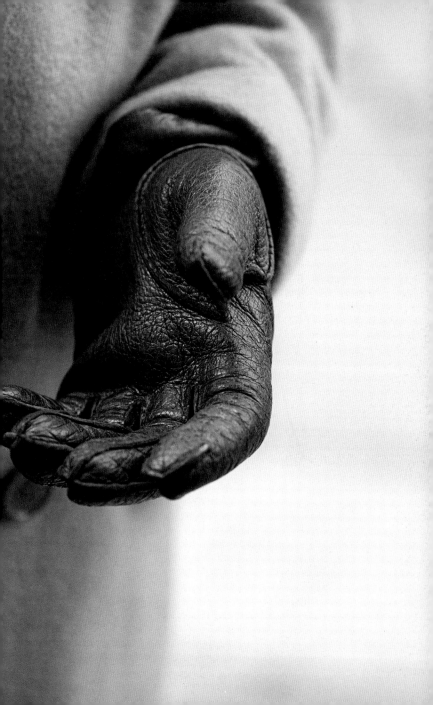

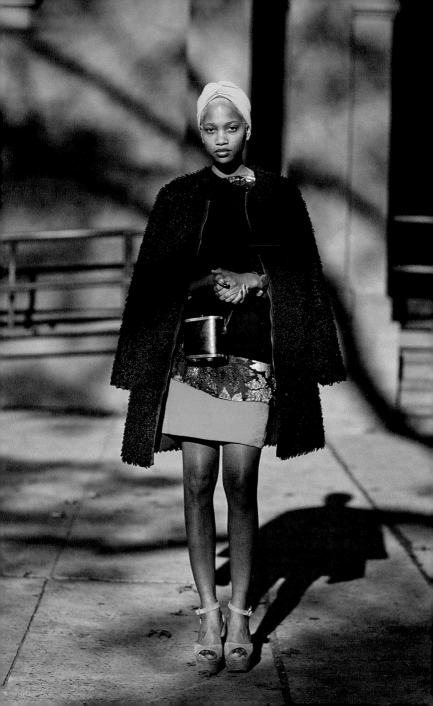

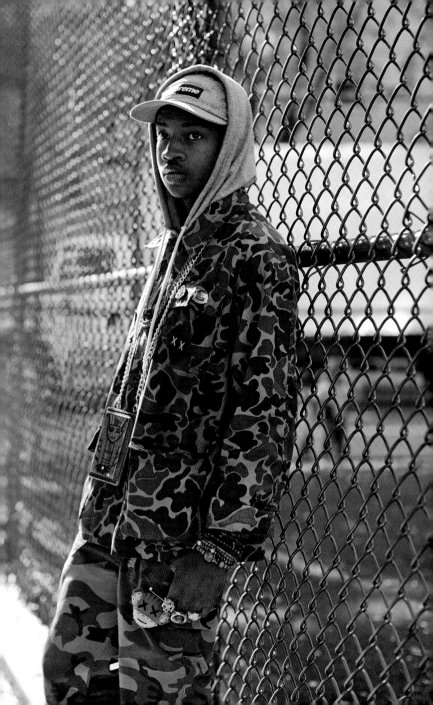

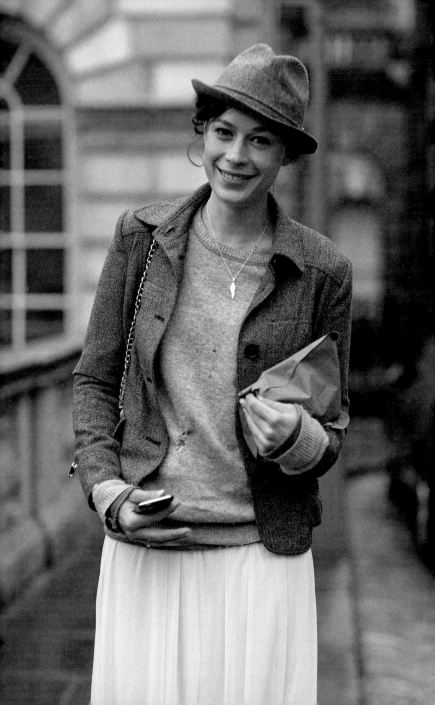

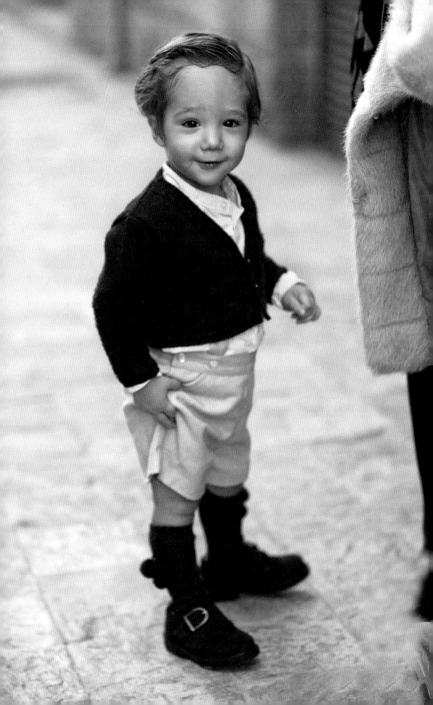

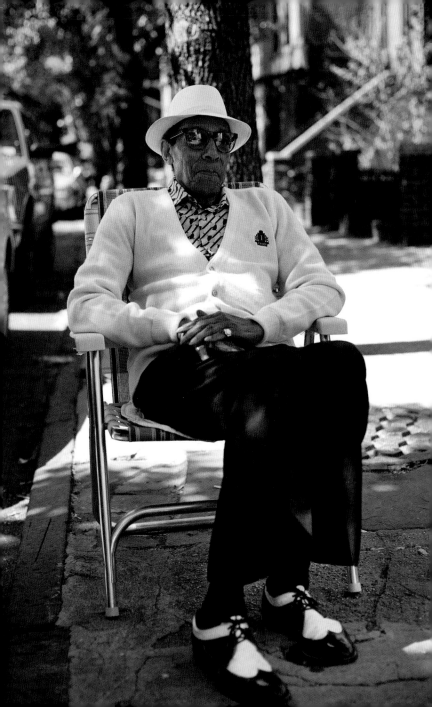

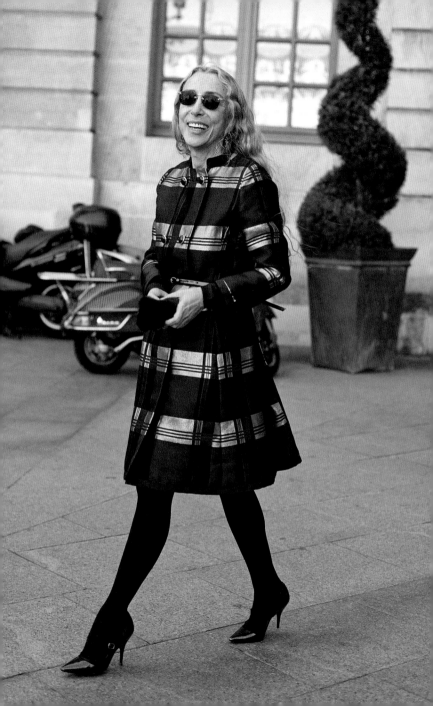

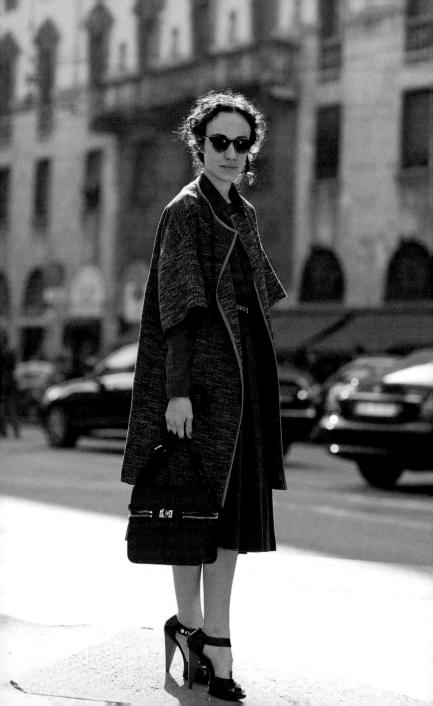

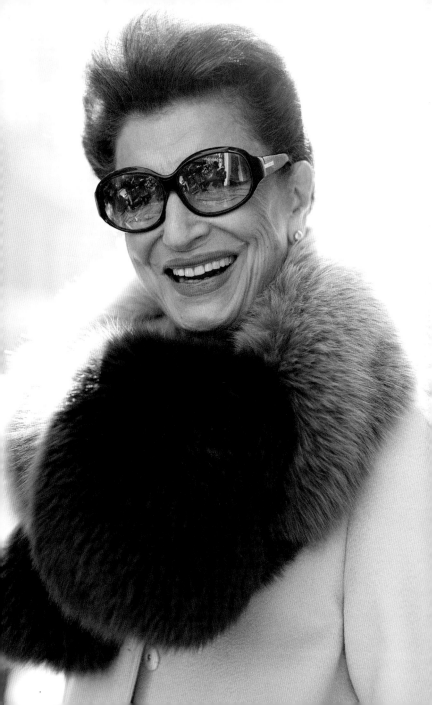

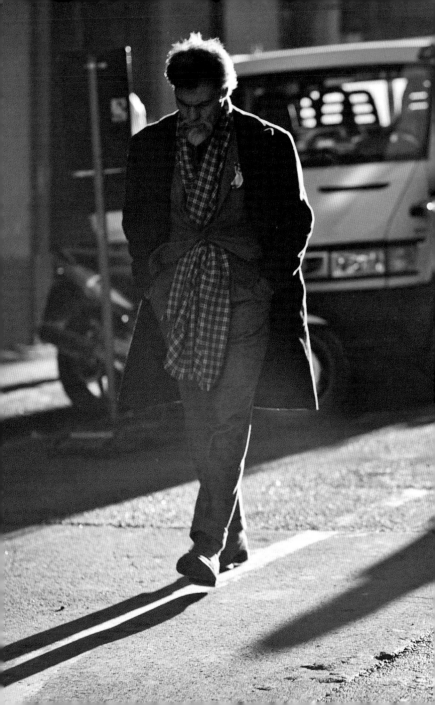

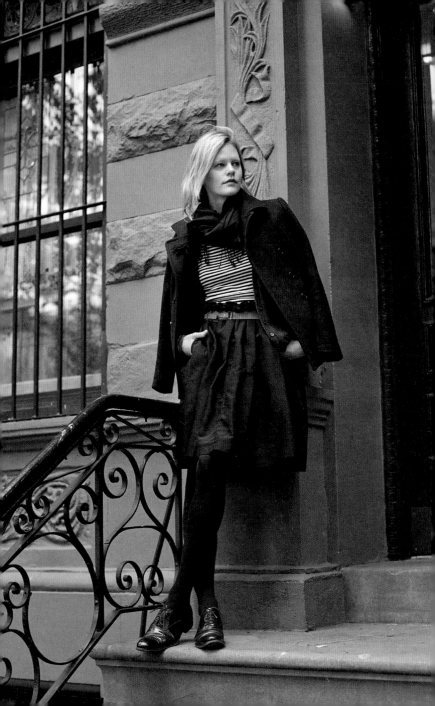

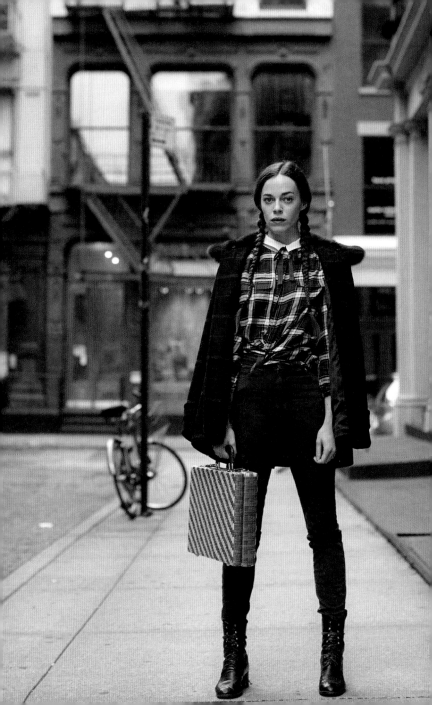

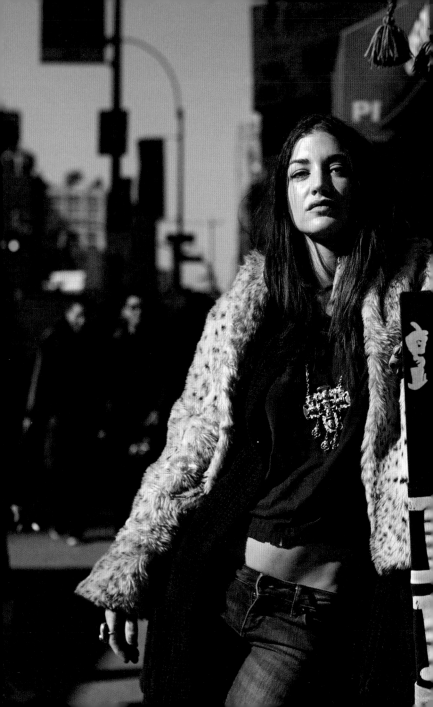

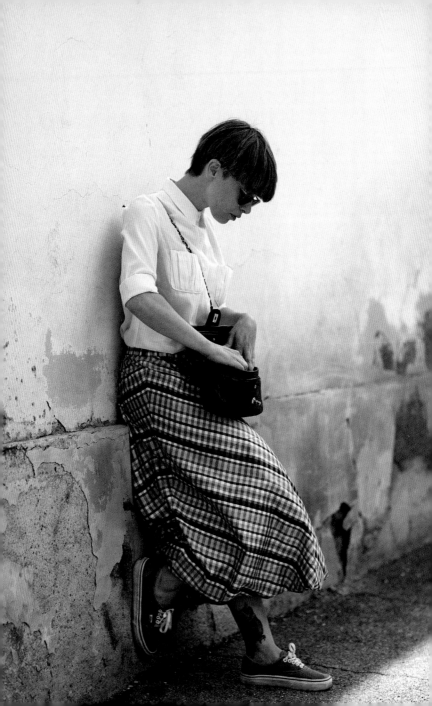

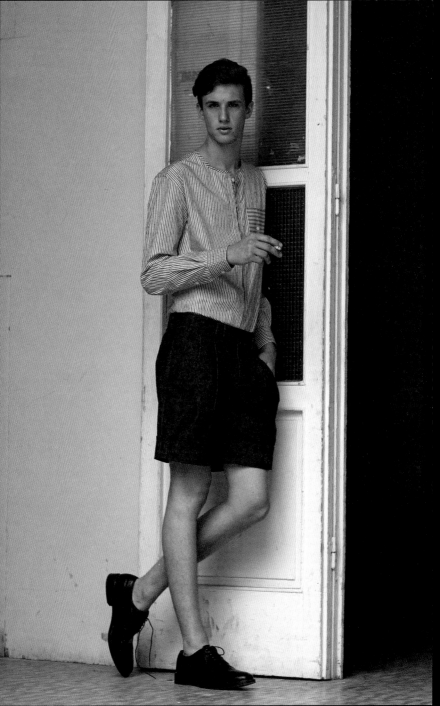

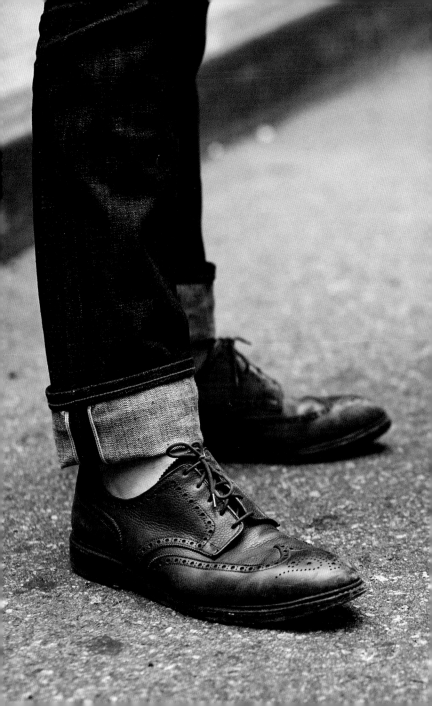

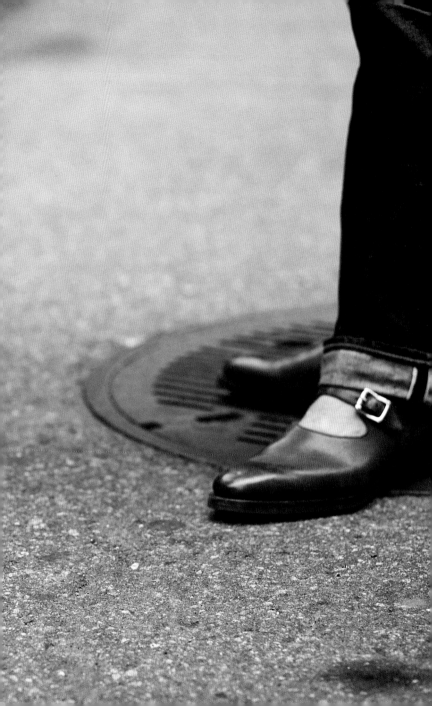

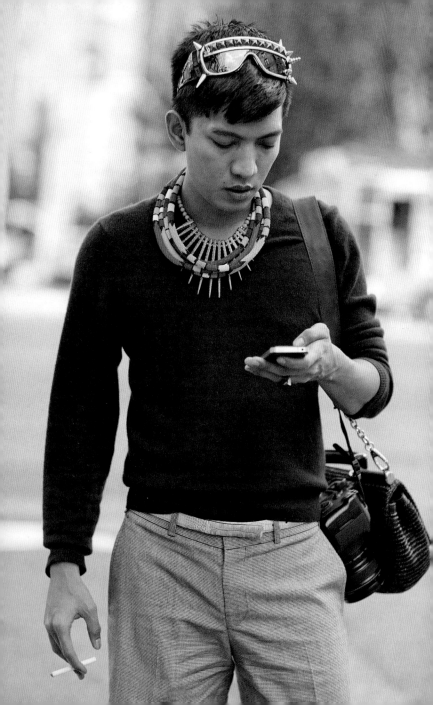

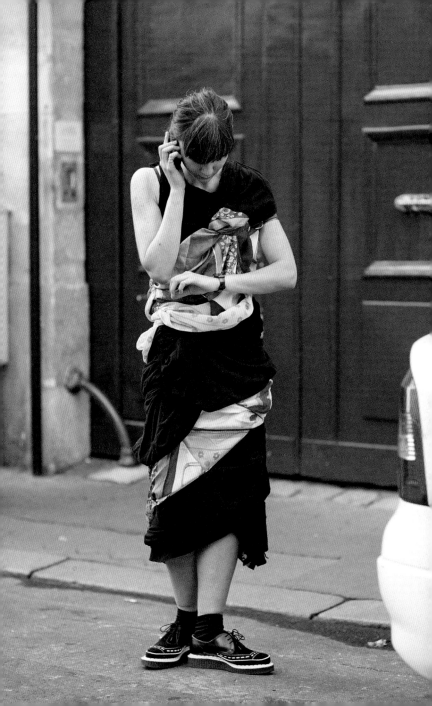

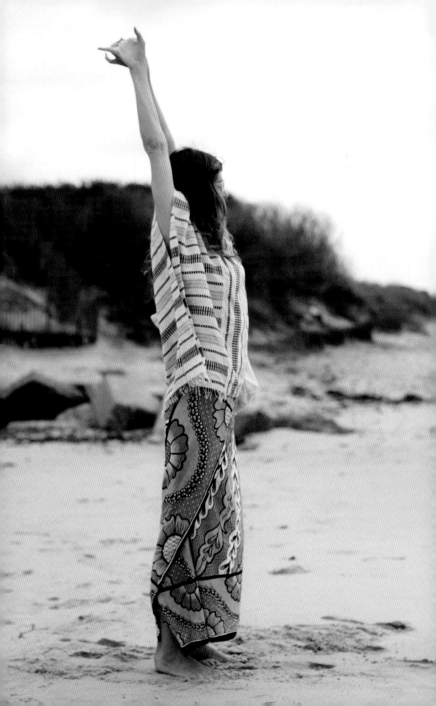

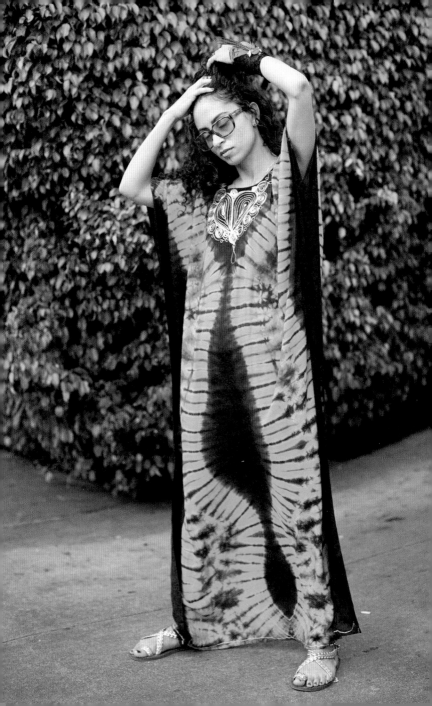

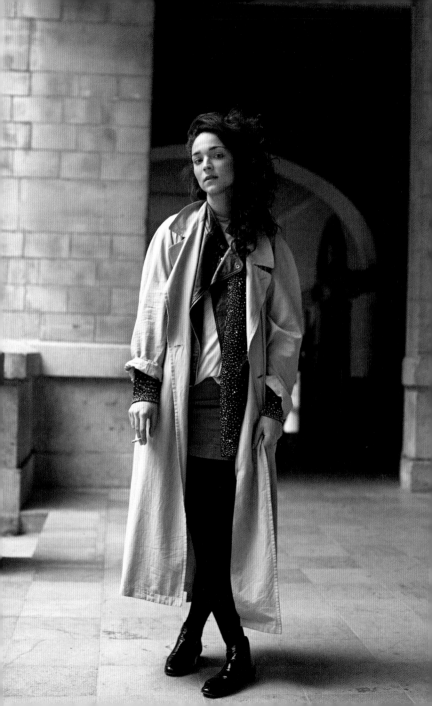

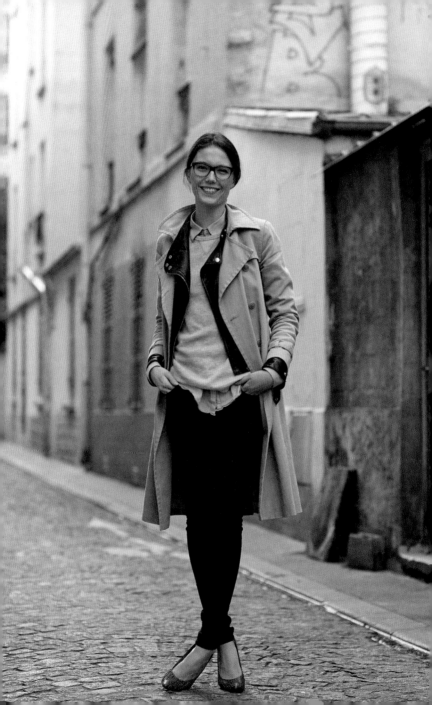

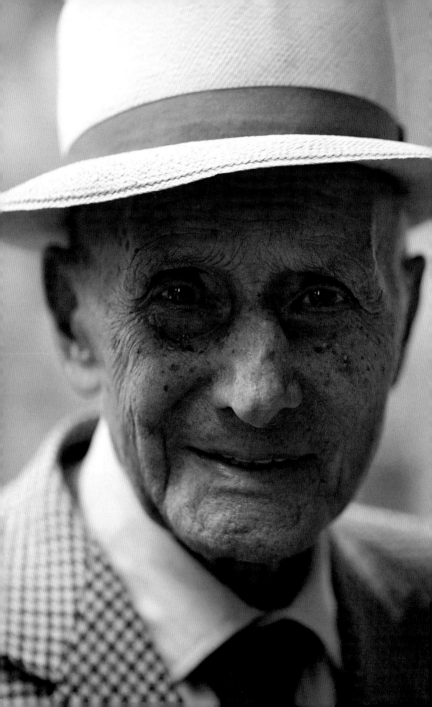

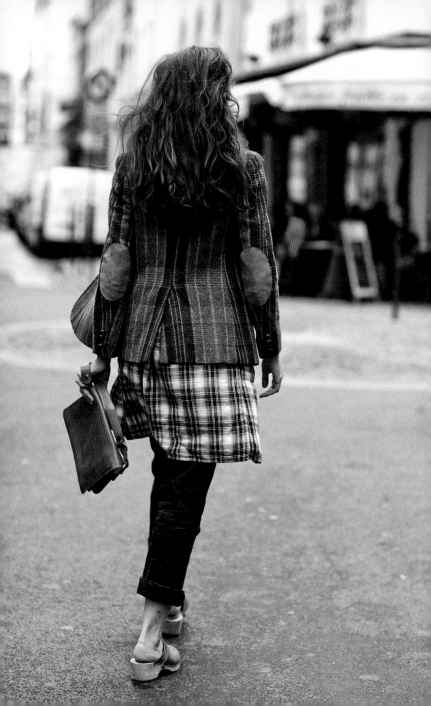

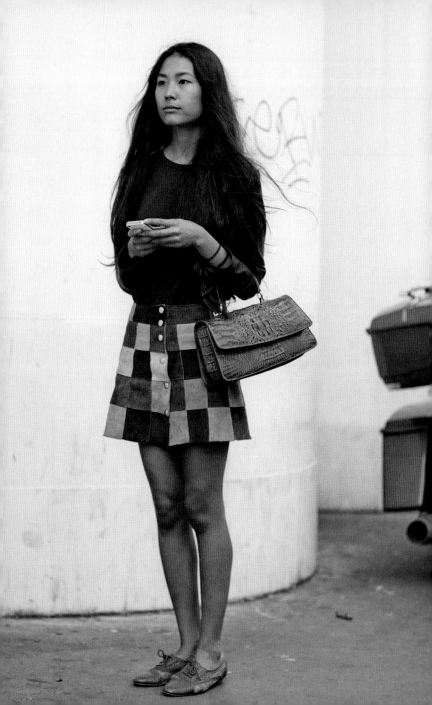

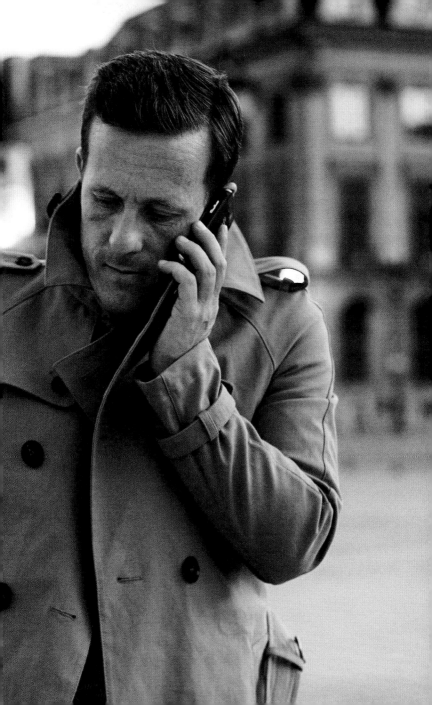

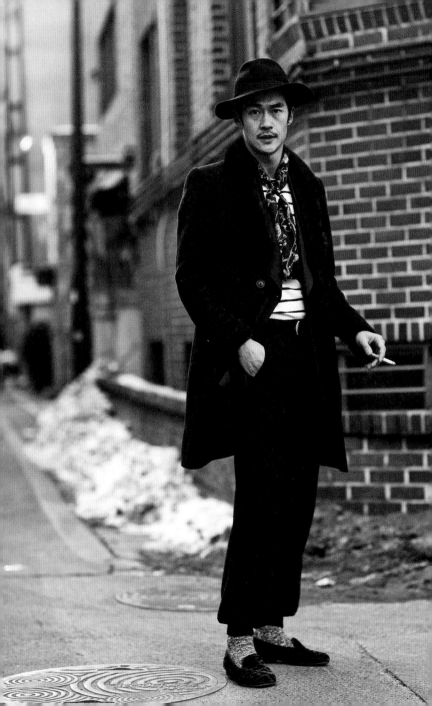

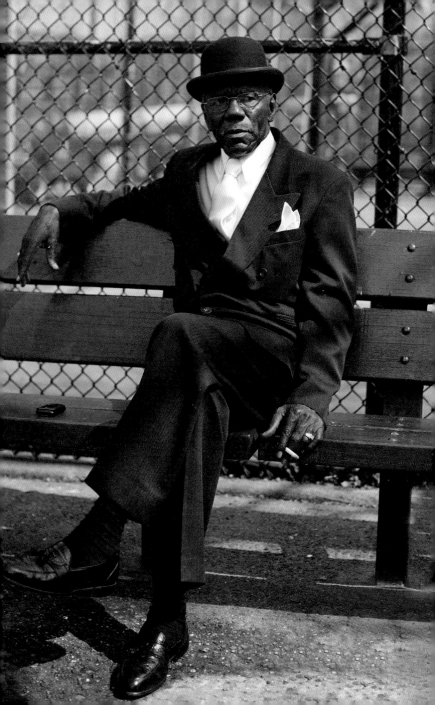

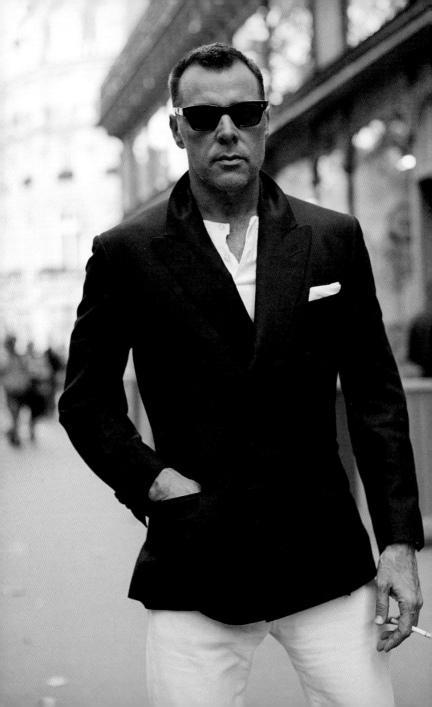

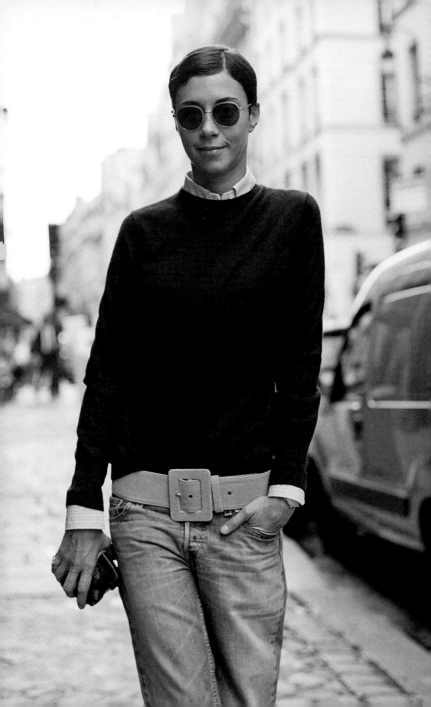

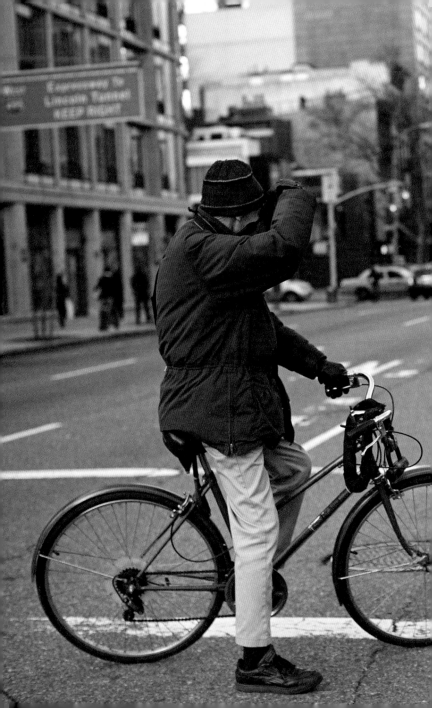

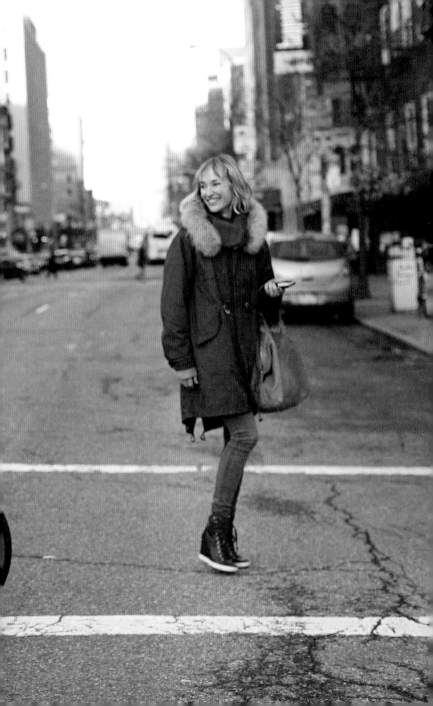

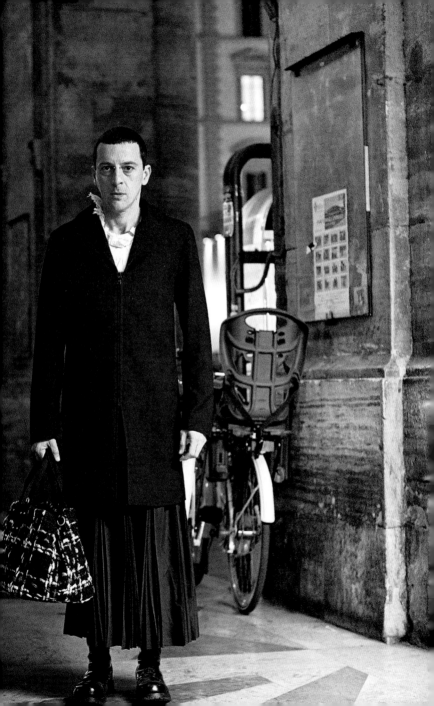

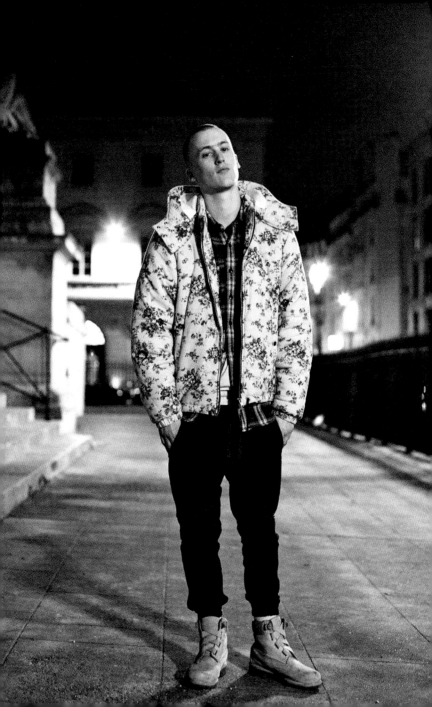

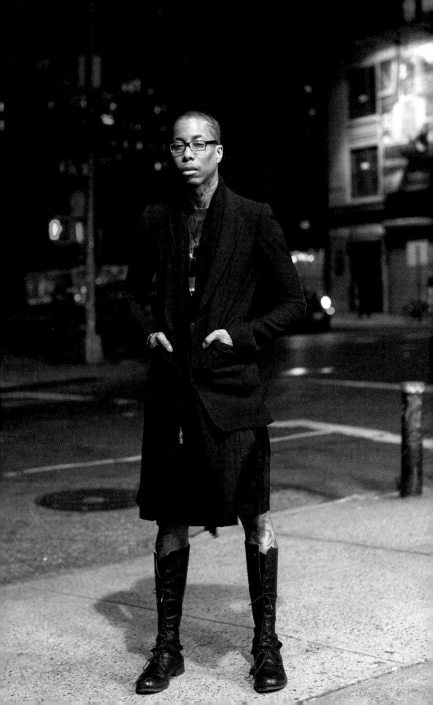

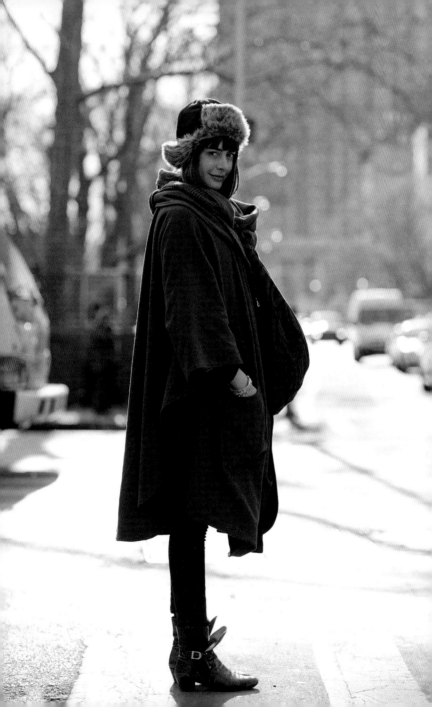

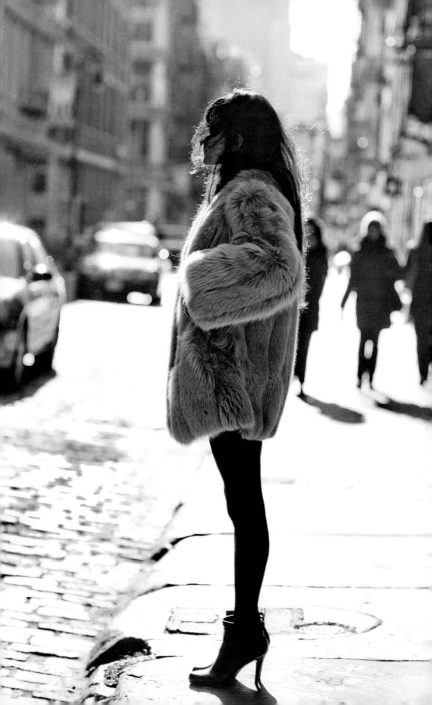

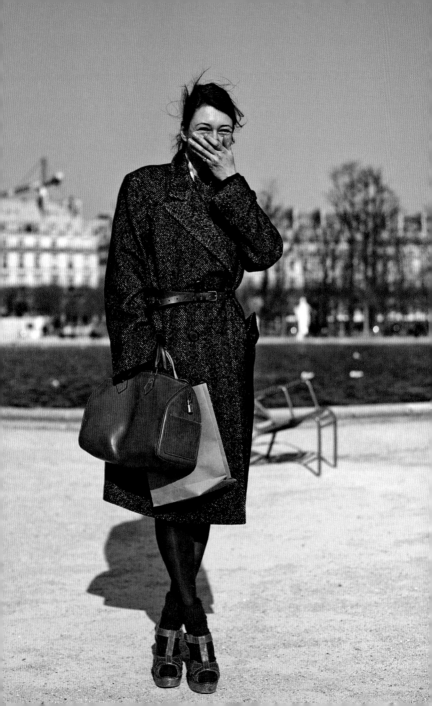

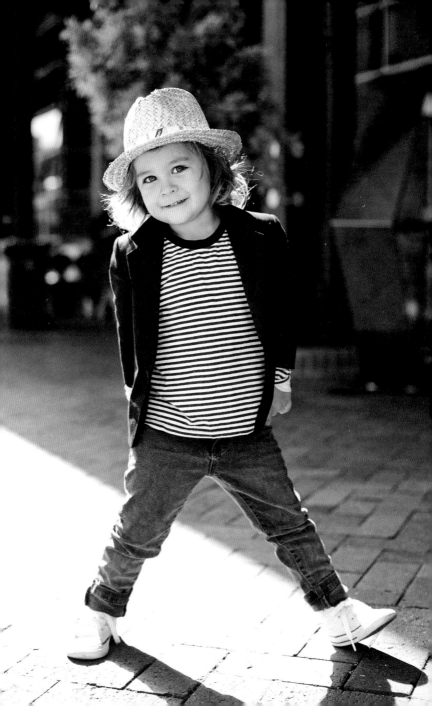

Garance

Garance is easily one of the most stylish women I have ever met. After spending the last few years living together I think I have finally figured out her secret to great style.

Garance has an ability to make her decisions based on the intrinsic beauty of any item and not be awed by the status of a designer label or deterred by the stigma of an item being 'common'.

It sounds like an easy concept, but don't we all know people that try to buy style?

In this section there is a shot of Garance on a bike wearing one of my white shirts as a bathing suit cover-up and a dime store straw hat. I was with her when she bought it and remember thinking 'ugh'.

And yet there she was, looking adorable in Montauk all that summer.

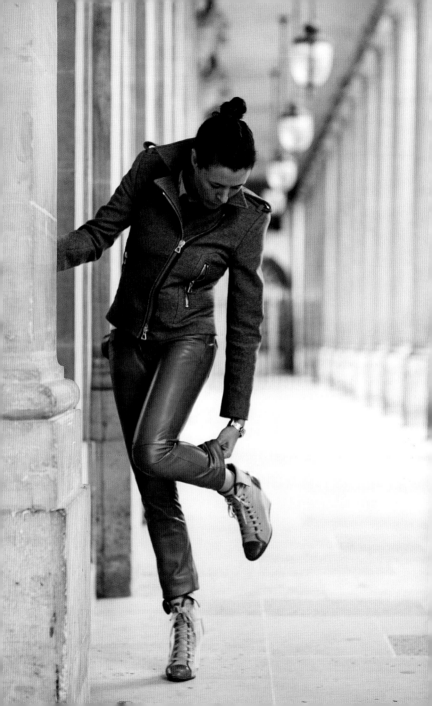

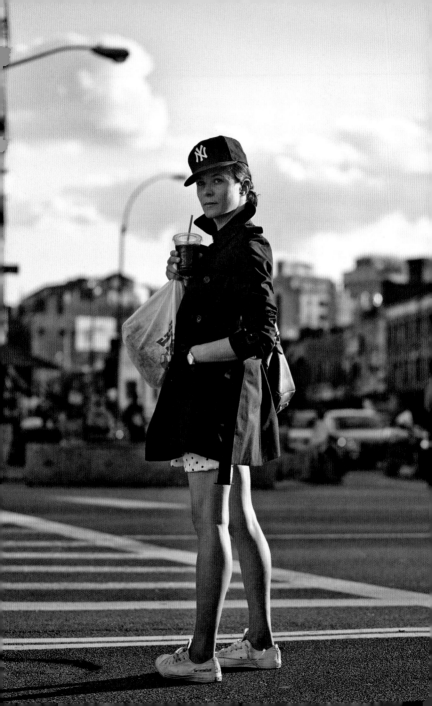

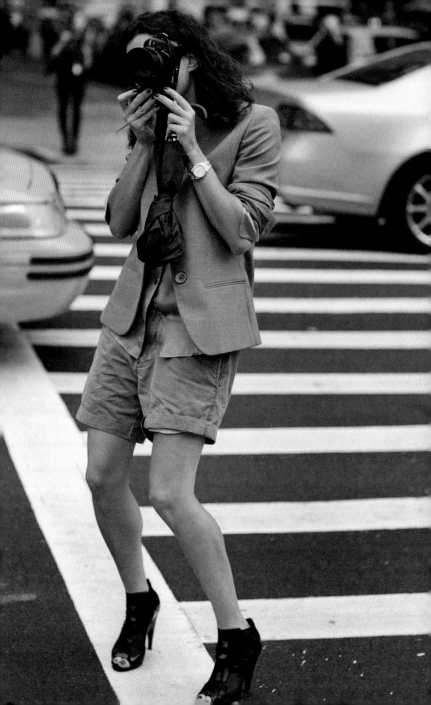

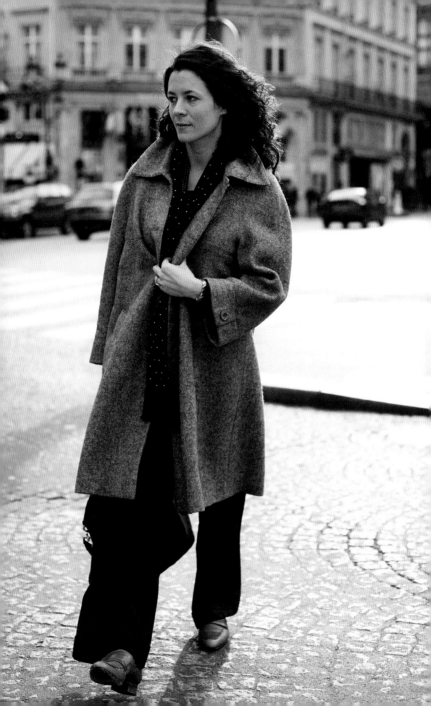

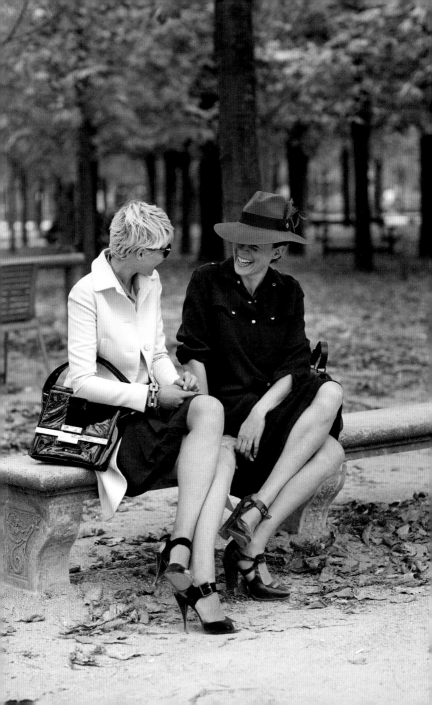

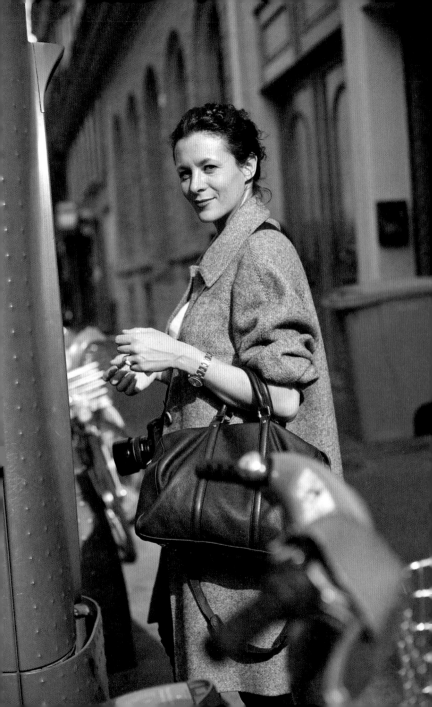

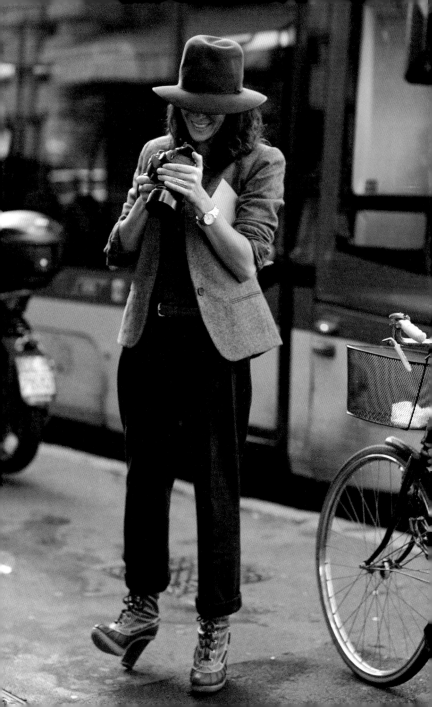

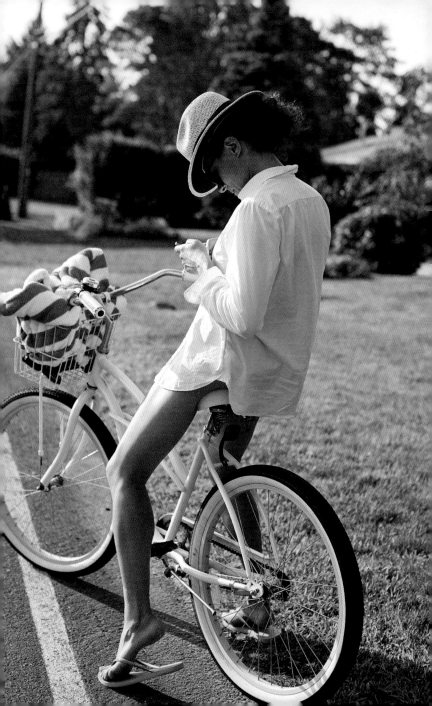

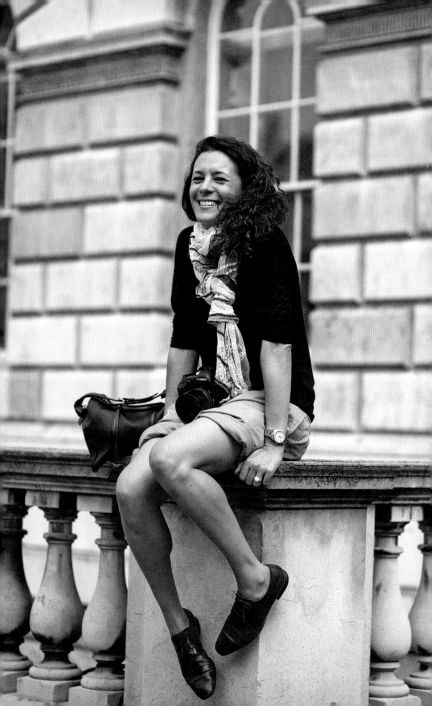

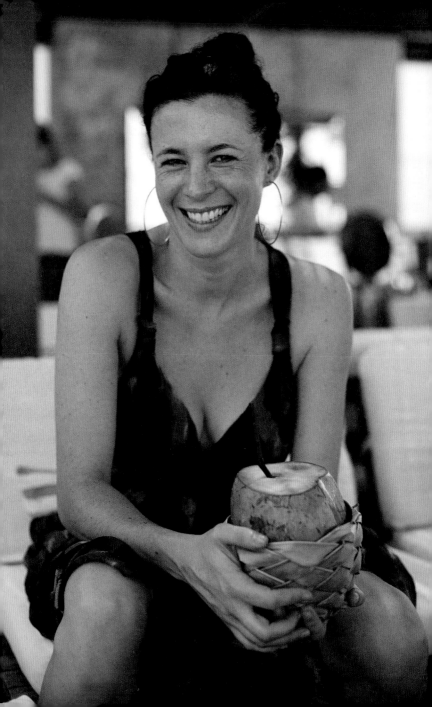

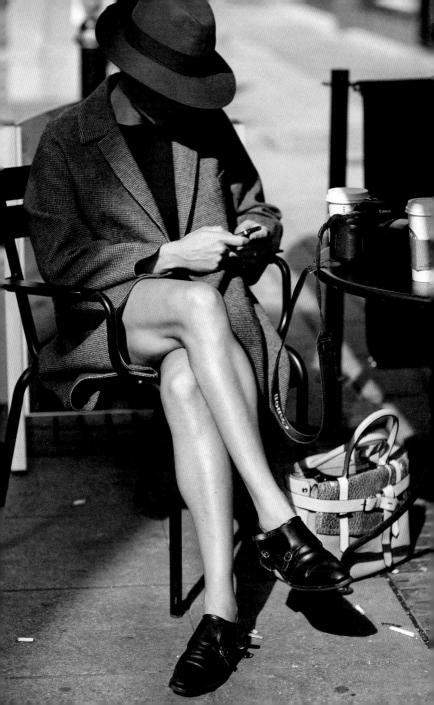

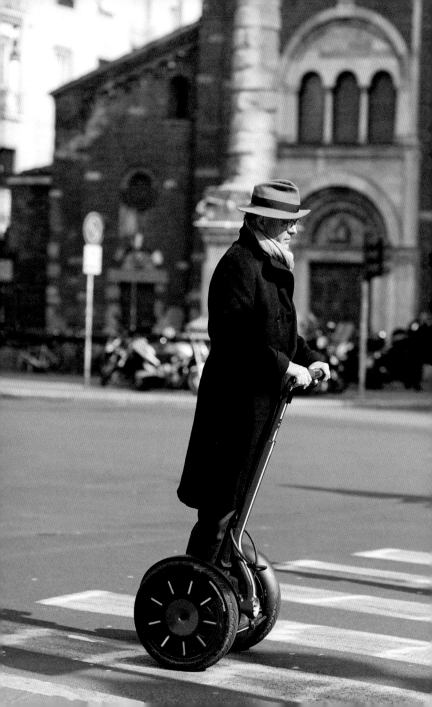

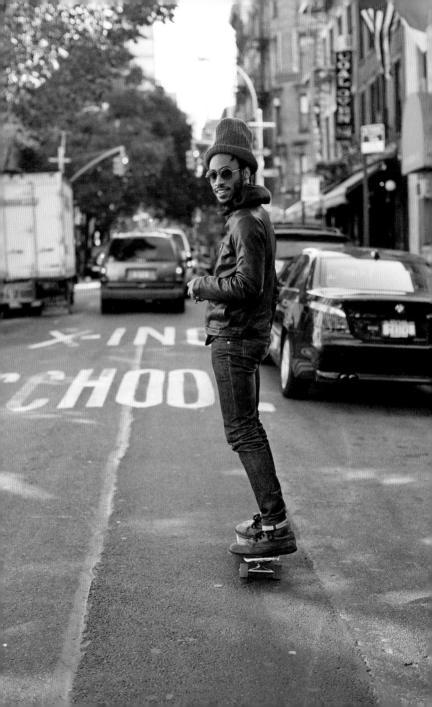

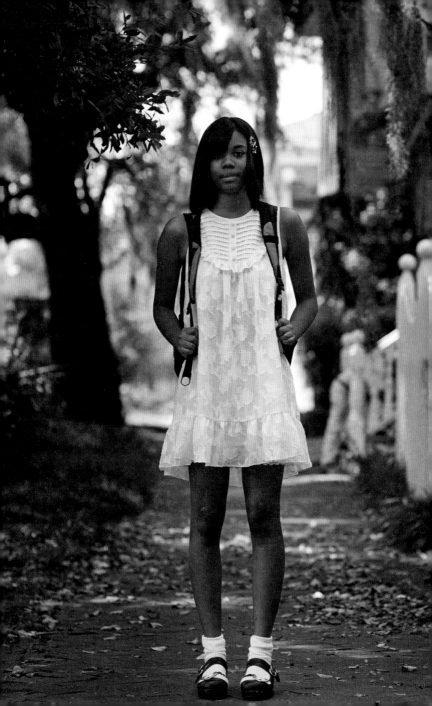

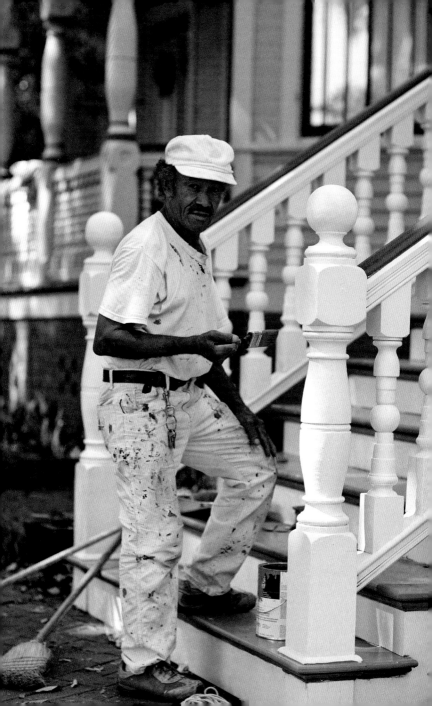

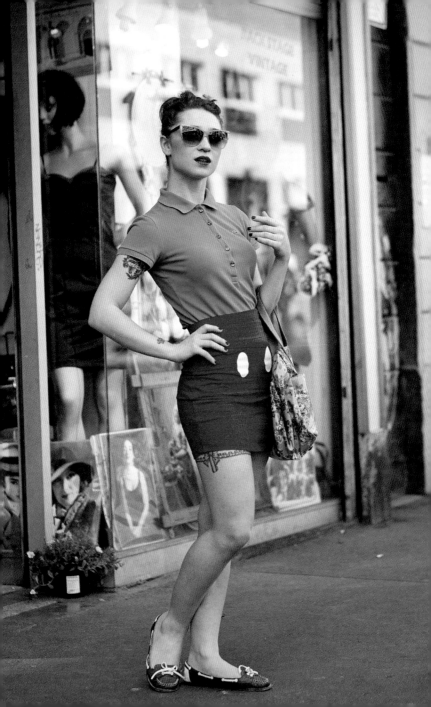

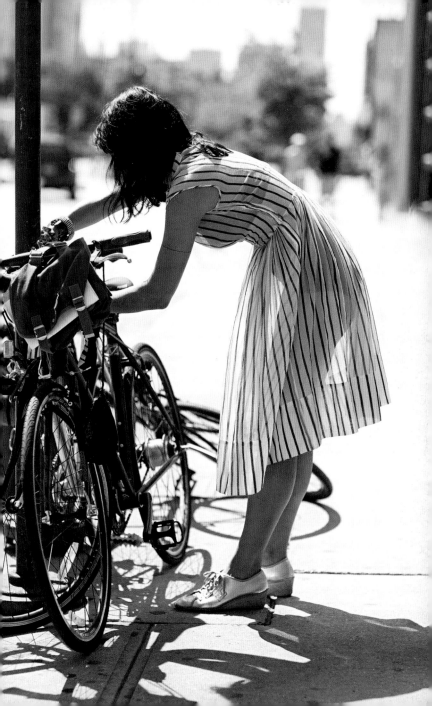

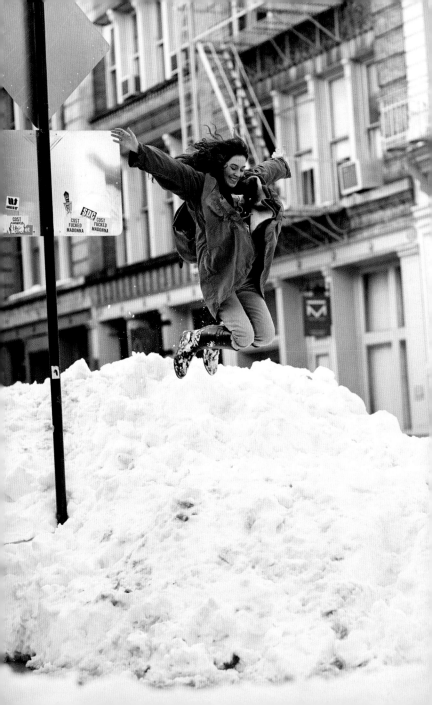

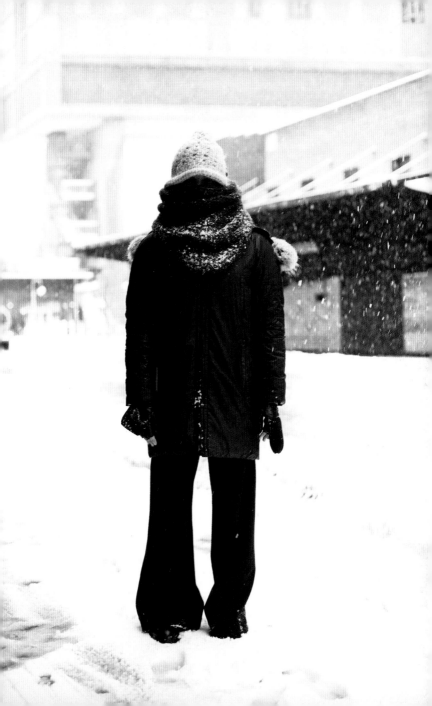

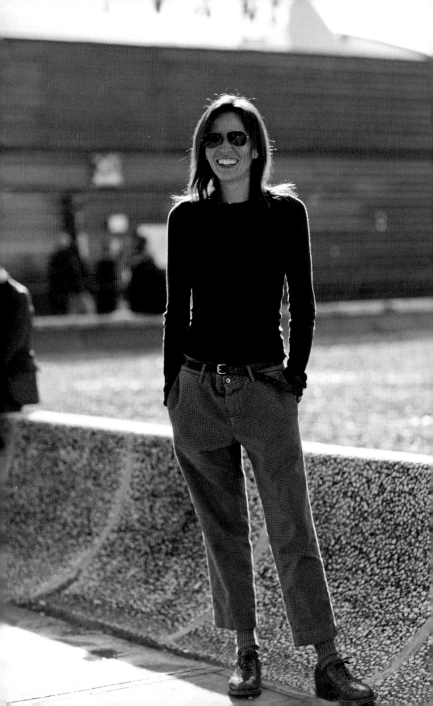

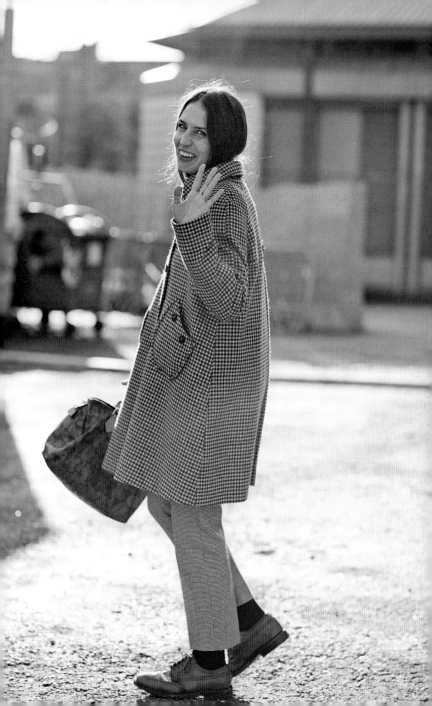

On the Street . . .
Bowery, New York

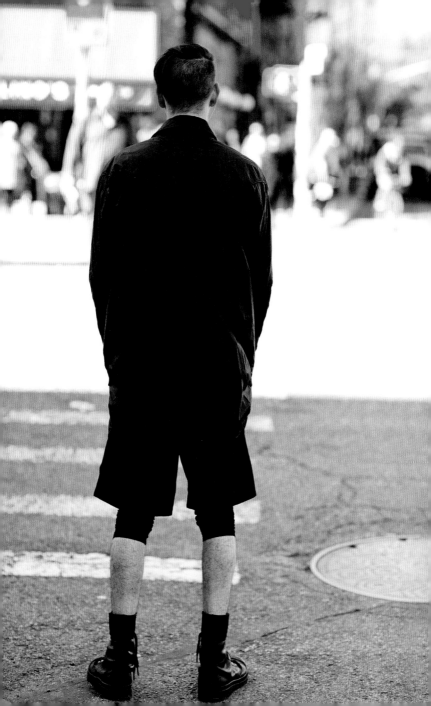

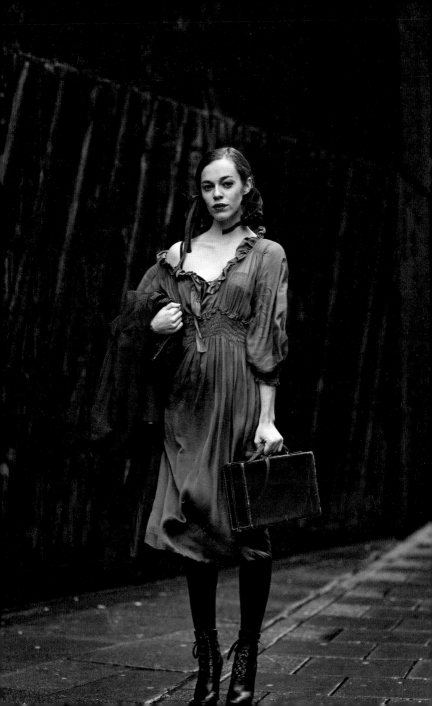

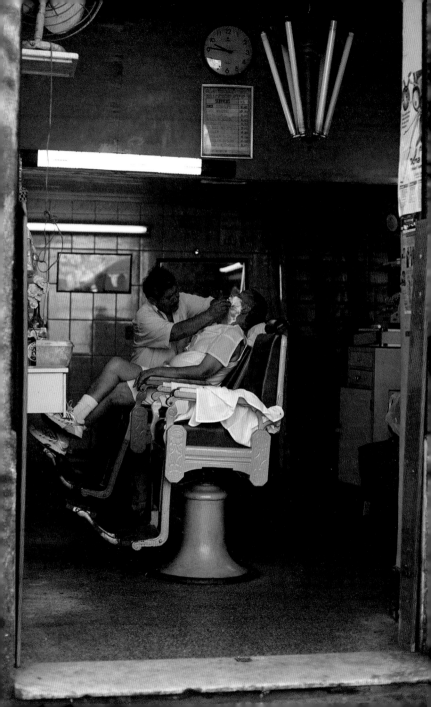

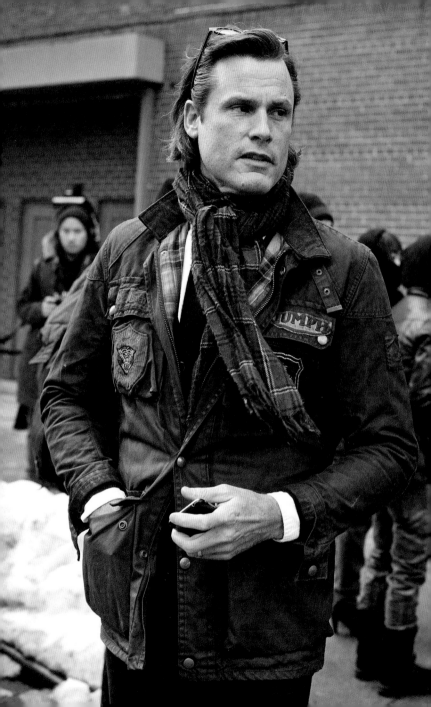

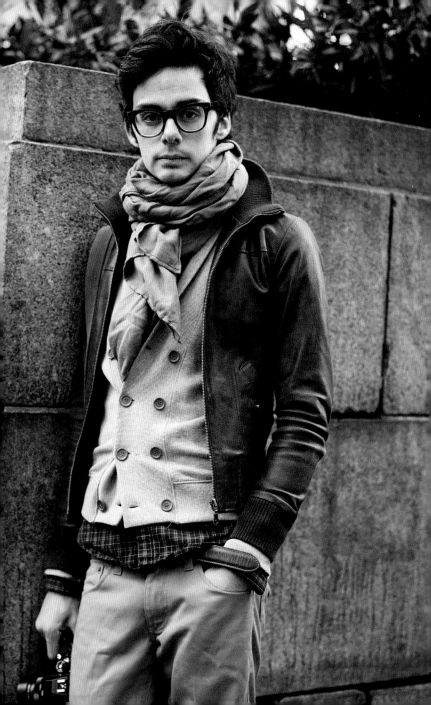

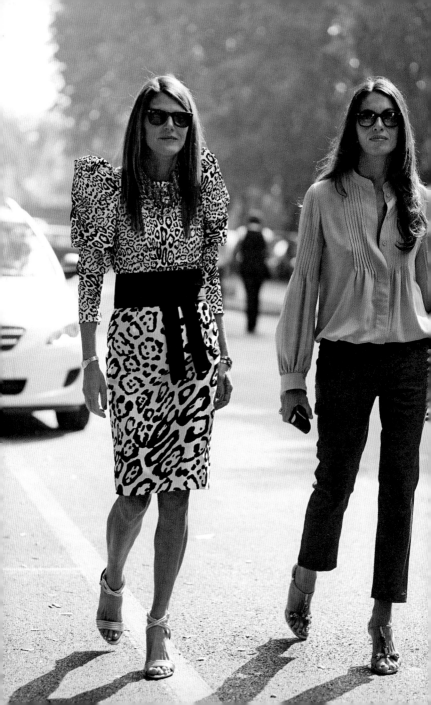

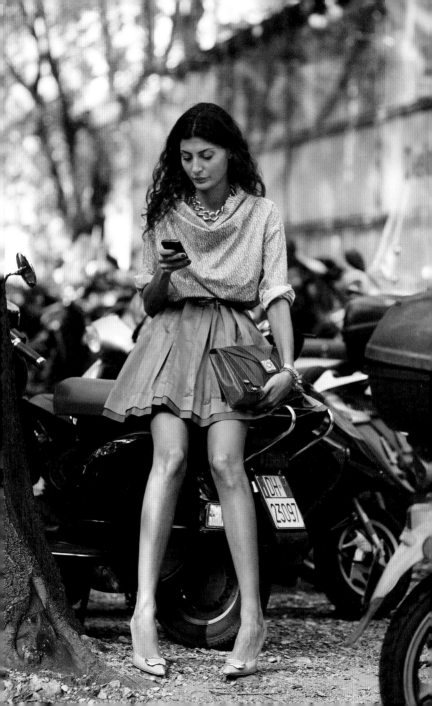

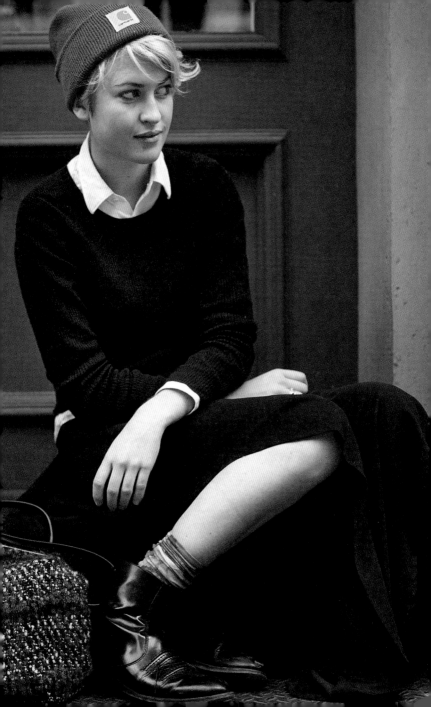

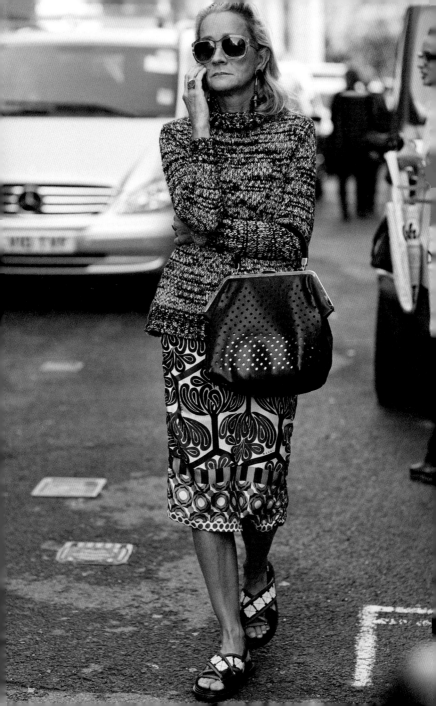

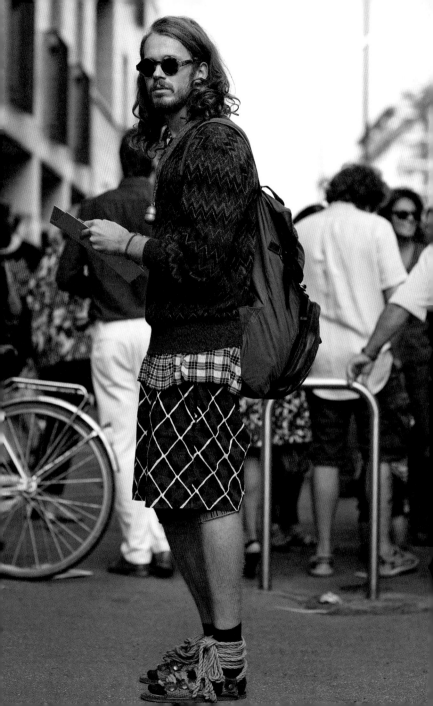

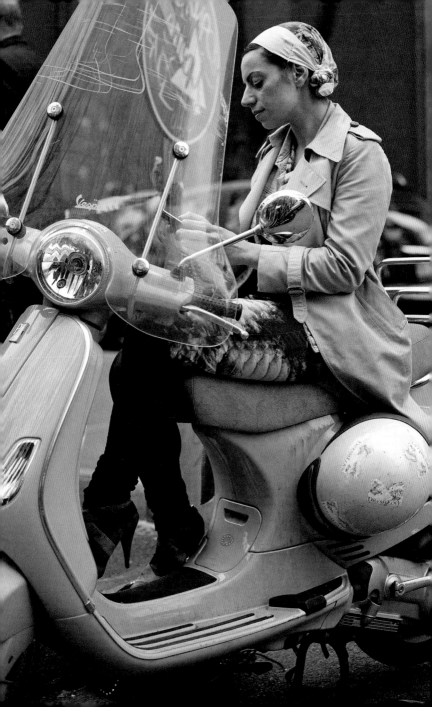

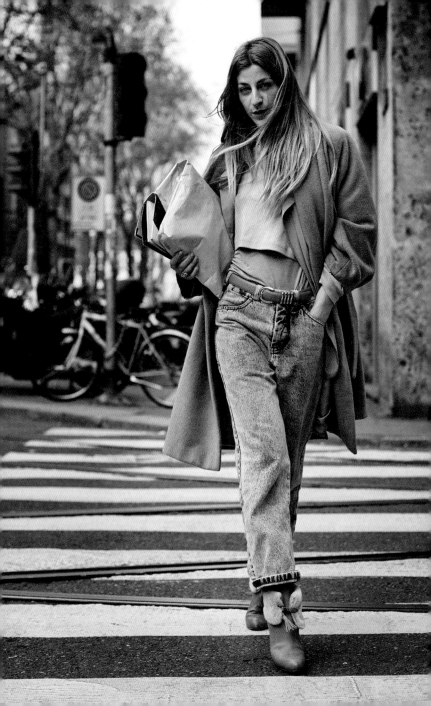

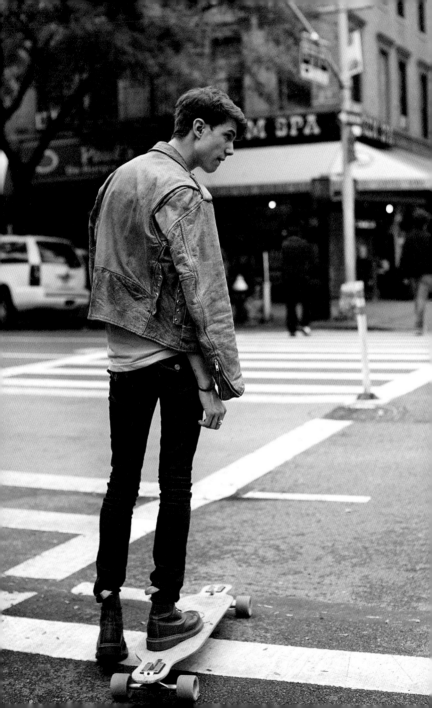

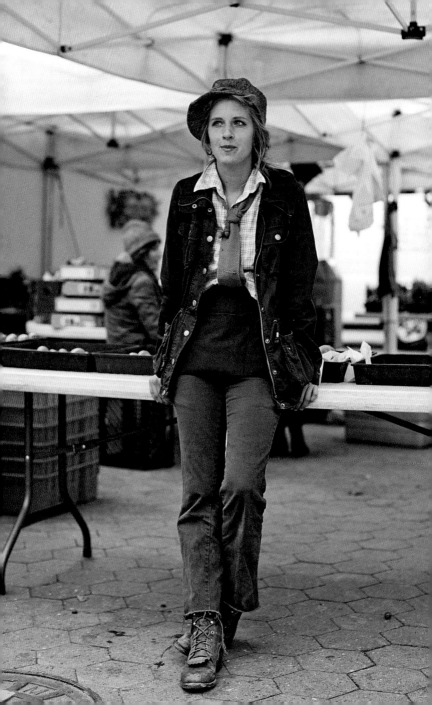

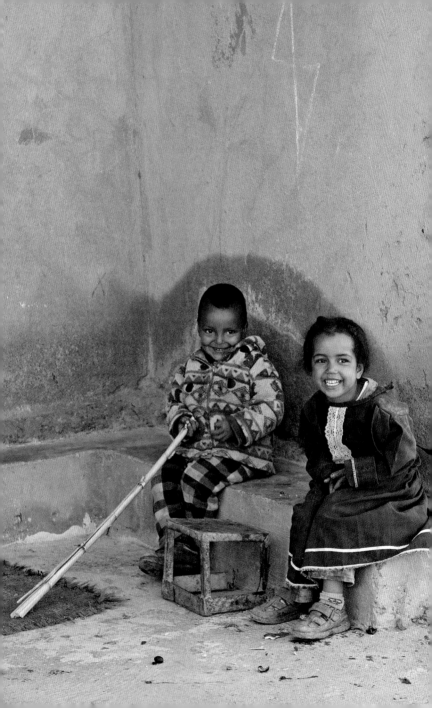

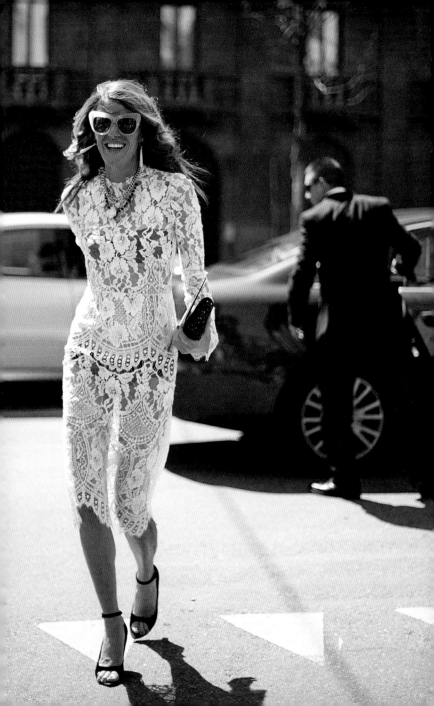

The myth of effortless chic

There is no such thing as effortless chic. If you are secretly harboring the dream that some day you will be able to *consistently, thoughtlessly* reach in to your closet and pull out a super-chic ensemble, well, you are fighting a no-win battle with yourself.

The most stylish people I know have spent lifetimes searching for what complements their body shape, their professional and personal lifestyle, local climate and how much they can reasonably budget for this pursuit.

Let me stress that this is not about how much money they have, but how attuned they are to their reality. It's an almost zen-like sense of self-awareness.

They don't obsess daily about what they wear but they all tend to be cautious shoppers. They make the tough decisions in the dressing room, not in their closet. It stands to reason that if you only fill your closet with what works then just grabbing things from that closet will be a million times easier . . . hence the perception of 'effortlessness'.

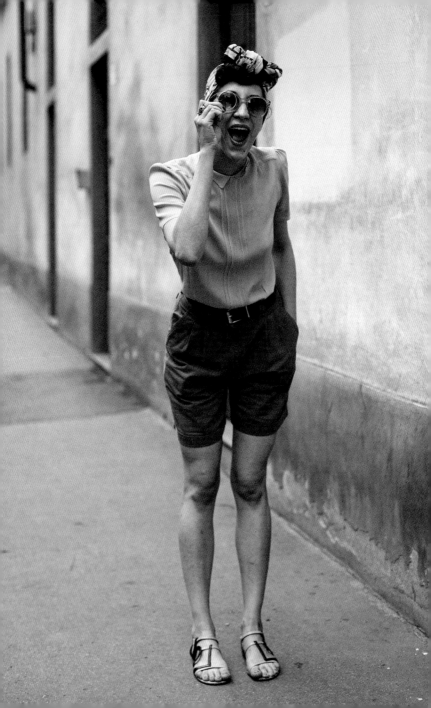

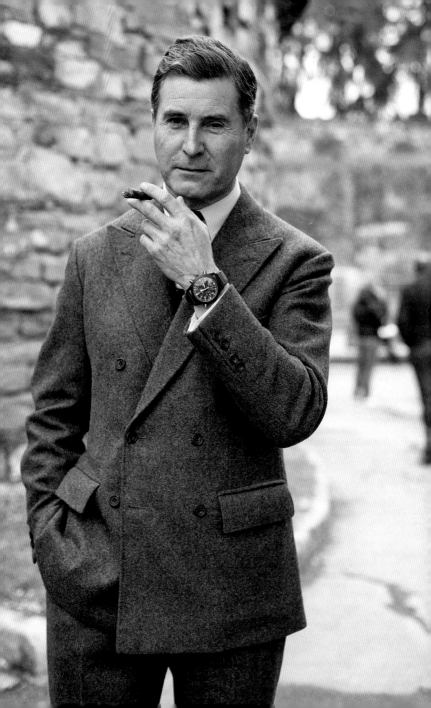

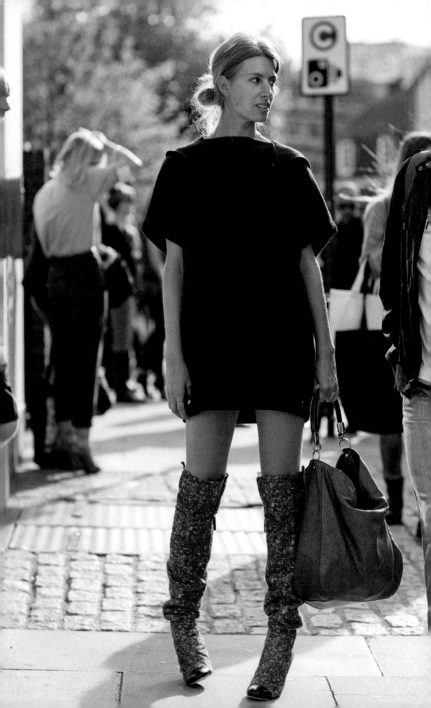

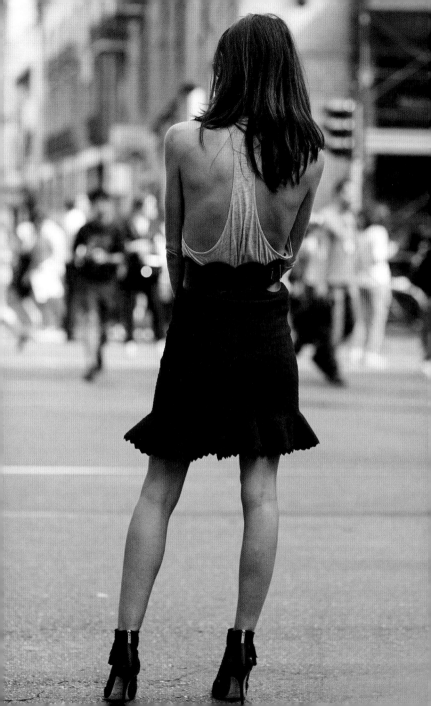

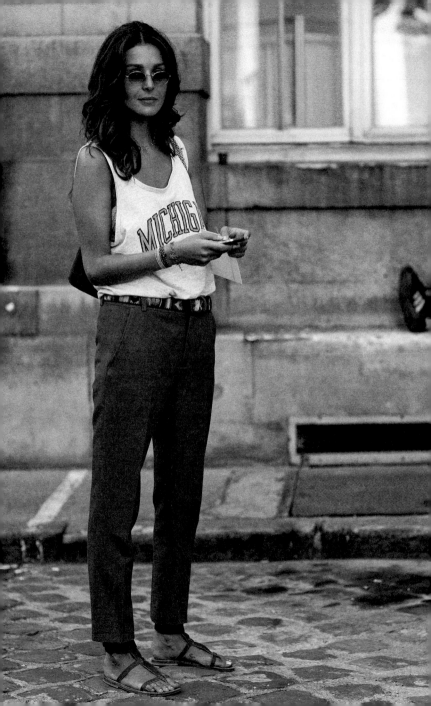

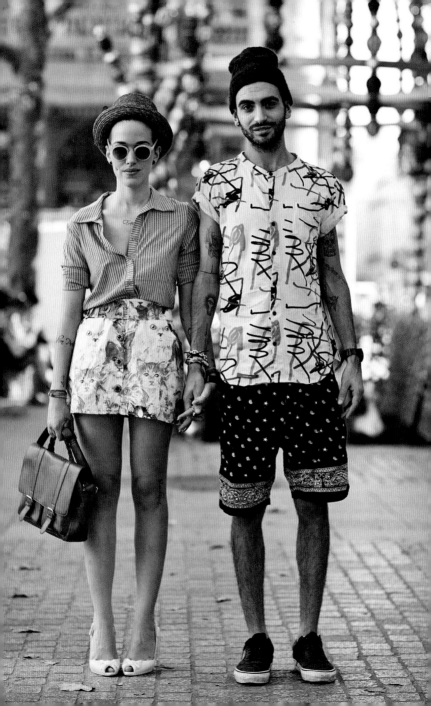

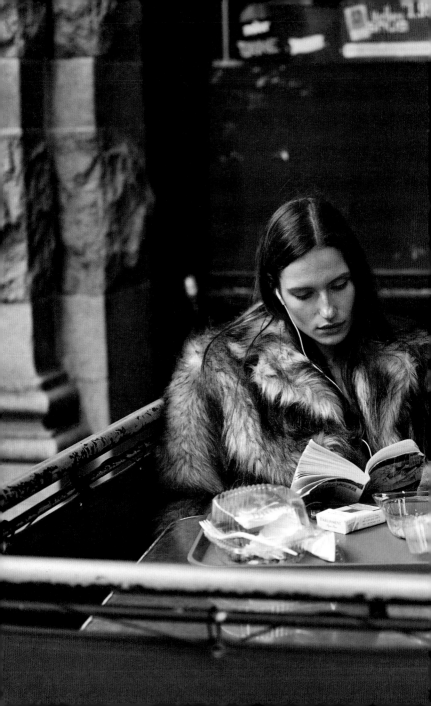

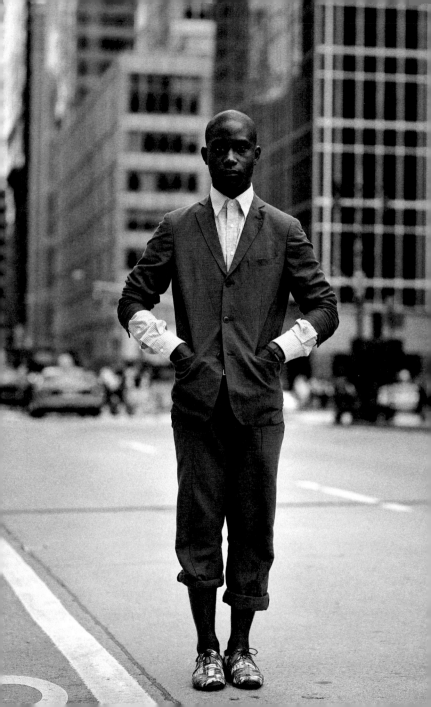

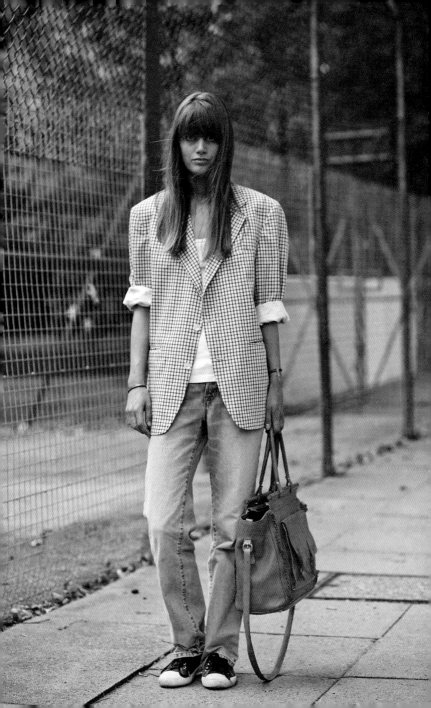

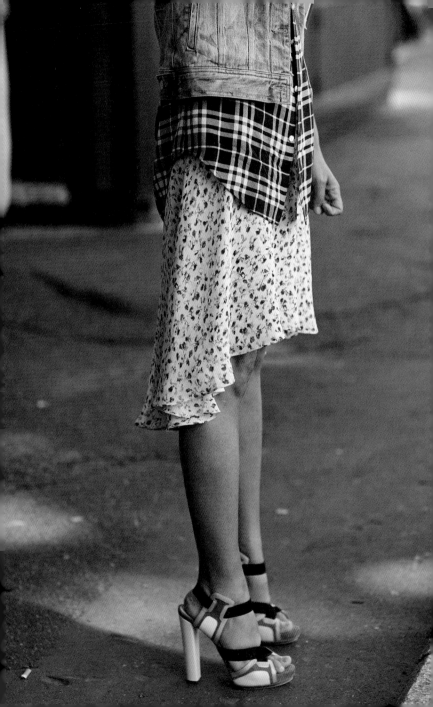

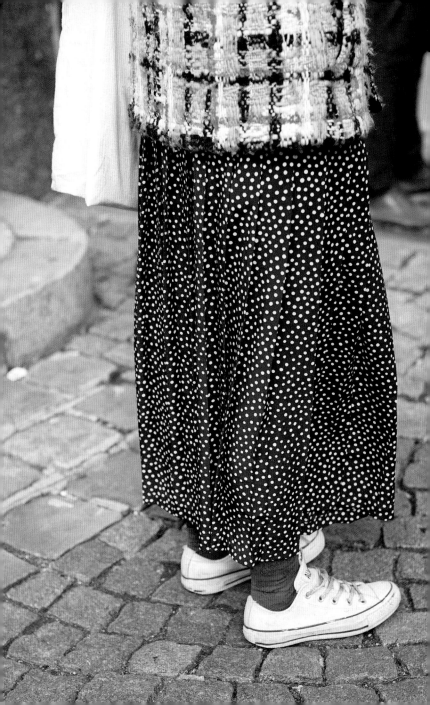

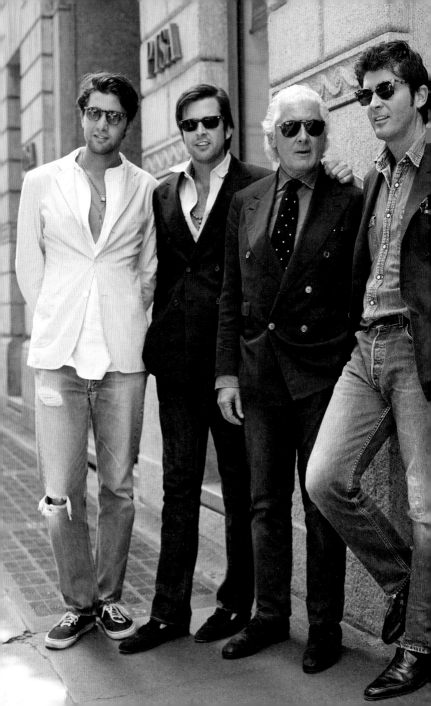

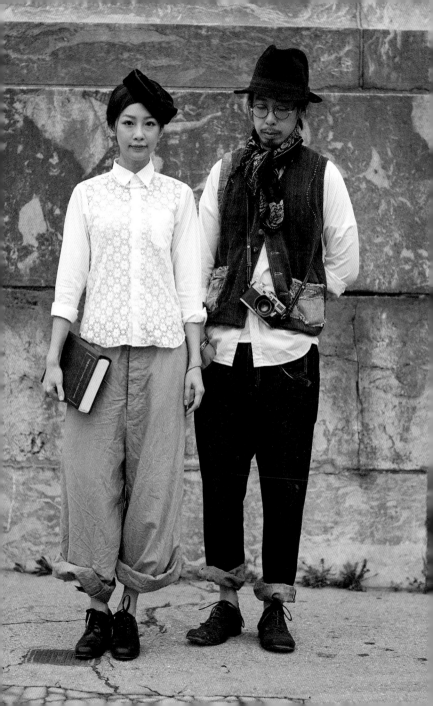

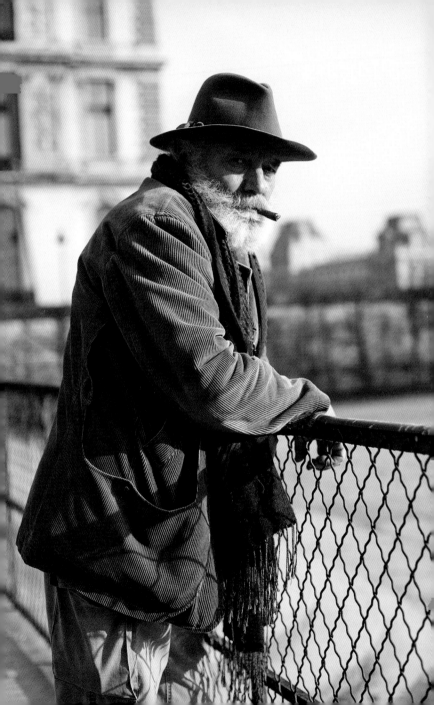

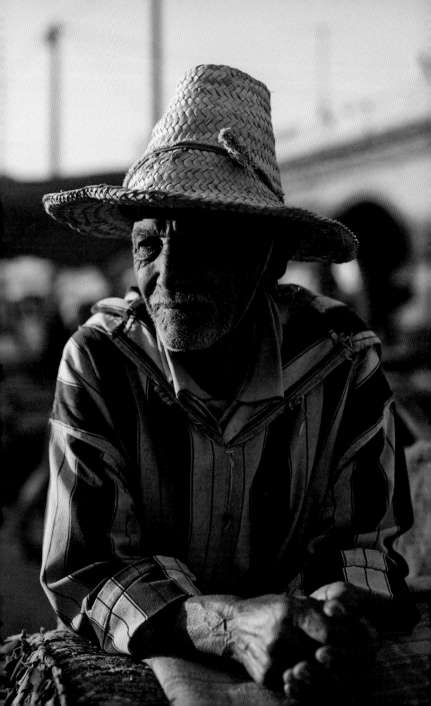

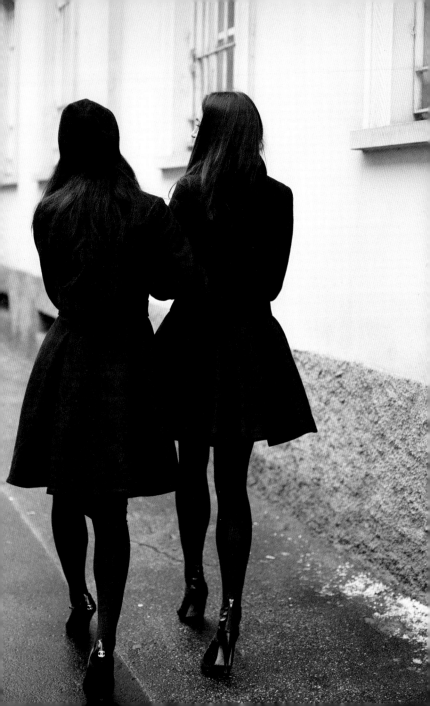

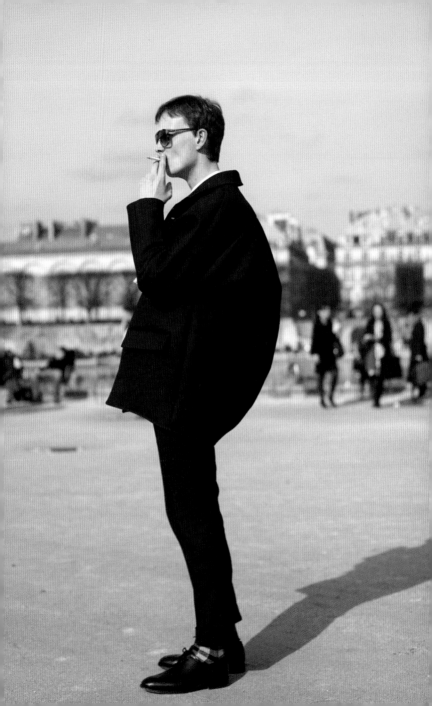

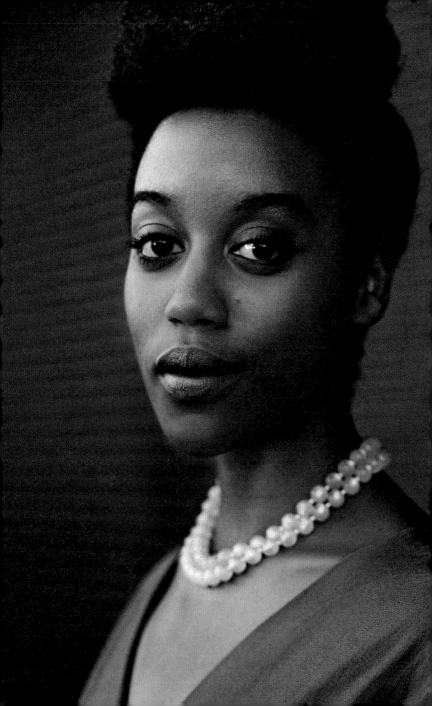

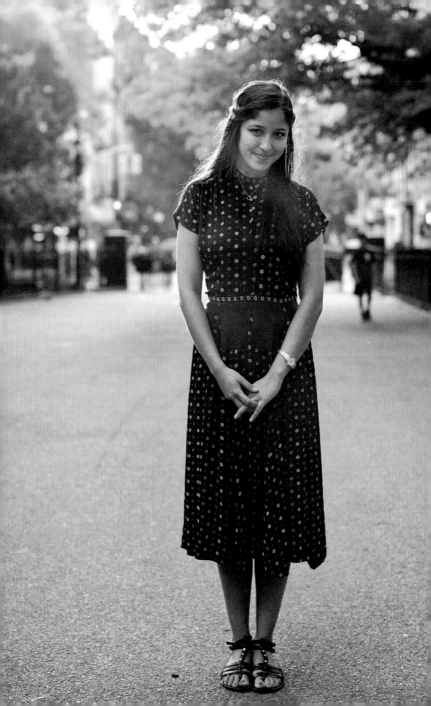

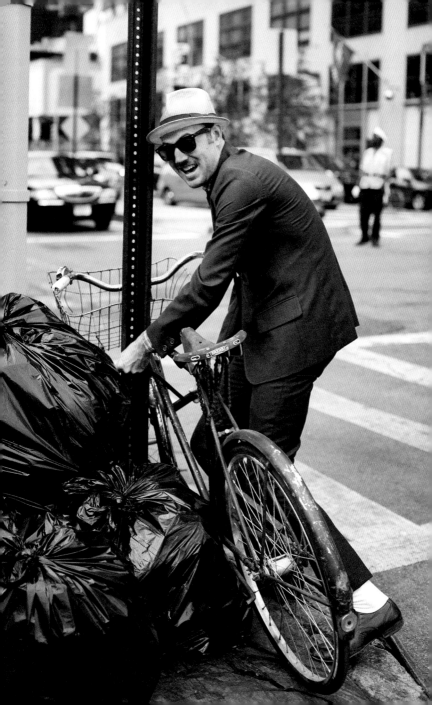

On the Street . . . North 3rd Street, Brooklyn

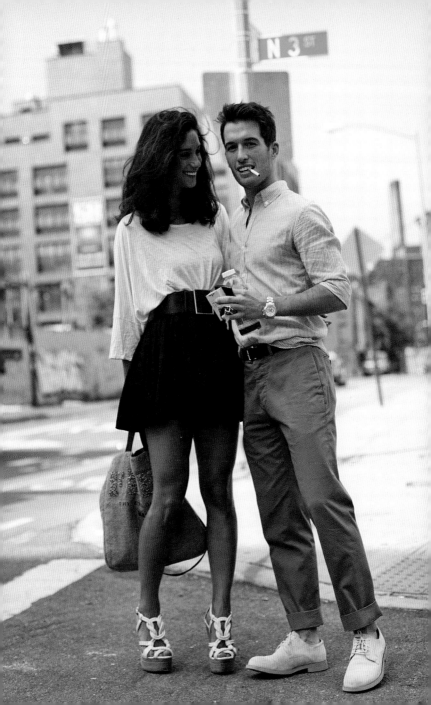

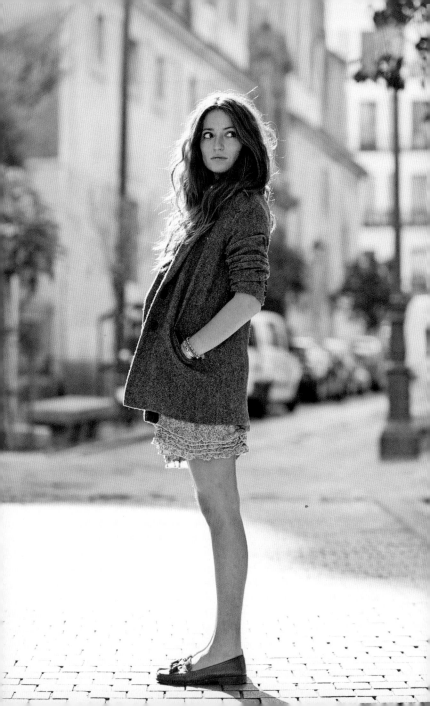

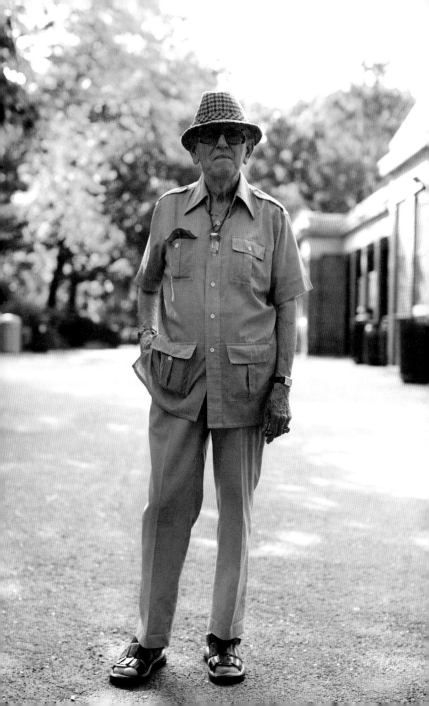

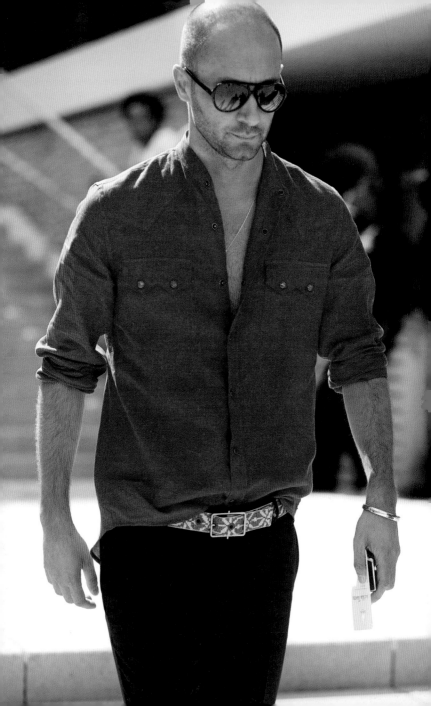

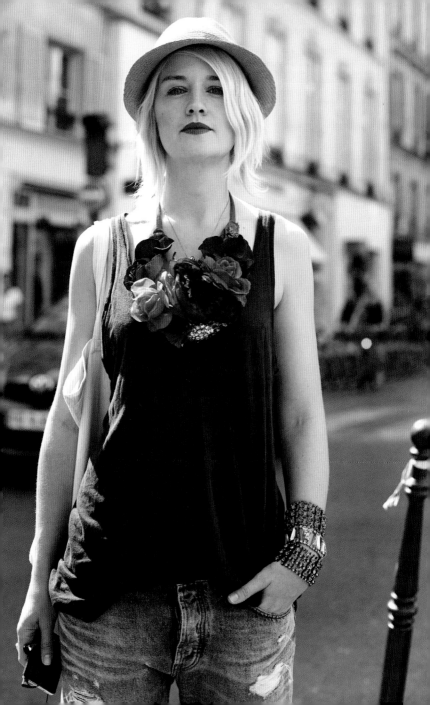

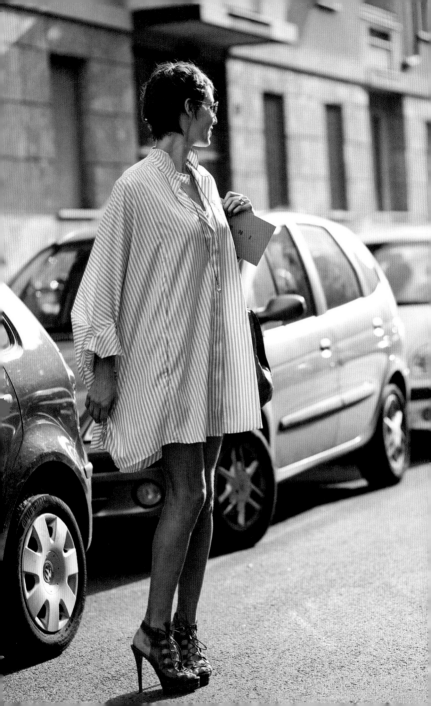

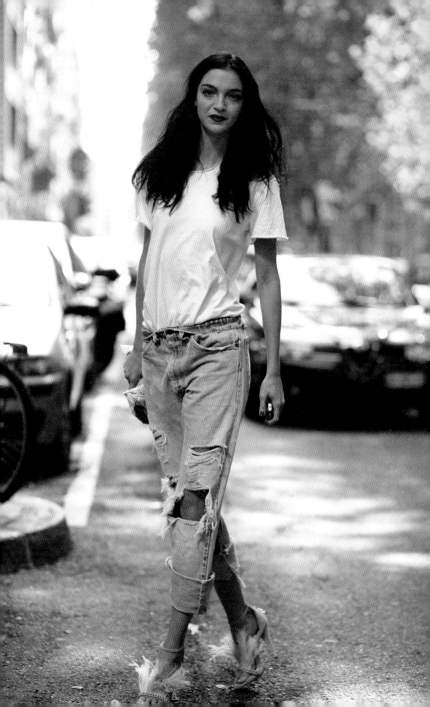

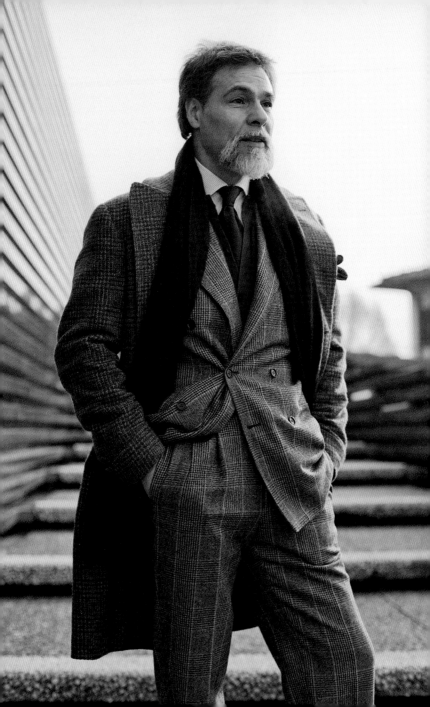

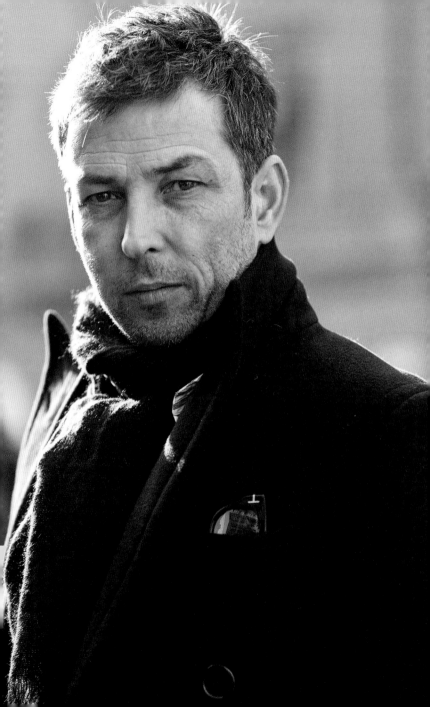

Cowboy boots

Growing up a Midwest suburban kid in the 80's, cowboys held no romance for me. I had missed the *Gunsmoke*, *Fist Full of Dollars*-era and only had cheesy *Bonanza* and *F-Troop* reruns to paint my vision of the West.

I've often cited cowboy boots as my number-one fashion pet peeve. I'm sure it's more psychological than visual, but nevertheless I had always hated cowboy boots . . . until that day at the rodeo.

Apparently cowboys use a very thin leather strap wrapped around their boots to keep them from flying off while they're riding the bull.

That simple element totally changes the silhouette of the boots and emphasizes the functionality of cowboy boots – past the country-line dancing which I previously thought was their main function.

I know it sounds shallow but it takes maturity to be open to seeing things in a new way. Just don't expect me to be wearing a pair anytime soon.

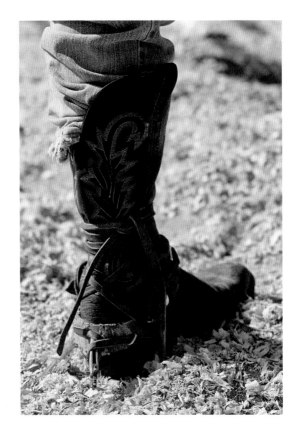

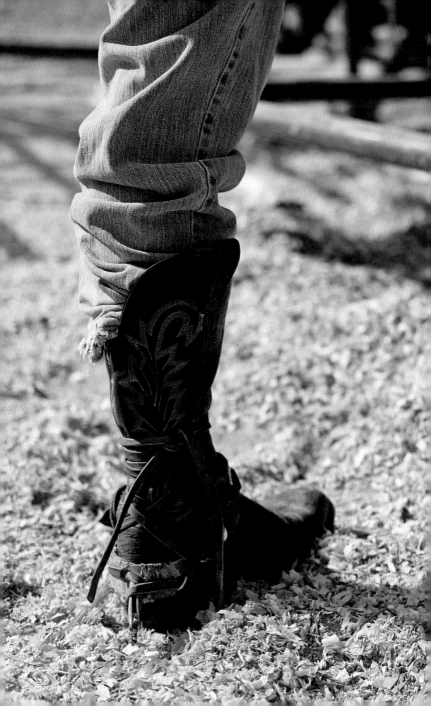

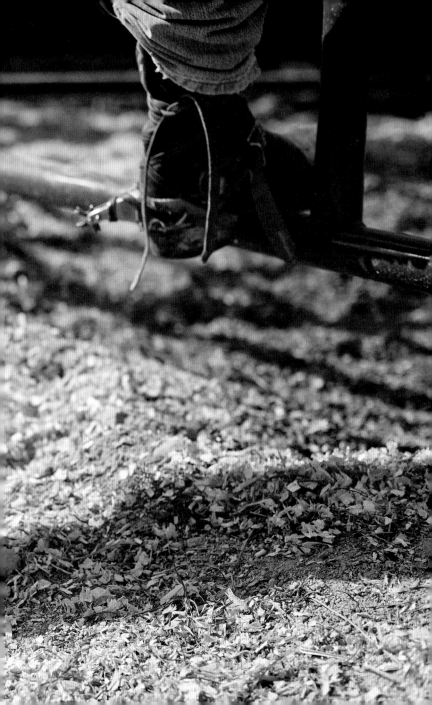

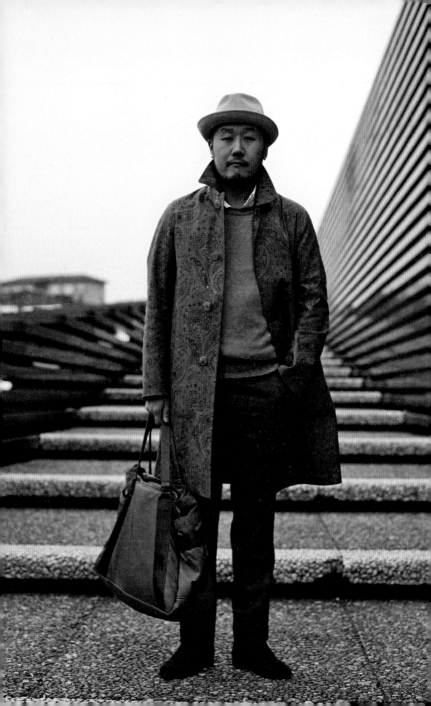

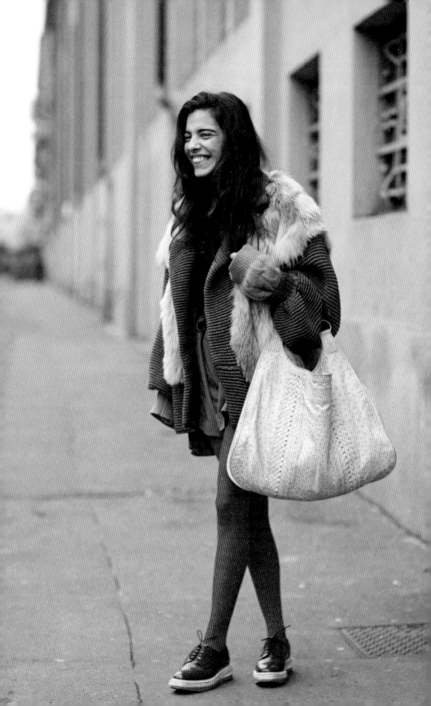

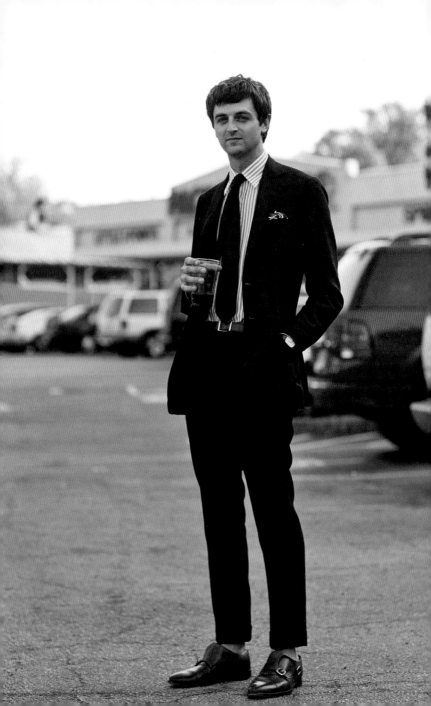

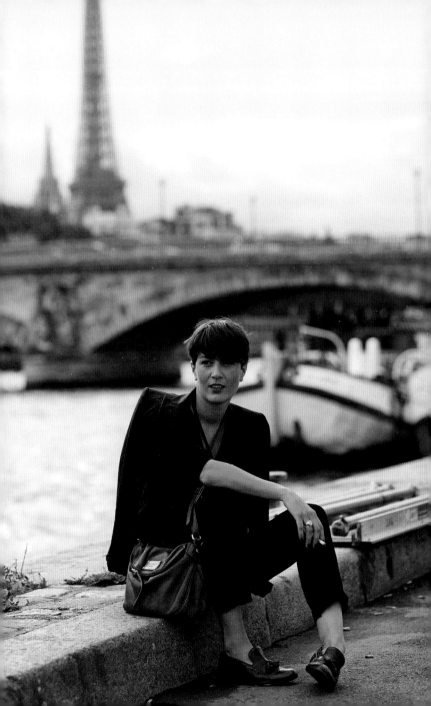

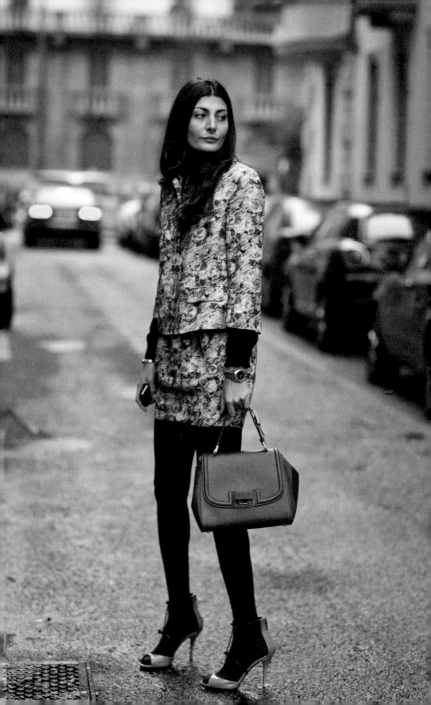

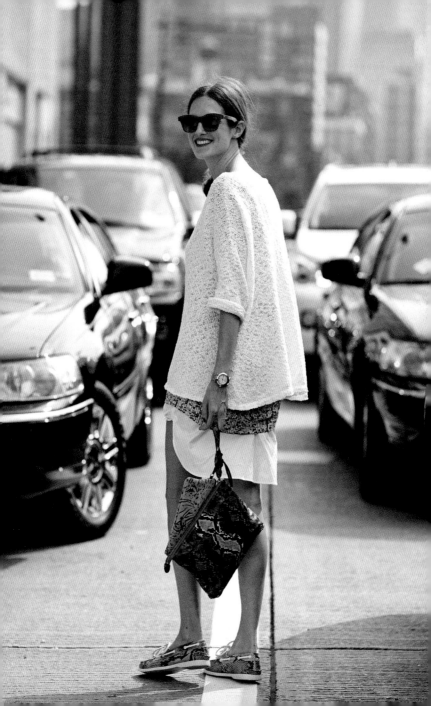

On the Street . . . Elizabeth Street, New York

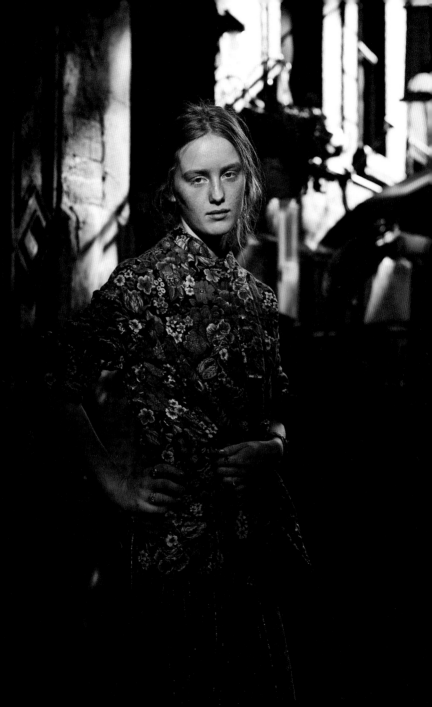

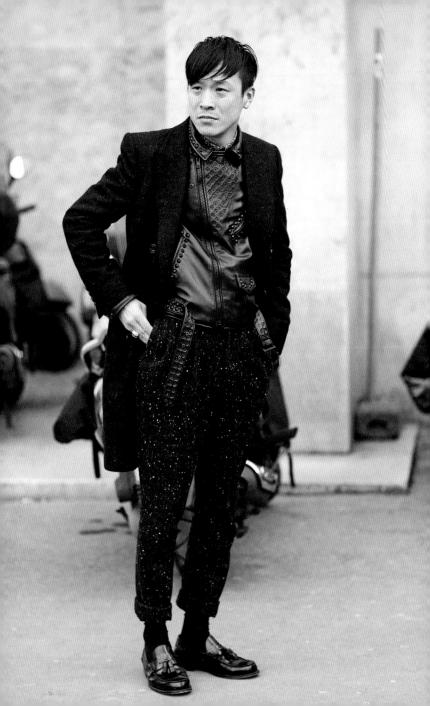

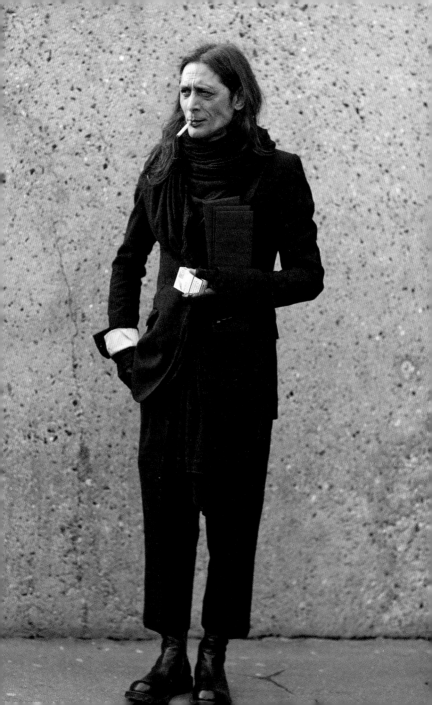

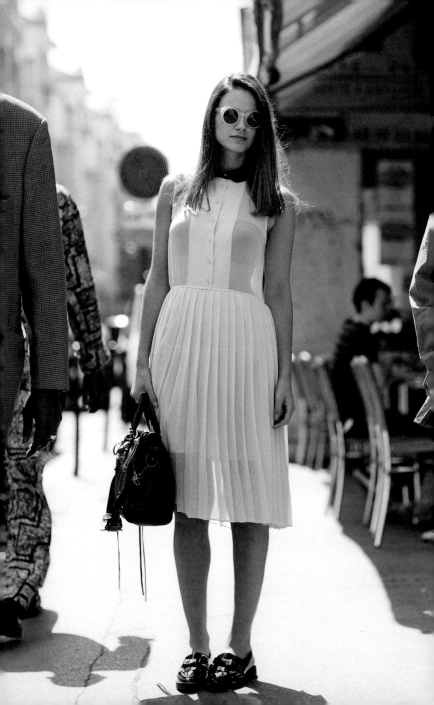

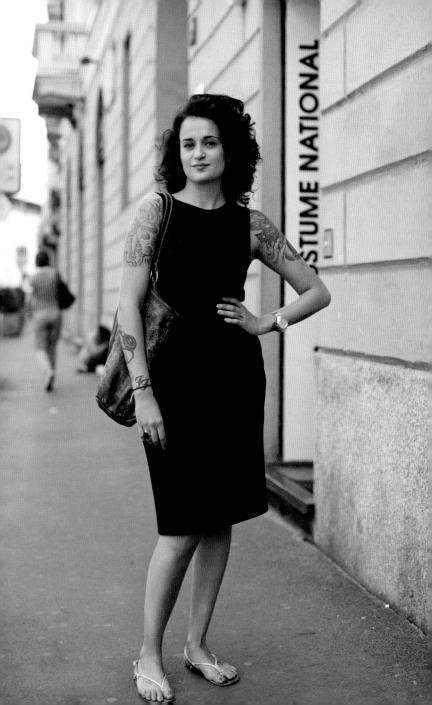

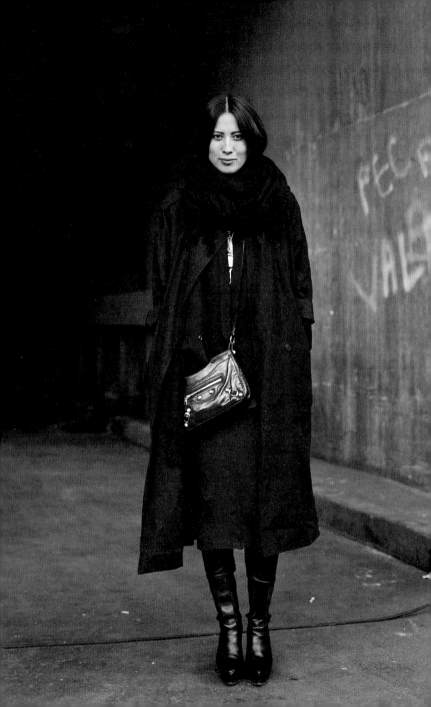

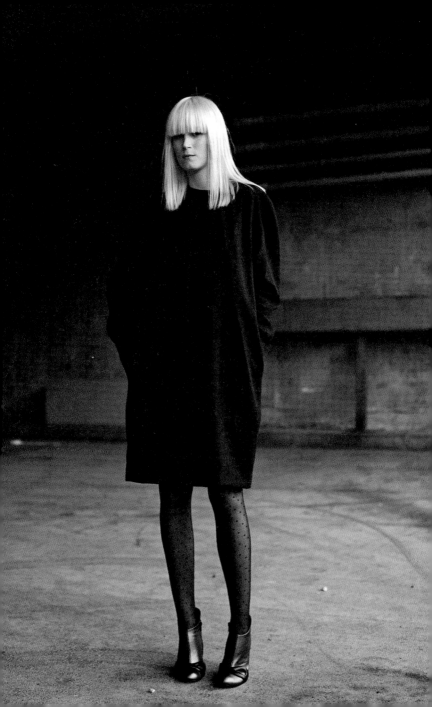

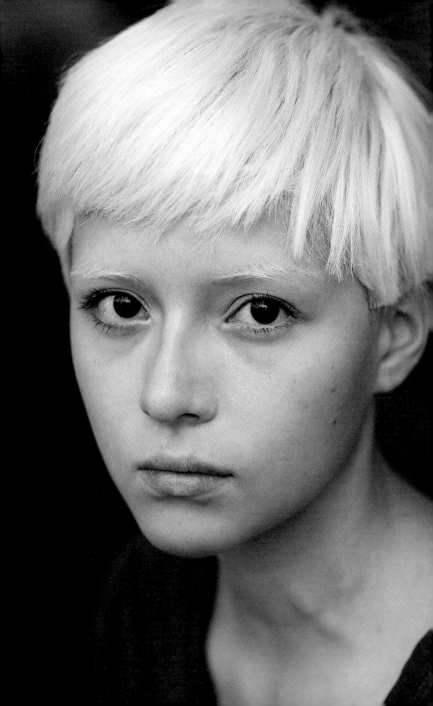

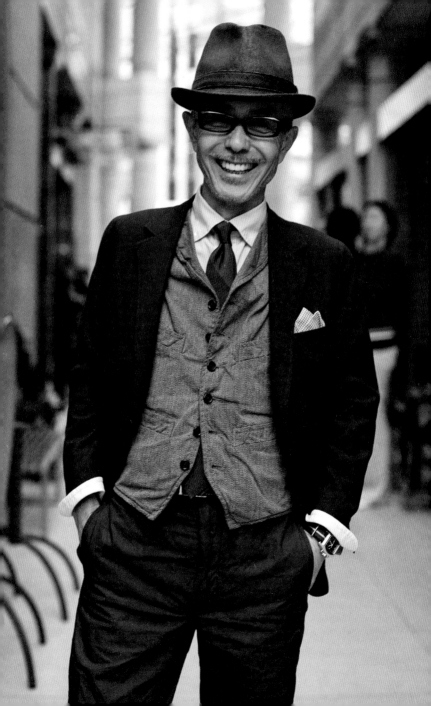

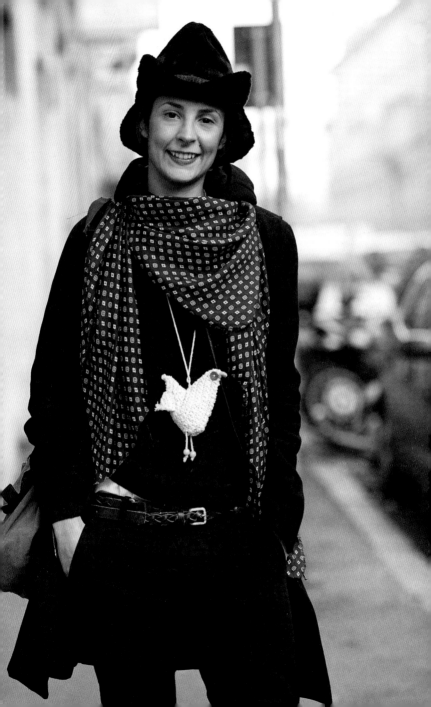

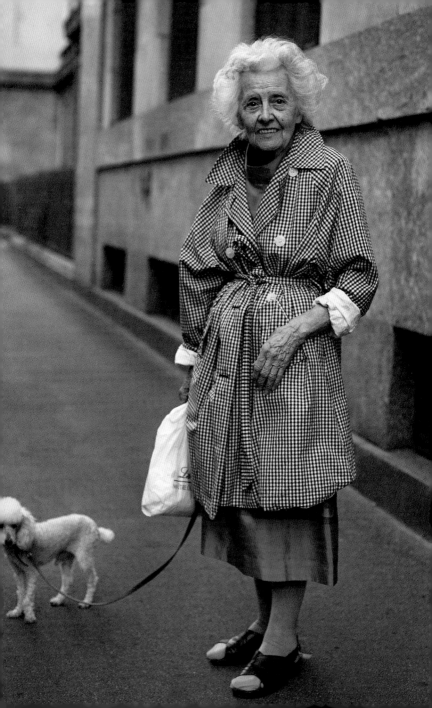

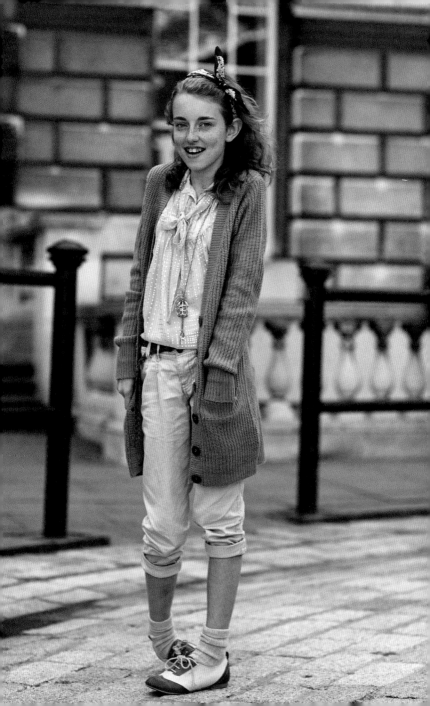

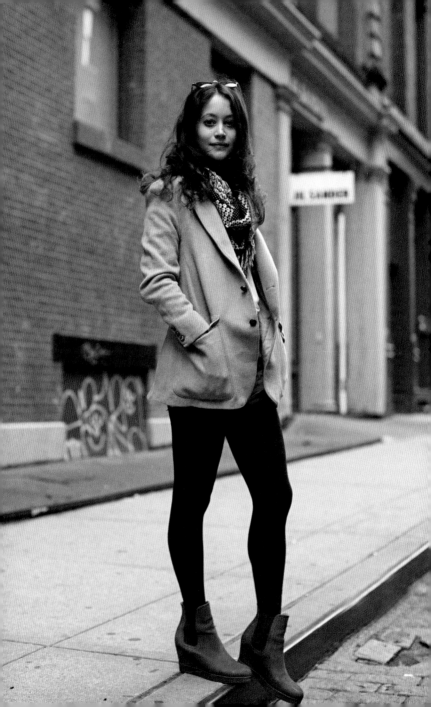

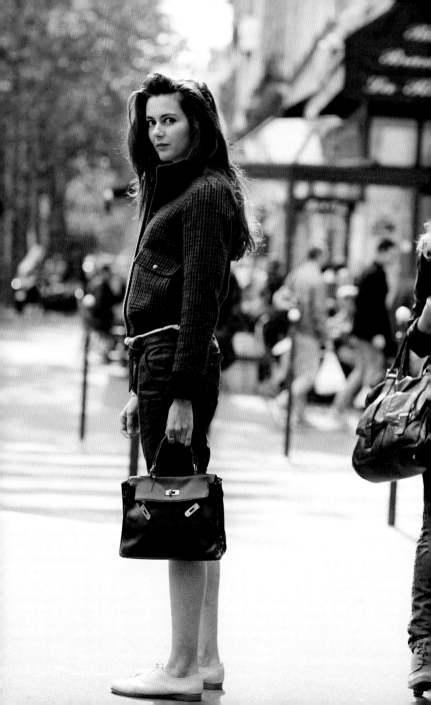

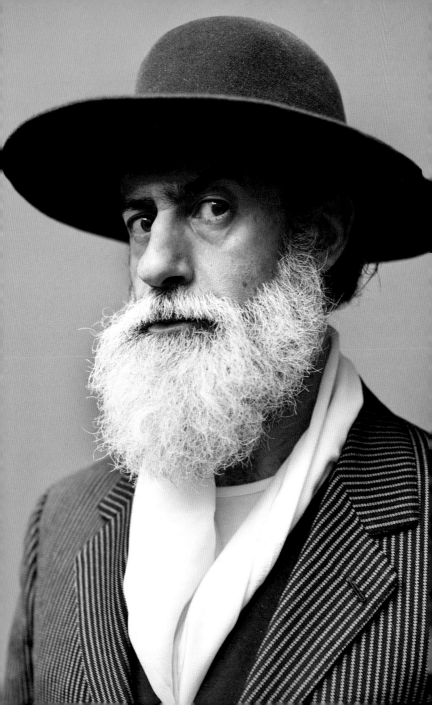

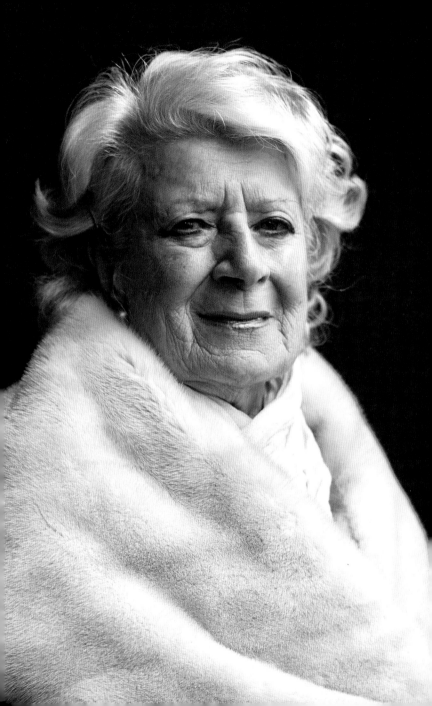

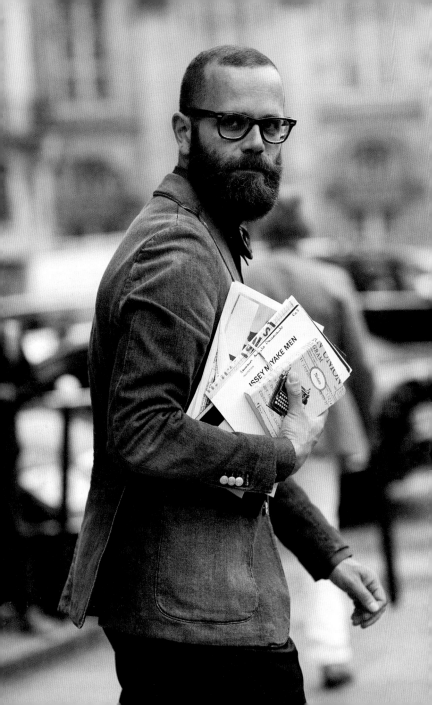

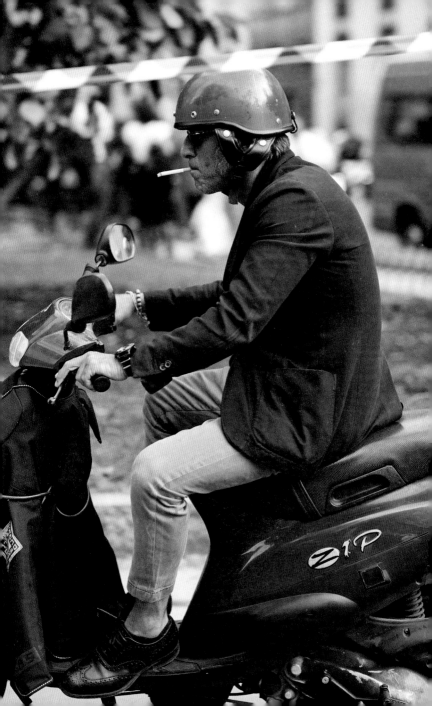

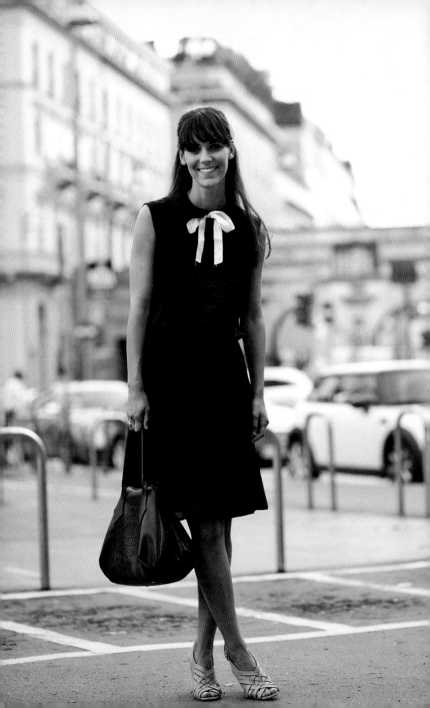

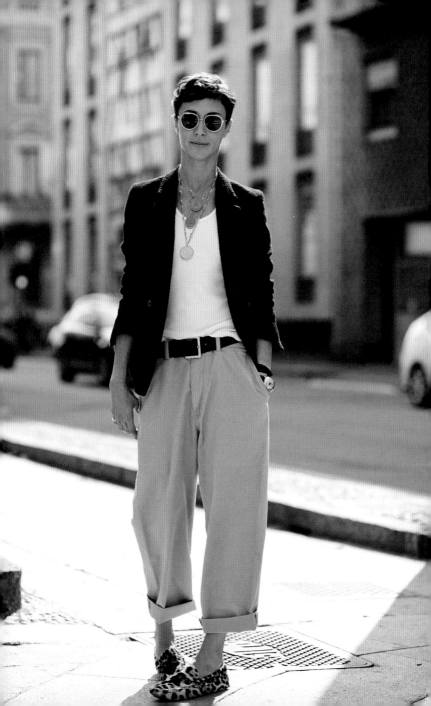

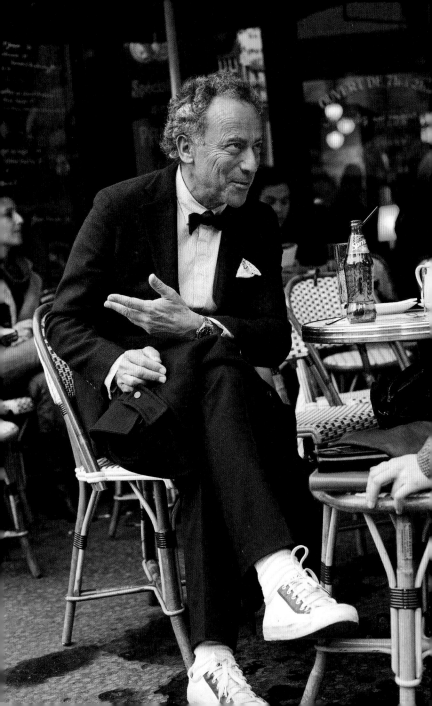

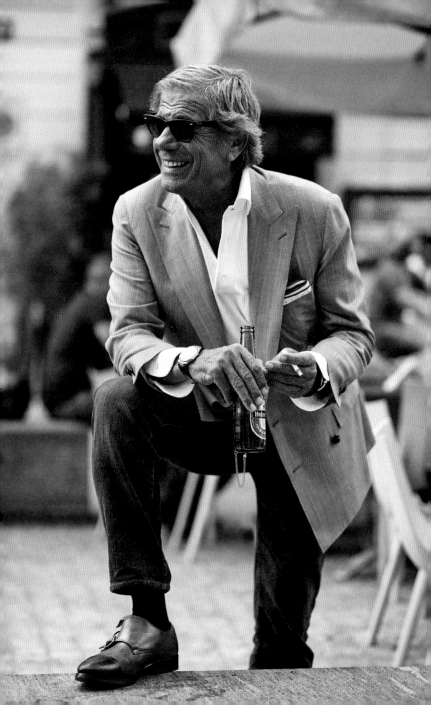

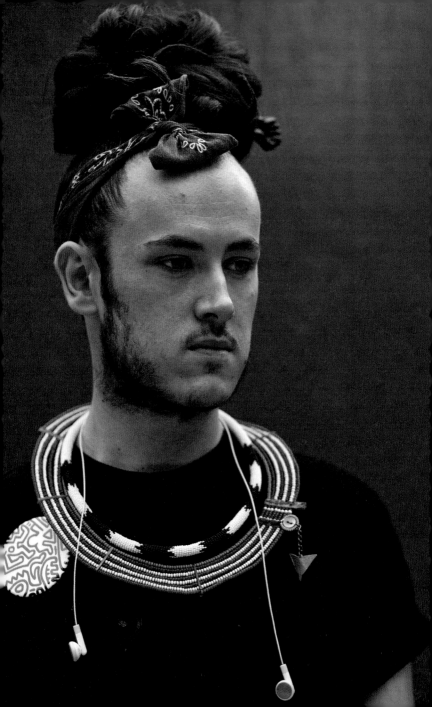

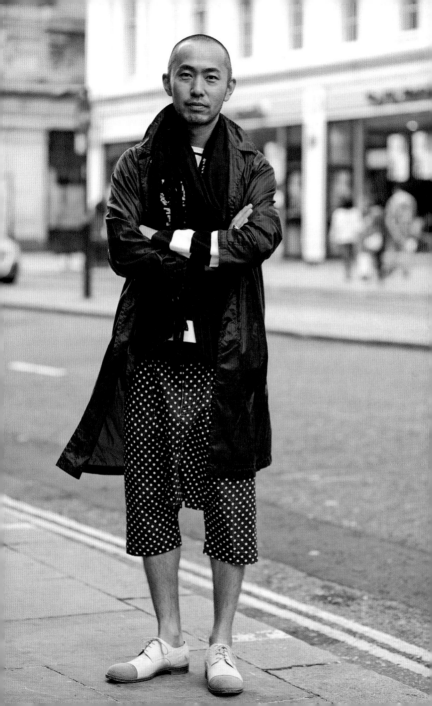

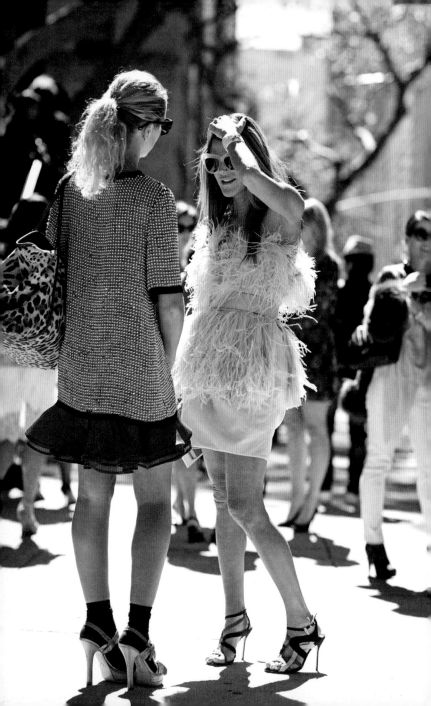

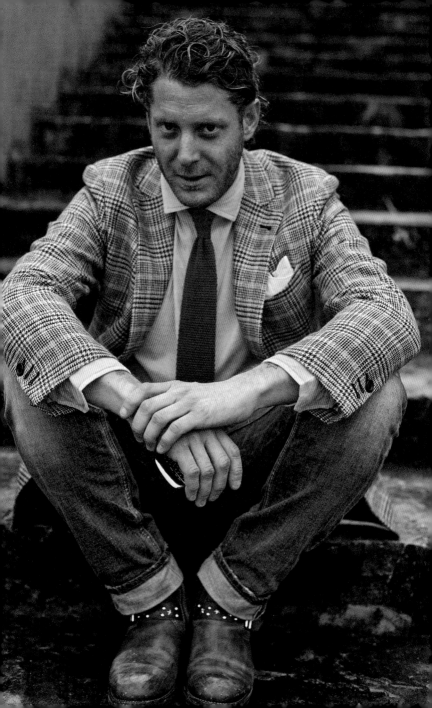

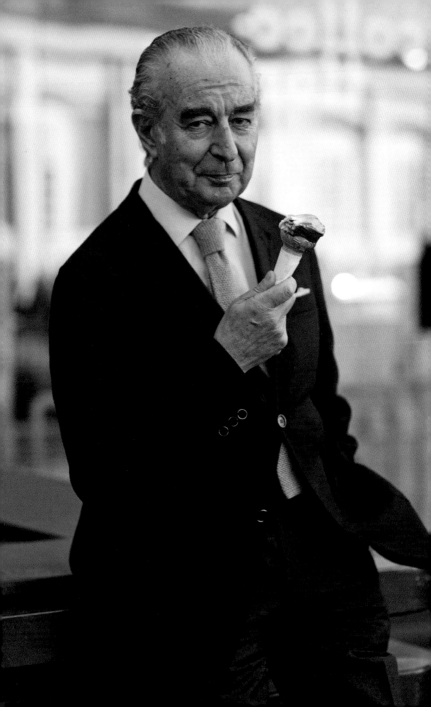

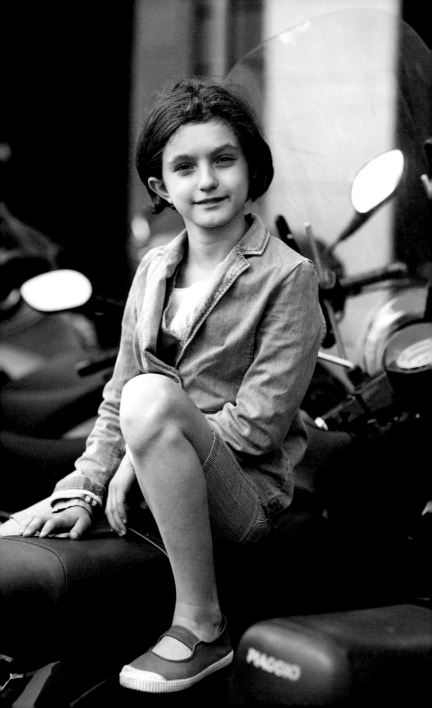

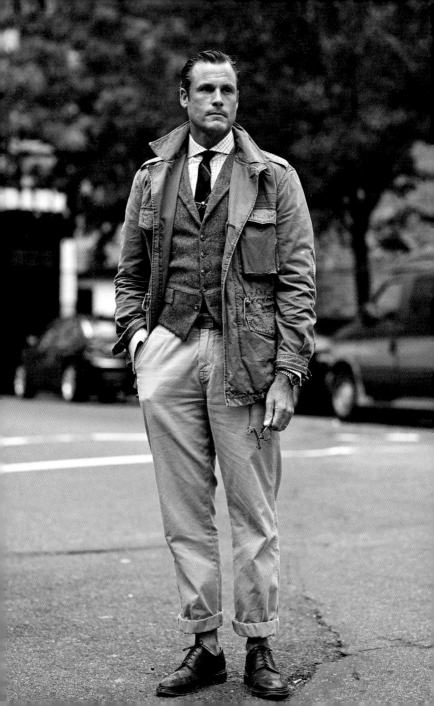

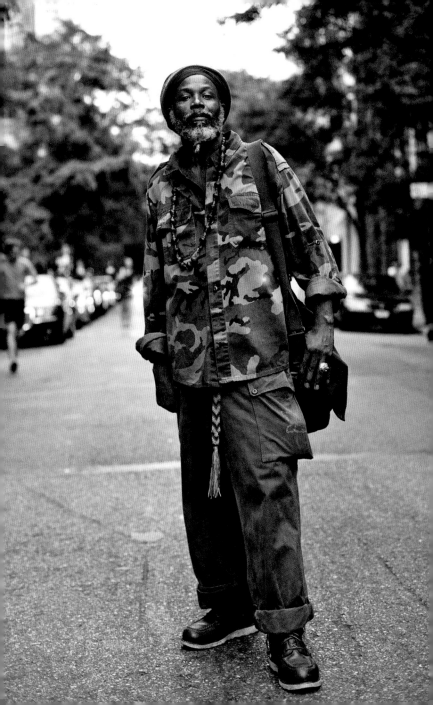

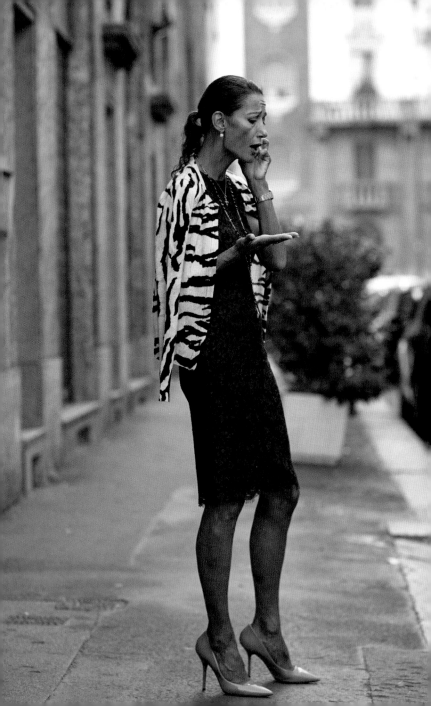

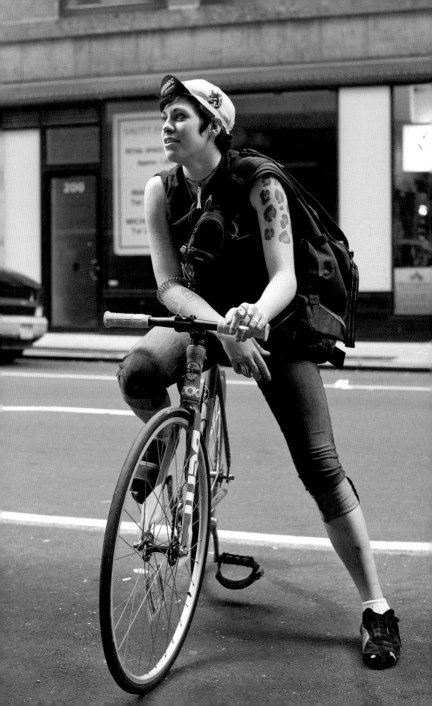

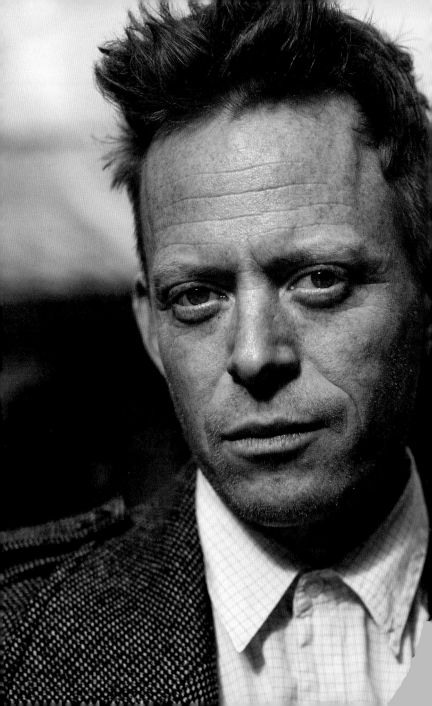

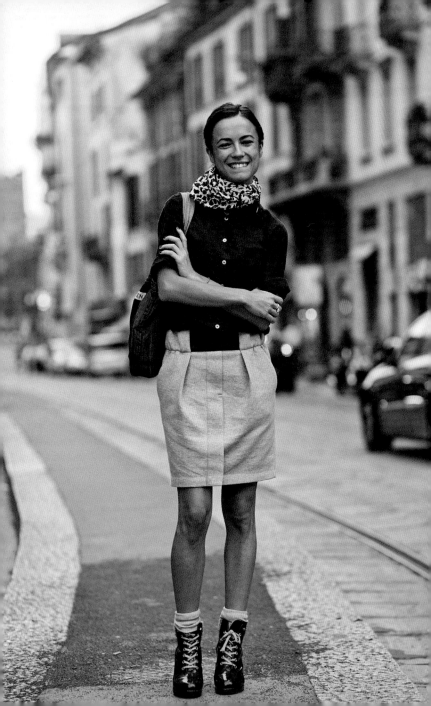

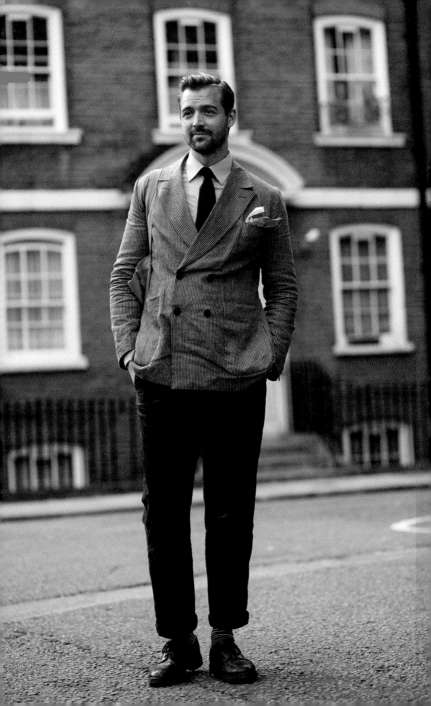

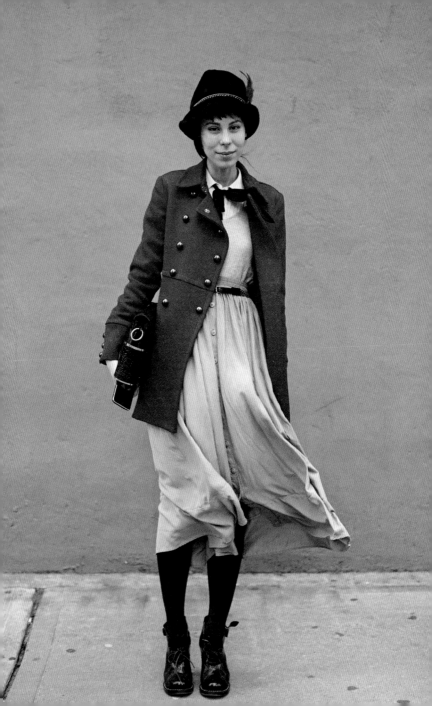

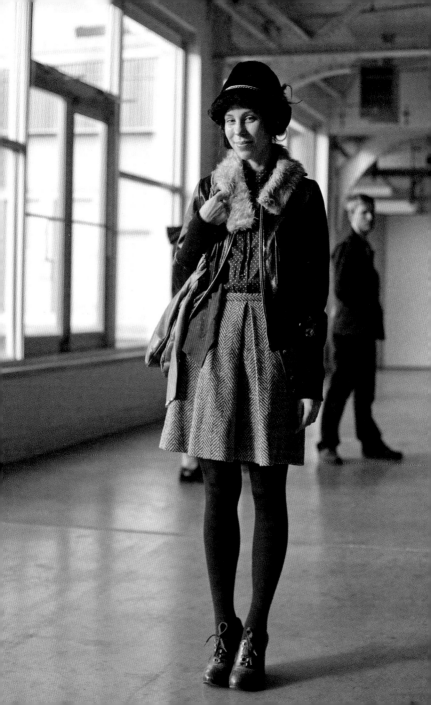

On the Street . . . Broadway, New York

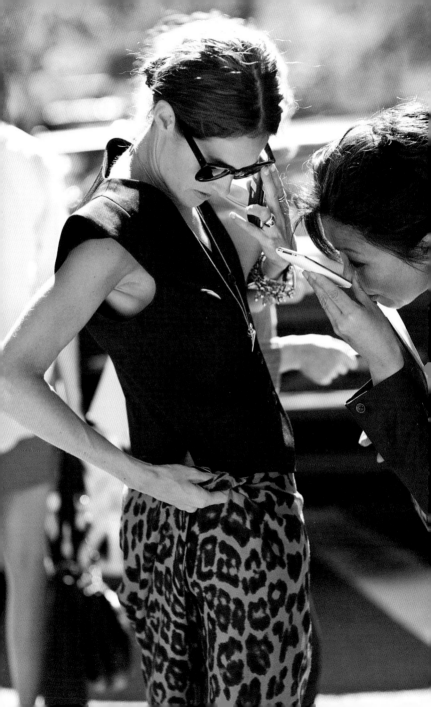

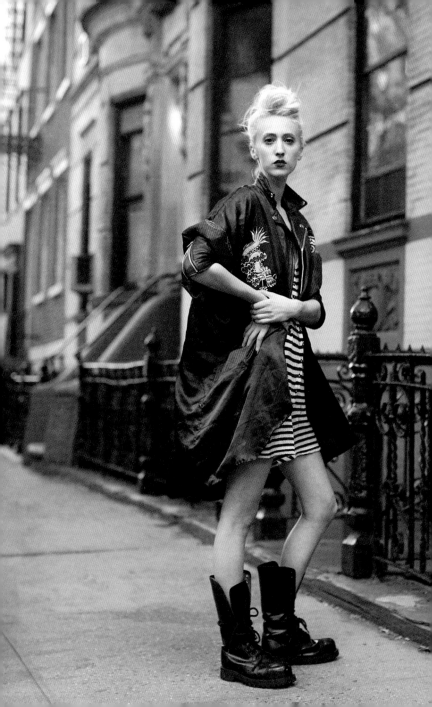

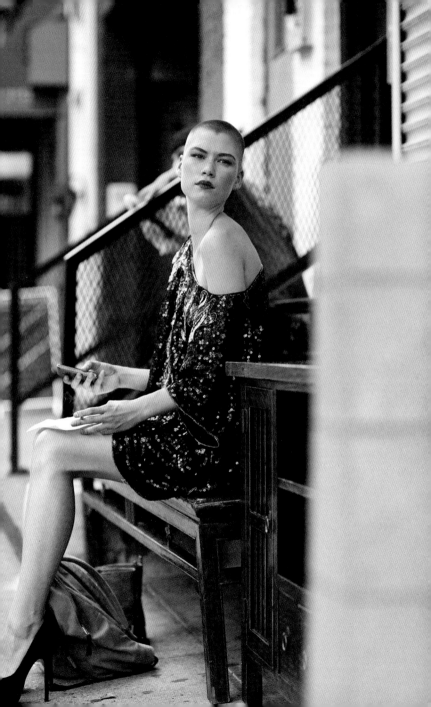

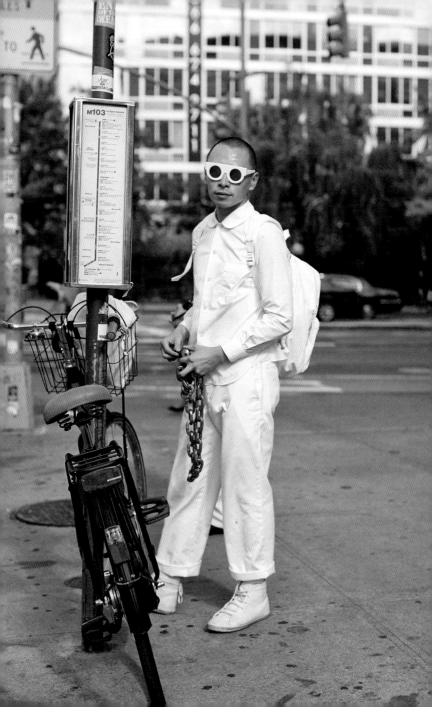

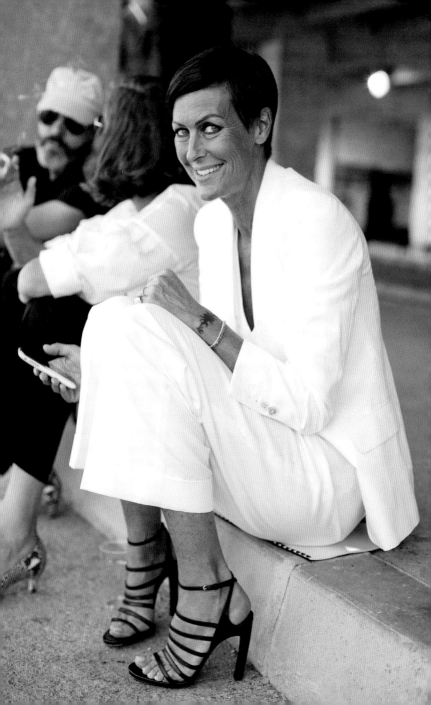

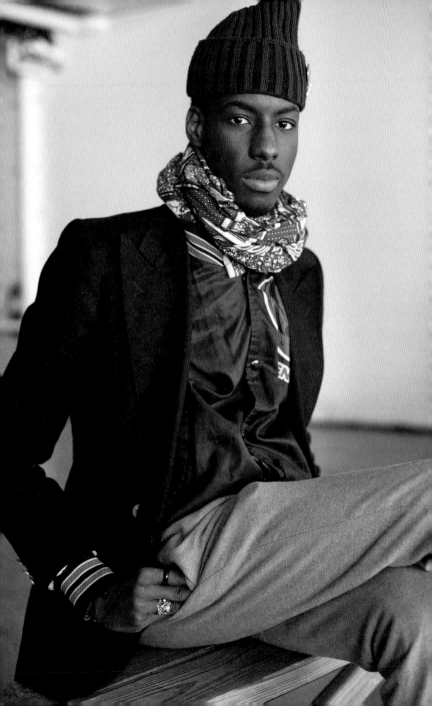

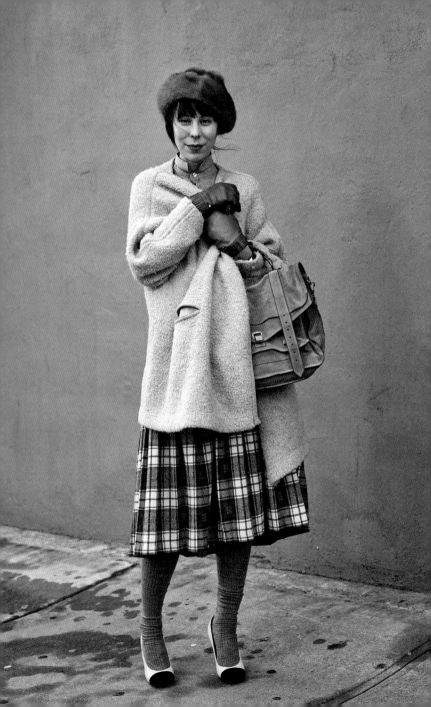

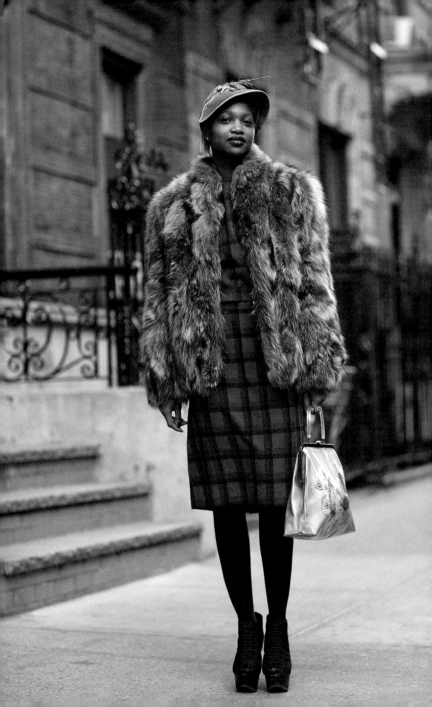

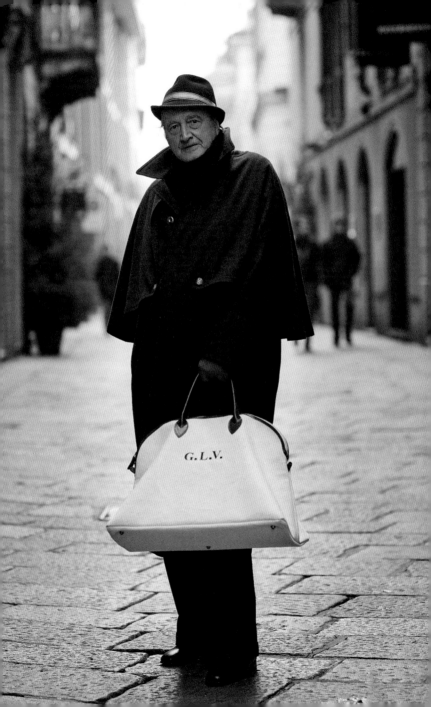

On the Street … Tenth Avenue, New York

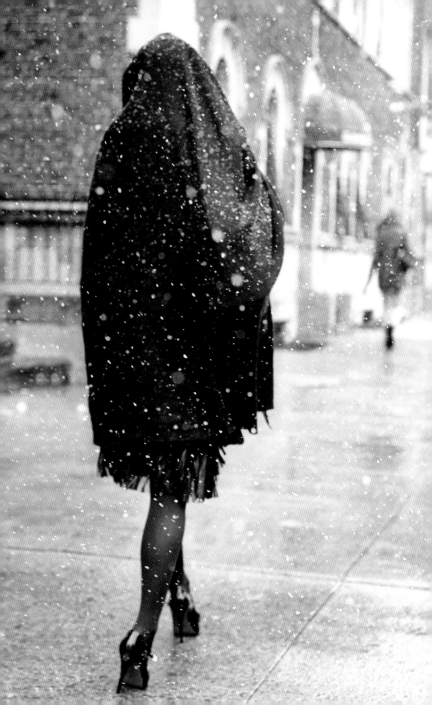

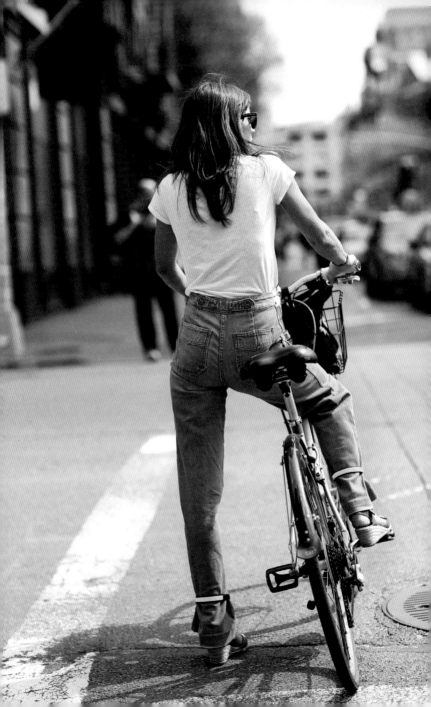

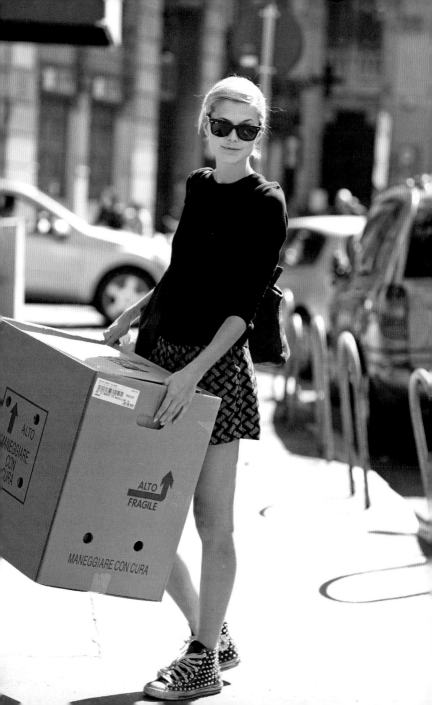

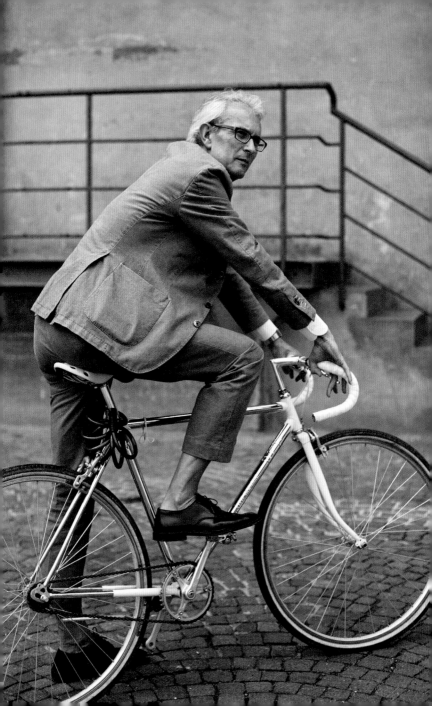

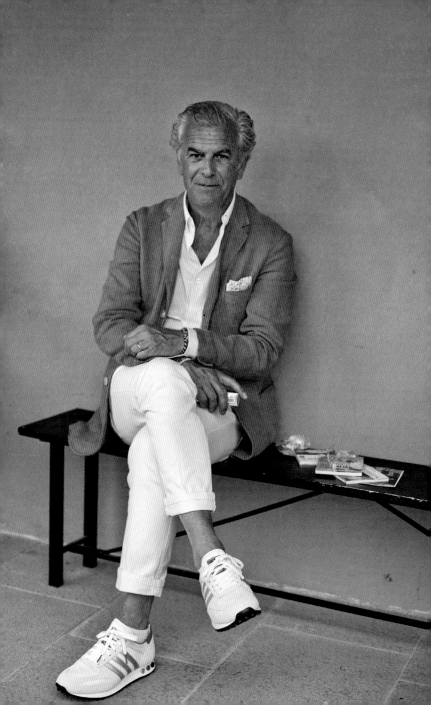

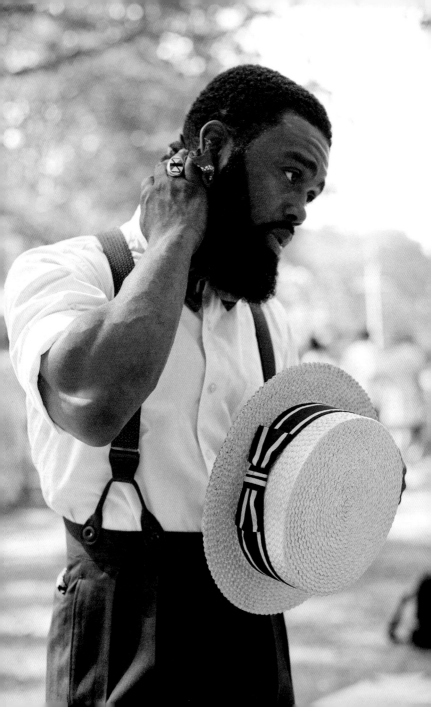

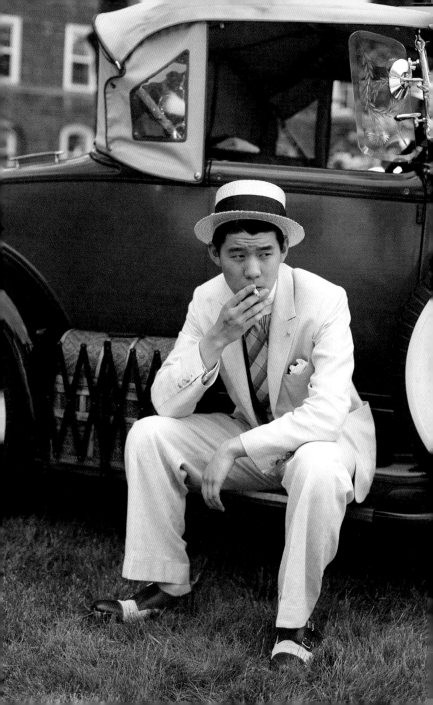

On the Street . . . Governor's Island, New York

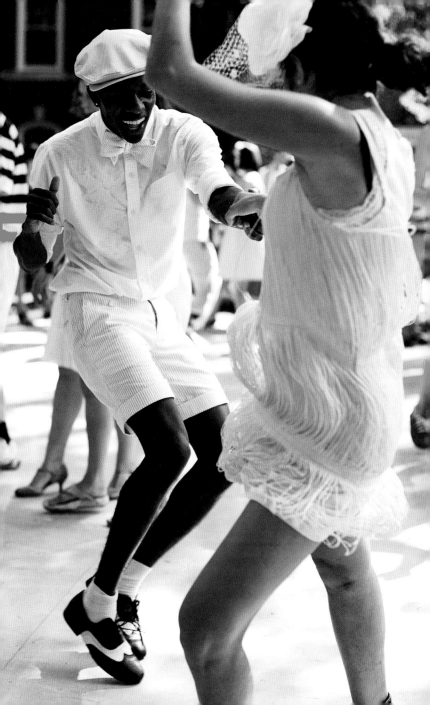

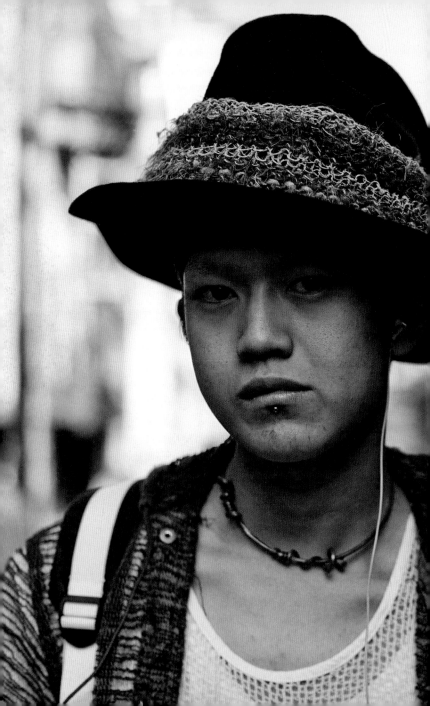

Bullfighting

Let's try to forget the politics of bullfighting for a moment and accept the fact that this 'sport' is really the only modern example of the Dandy.

I can't think of another field – music, sport, movies or the stage – where men are dressed in such exquisite, couture-level garments from head to toe.

I'm not just talking about the heavily jeweled bolero jackets we are all familiar with, but also the hand-tooled leather chaps, the hand-embroidered shirts, and the painted-on pants.

Just look at the clothing in these two photos. These incredible garments are not even their competition dress – they are their *practice* clothes. Though I agree that we have moved past the days of bullfighting as a politically correct activity I will miss the unique pageantry that was such an important part of that culture.

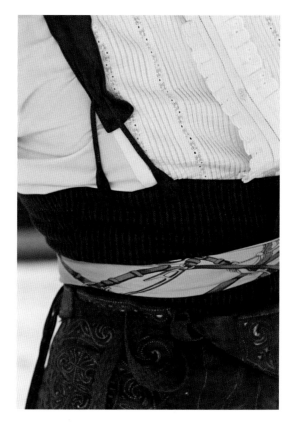

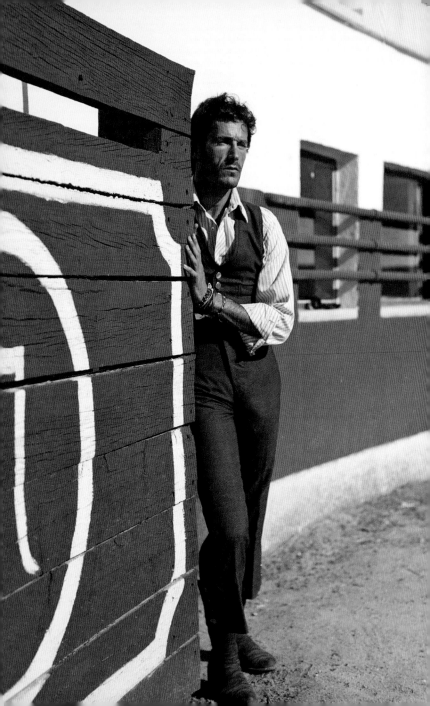

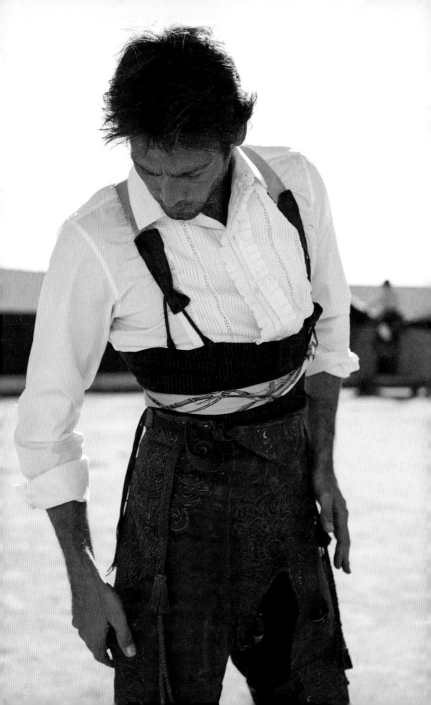

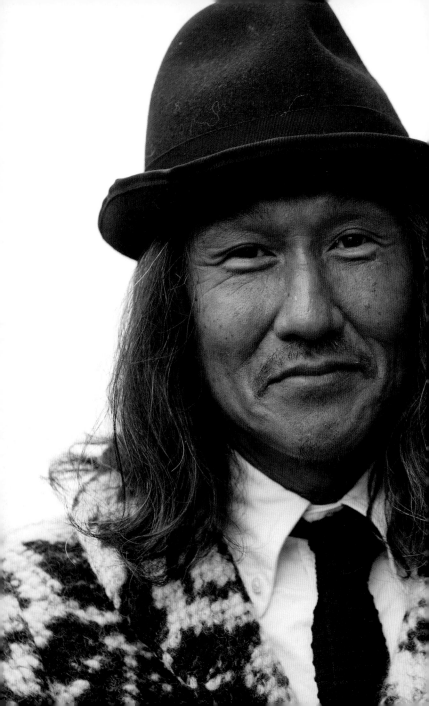

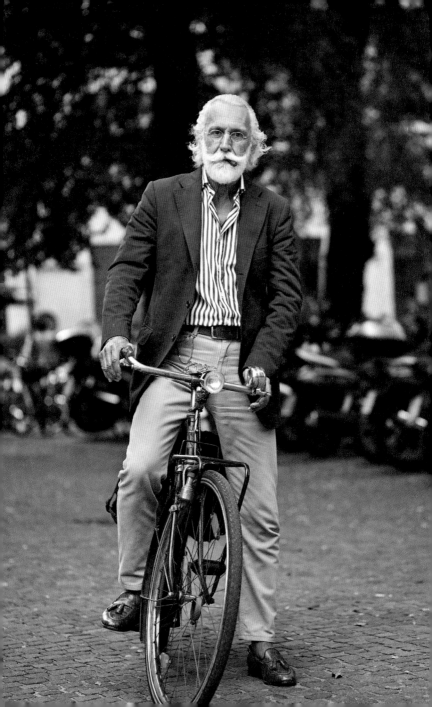

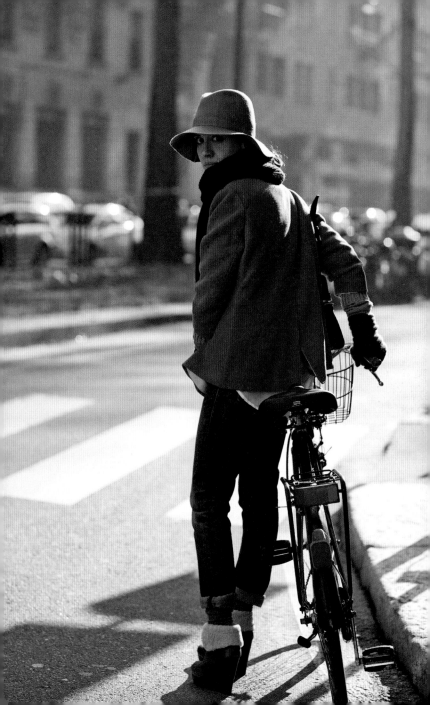

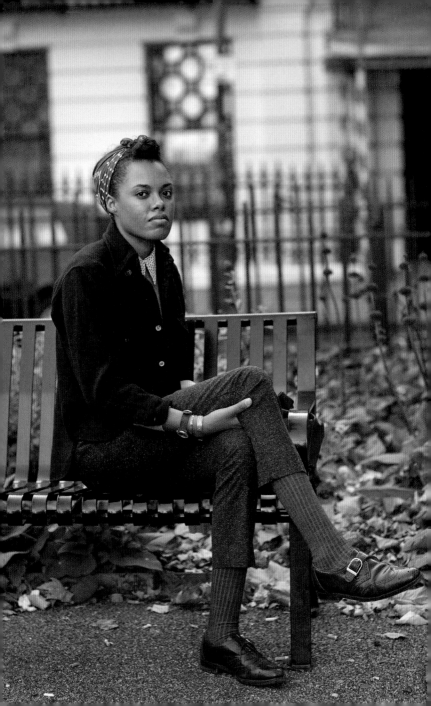

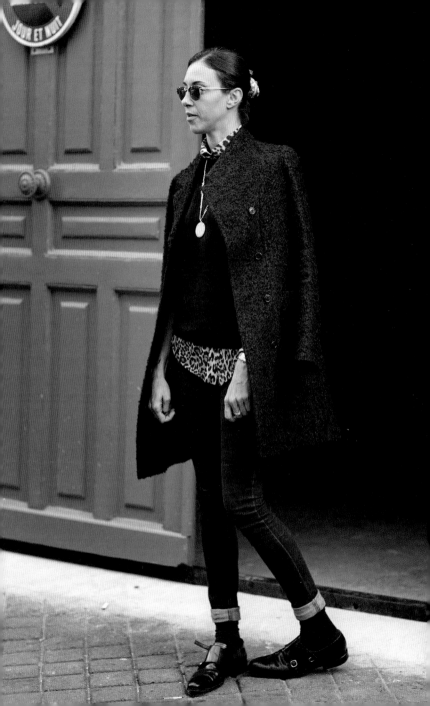

On the Street . . . Via Manzoni, Milan

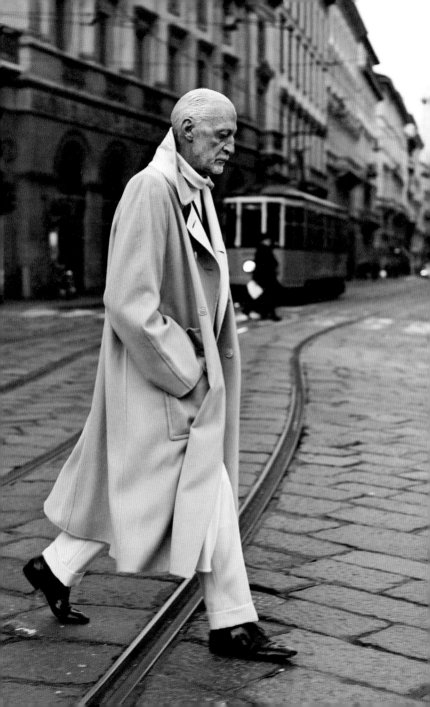

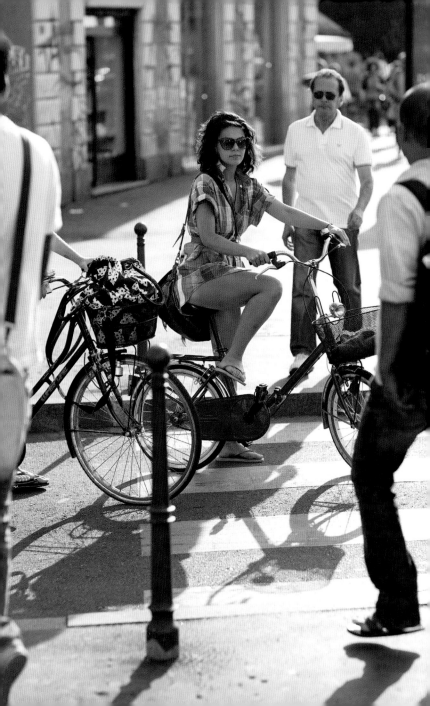

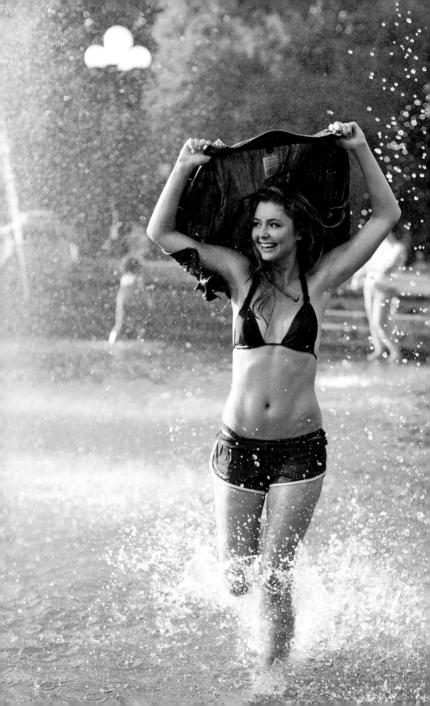

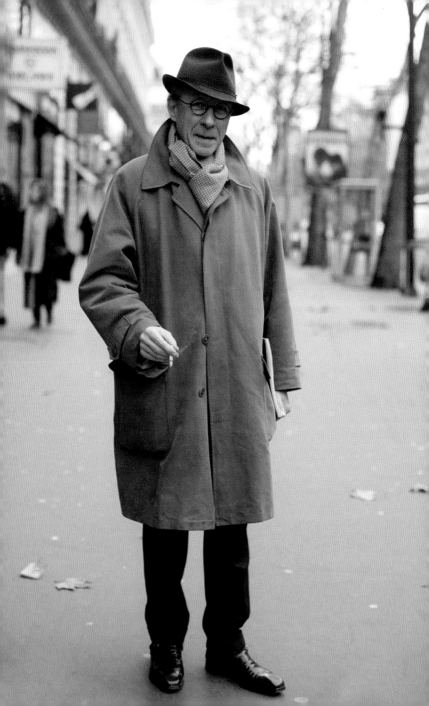

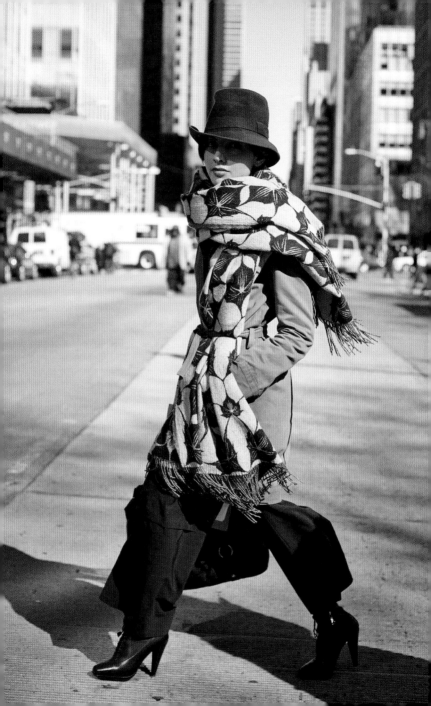

Eva

I had featured Eva in my first book and I hadn't planned on doing a feature again. However, as I sifted through my images of the last three years I just kept coming across one strong image of Eva after another.

The strength of these images, as I came to realize, comes from the timelessness of Eva's style. Even though she is a stylist and has fun with fashion, she is not marked by the stigma of wanting to be '*on trend*'. No *it-bags* or *must-haves*, just a playful expression of her personality.

The smile, the style, and the grace she embodies is what most of us find so alluring about fashion and creates the foundation of what could make a modern fashion icon.

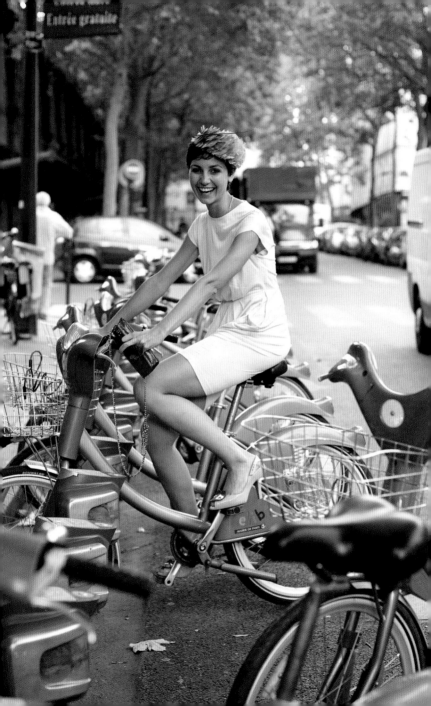

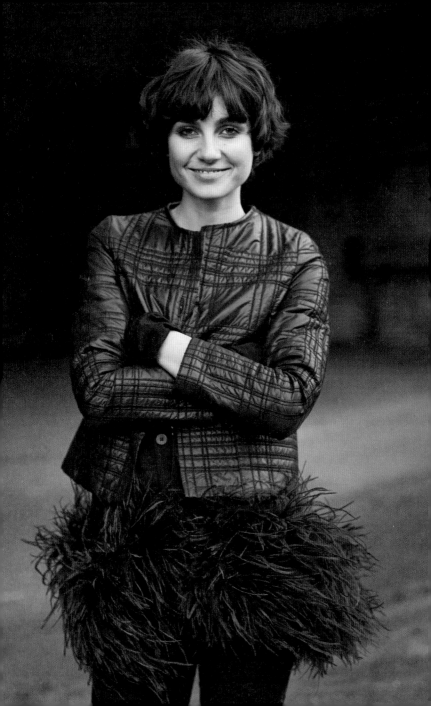

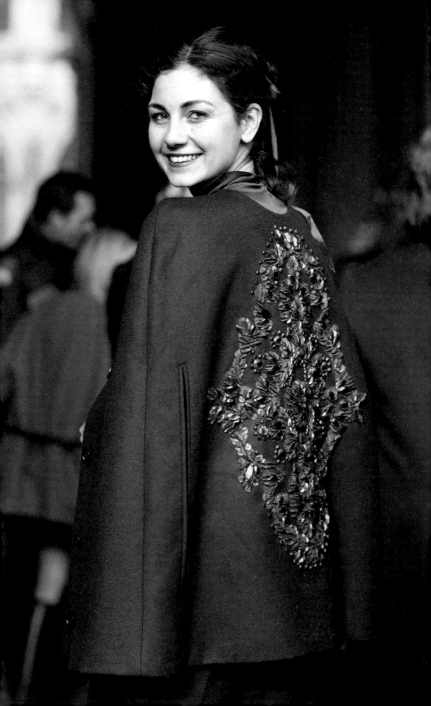

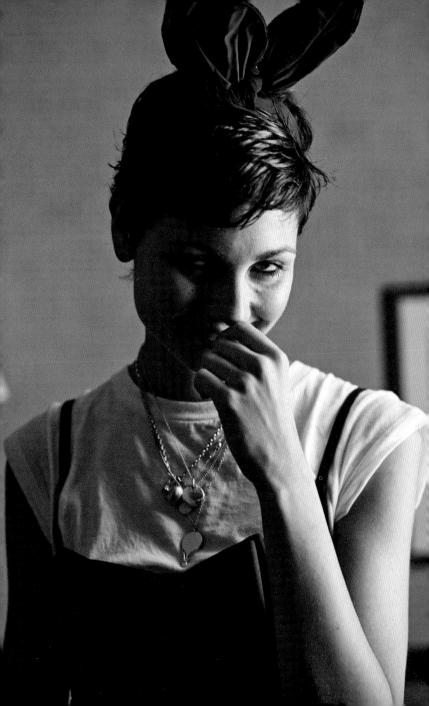

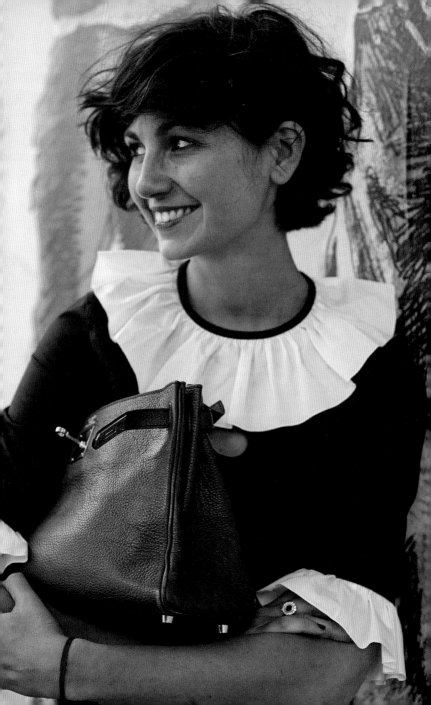

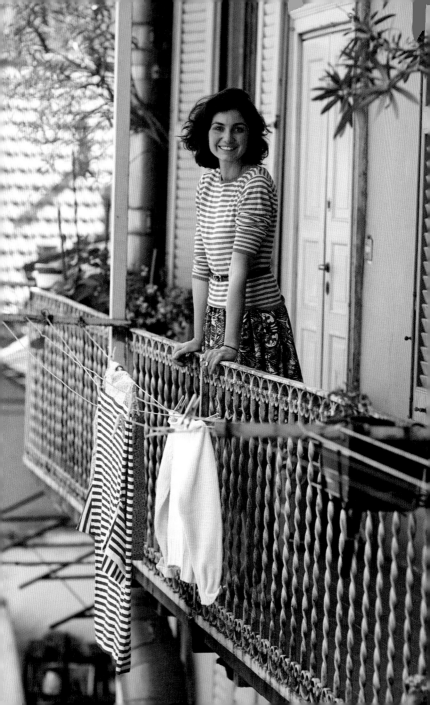

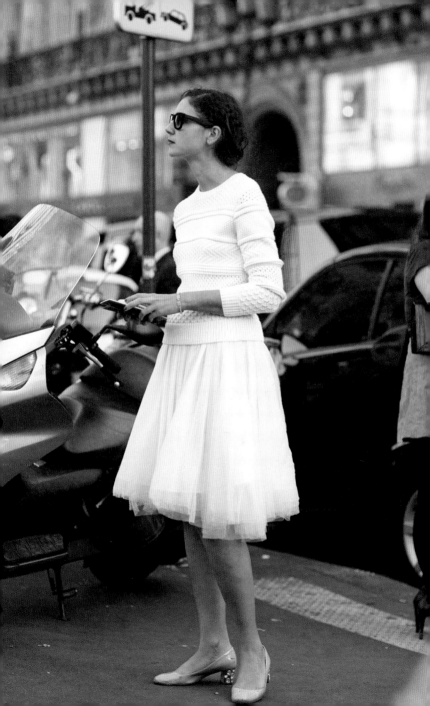

Italian girls

French girls have a smoky, sexy allure. English girls are great at shock value, the 'it's so bad it's good' aesthetic. Japanese girls have a sense of beauty and style references that I'm still trying to understand.

American girls have a sense of physicality and sportiness in how they wear clothes that set them apart.

The one thing that these varied sensibilities seem to share is a certain cynicism about beauty. These young ladies want to be pretty but not *too* pretty, not too demure, not too Grace Kelly-ish. It seems that what they want is a certain edge to their persona, a certain subtle aggressiveness to their beauty.

I don't find that attitude nearly as prevalent in Italy. There is a charming respect and aspiration to the classic standards of femininity and beauty. The concept of being bourgeois is not something the Italian woman fights against but something she likes to redefine in a modern setting. Milan and Florence are some of the only cities in the world where girls can dress entirely in American Apparel without even a hint of irony.

Most of the young Italian girls I know have a wardrobe a quarter of the size of the typical young American girl. They don't throw money at fashion and have not adopted the fast fashion new-wardrobe-every-week approach that seems to be swallowing the rest of the world.

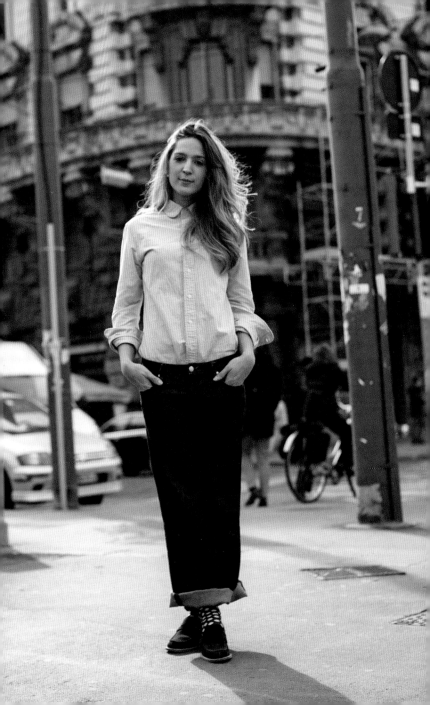

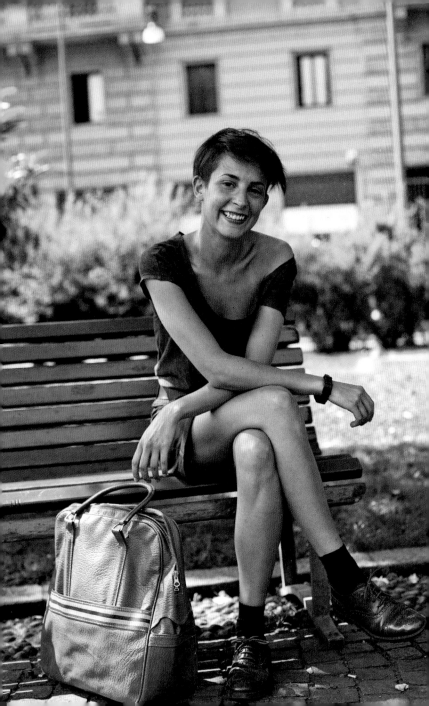

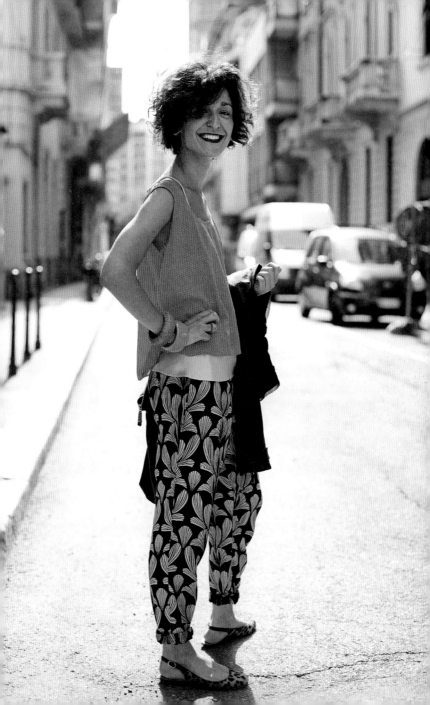

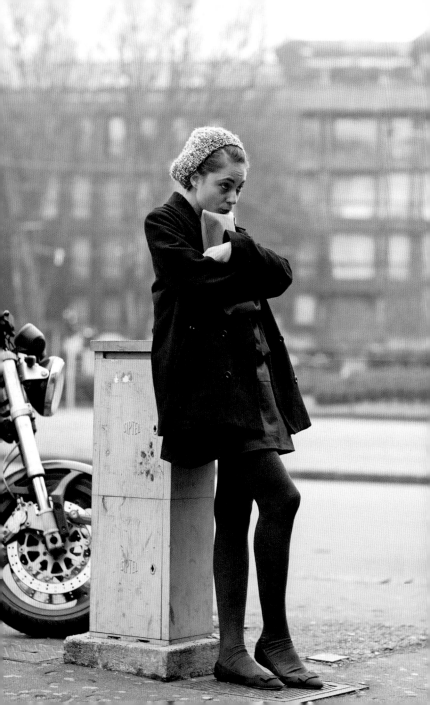

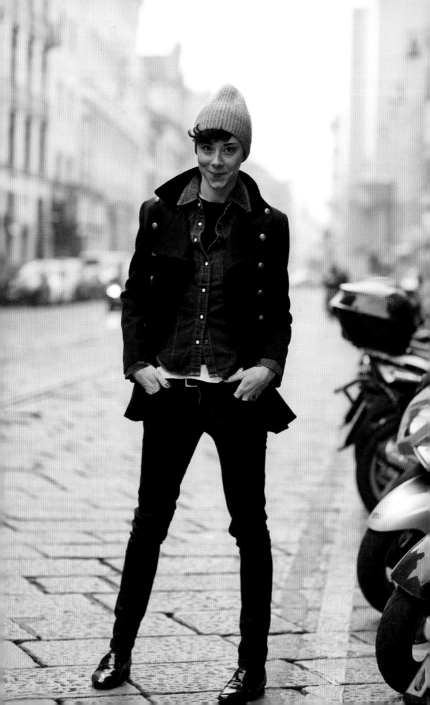

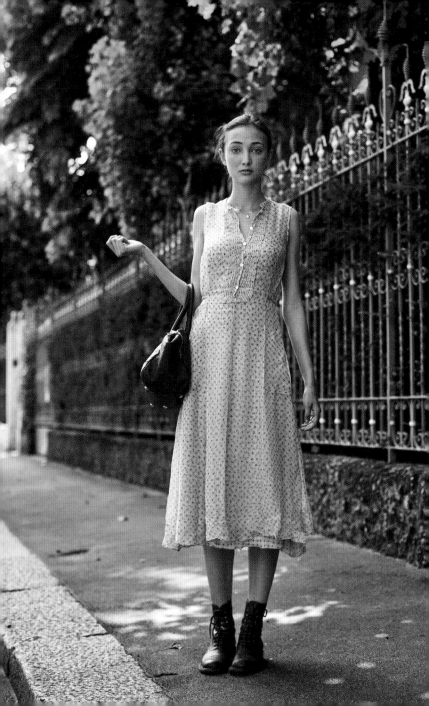

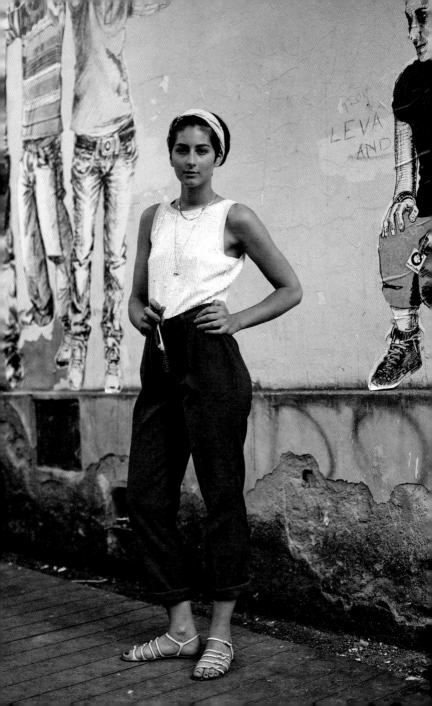

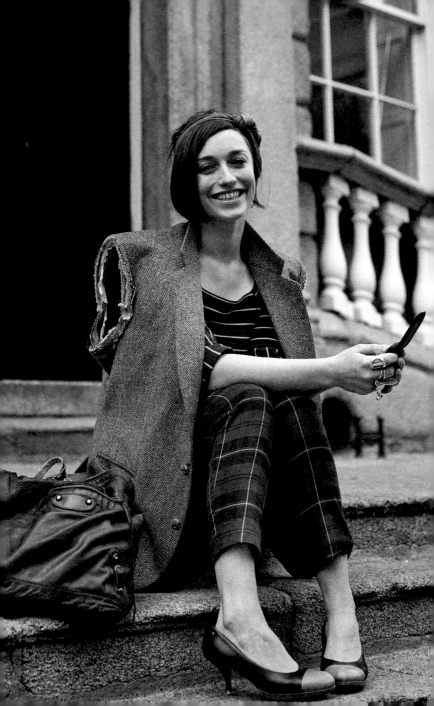

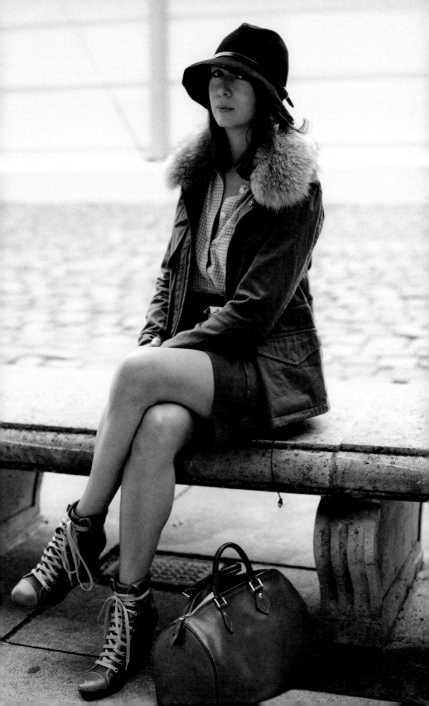

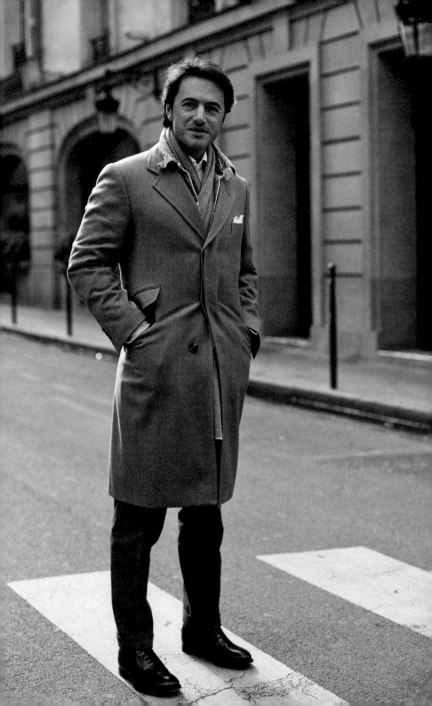

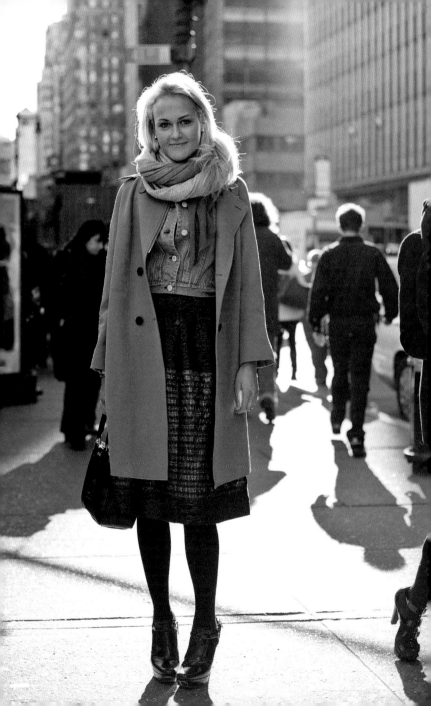

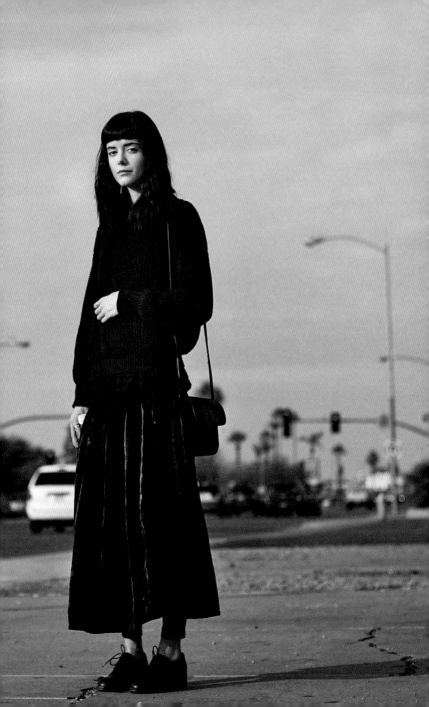

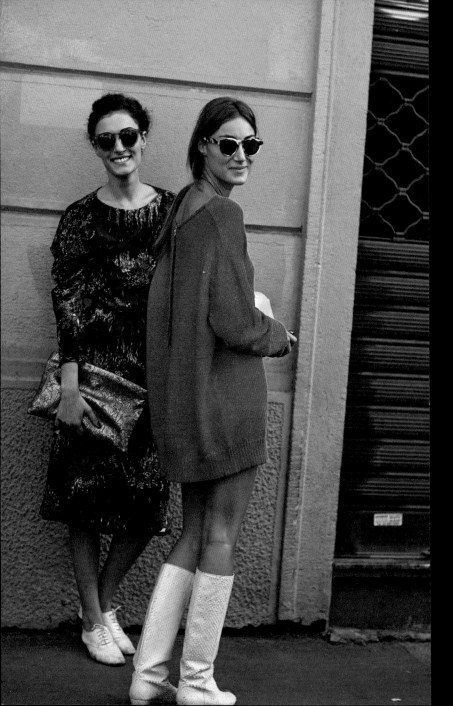

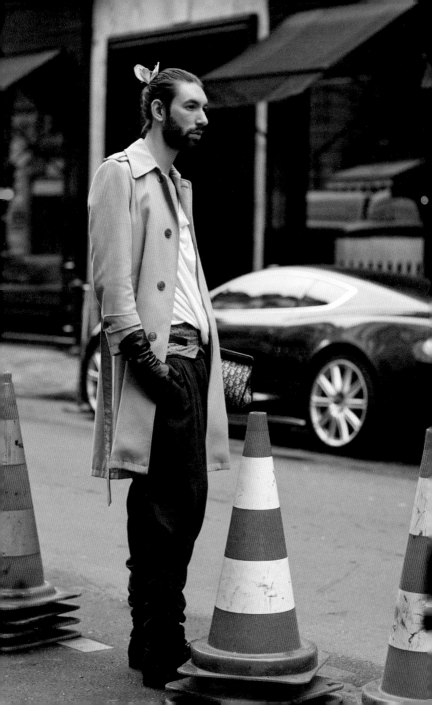

Venice

In 2009 a friend of mine arranged for me to teach a summer class on photography in Venice.

It was the perfect set up. A beautiful room in a Renaissance *palazzo* right on the Grand Canal. I only had to teach a few hours of class each day, and the rest of the time was free to explore Venice.

The students arrived. Every day we spent several hours walking along the Venetian canals. Wonderful setting for a photo lesson . . . but rarely a shot snapped or even a camera lifted. Nothing seemed to raise the interest of my students, and it wasn't because these kids were super-selective.

After a few days of this I finally asked them out of desperation 'Where do you want to go shoot?'

'The Lido!!!', they all answered.

Of course, the beach!

The next day we met at The Lido and, of course, most of them had left their cameras at home. They were there for the fun. I tried to explain that taking photographs doesn't have to be a choice between enjoying yourself or documenting the action. A happy photographer captures the spirit of the moment because he's involved.

Somehow that didn't translate into Italian very well.

I finally gave up and decided to let them have their fun.

The *ragazzi* were playing ball in the waves and even though I hadn't brought my swim trunks I waded in with my little digital point-and-shoot. Before I realized it I was chest deep in the waves, wallet in my mouth to keep it dry, shooting blindly in the general direction of the action because the sun was too bright to see anything on the digital viewfinder.

To me these images convey the joy of summer at the beach. It wasn't about having perfect equipment or even an exotic setting, but about allowing yourself to be totally in the moment.

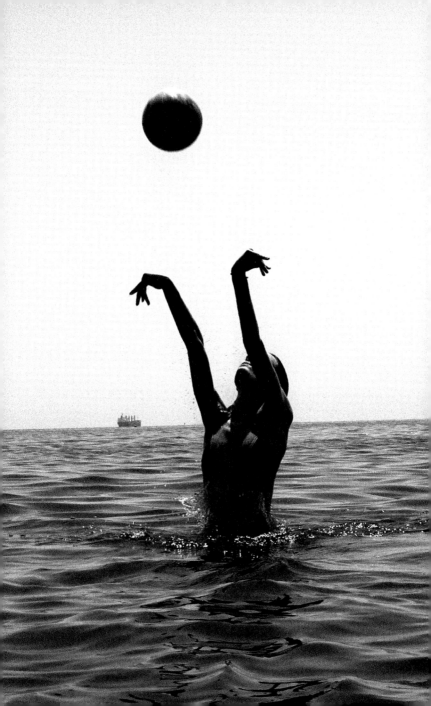

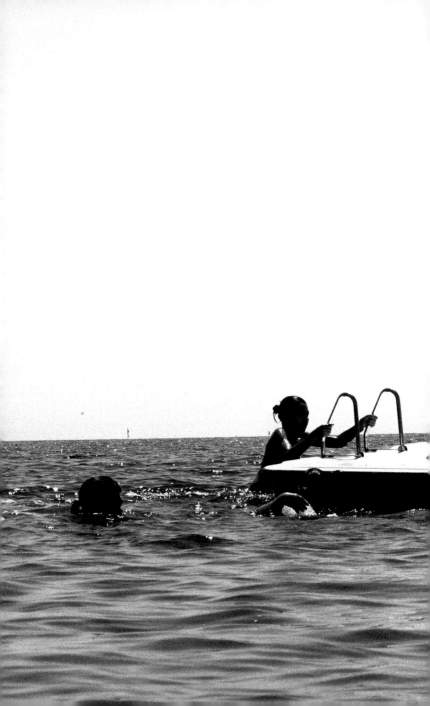

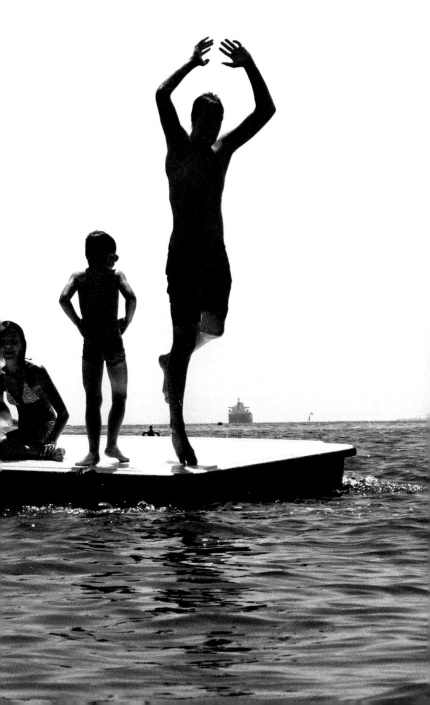

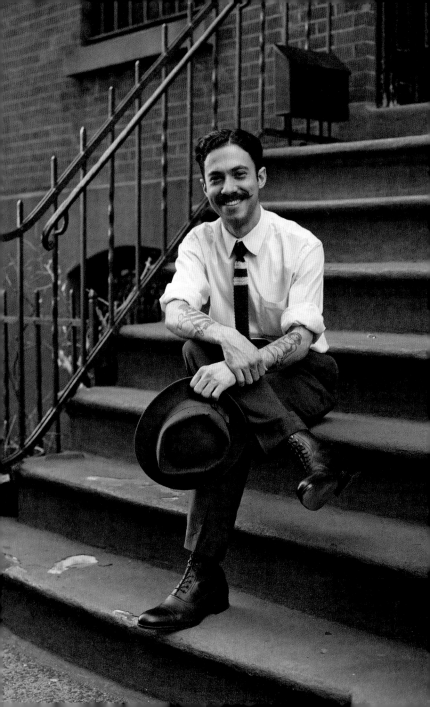

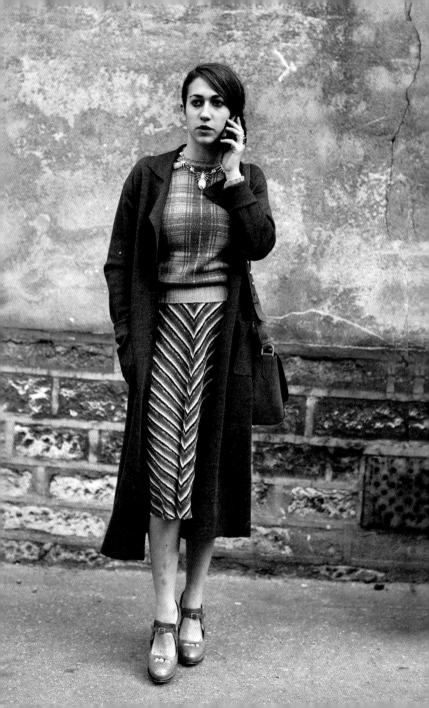

Cult

My Dad always used to say he didn't care at all about fashion. But he (and everyone I know) care deeply about style and what it says about who you are and the group you want to fit in with. Everyone from the Cowboy to Joe sixpack, the retiree to grumpy teen, dress in a way that clearly communicates to others in their chosen group that they want to belong. My Dad would say 'I'm retired, I can wear whatever I want' but I never saw him wear a suit to play golf or an AC/DC concert T-shirt to the links.

'Style' as a concept has been hijacked to mean elite, refined and expensive when it should be thought of as a basic expression of life in much the same way as we all identify with music or speech. At the end of the day style is communication.

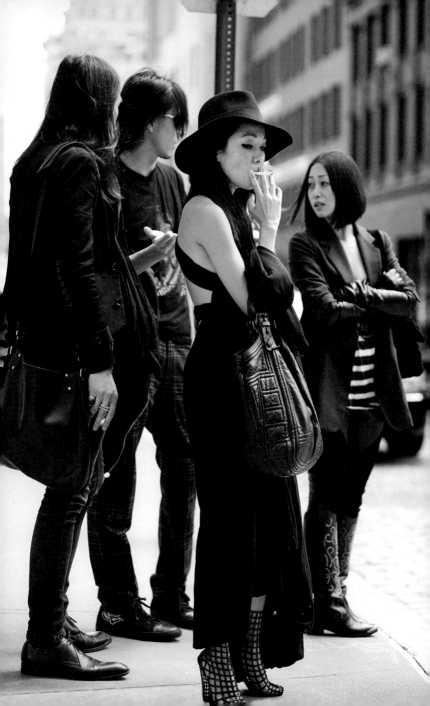

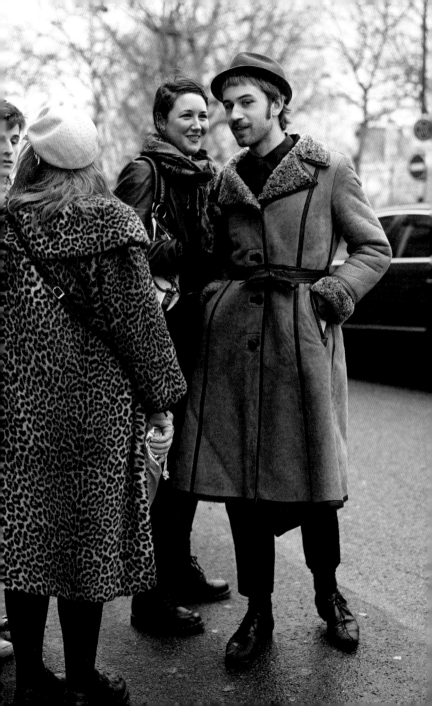

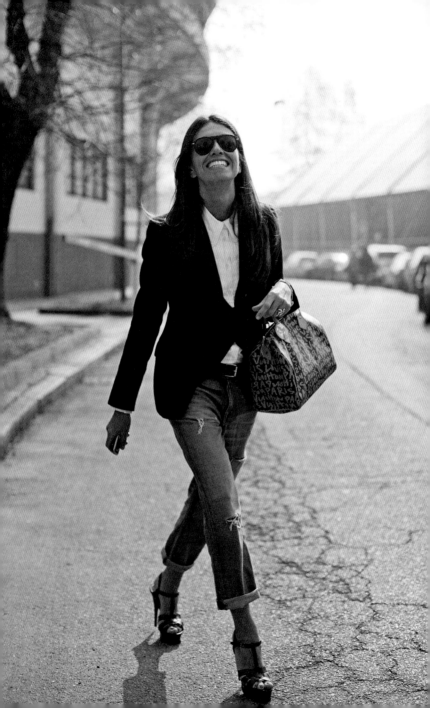

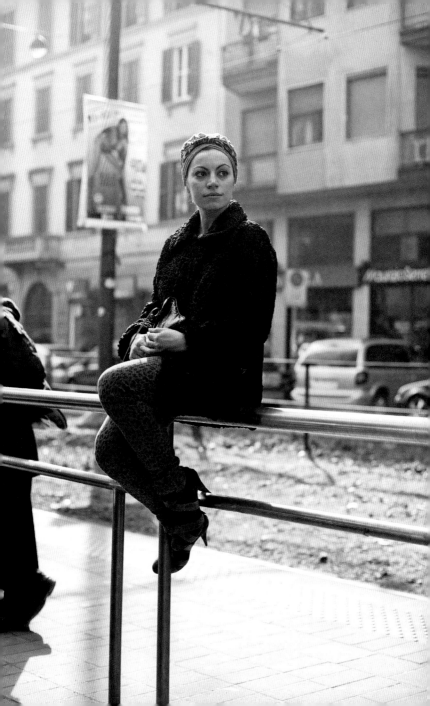

On the Street . . . Boulevard de Bercy, Paris

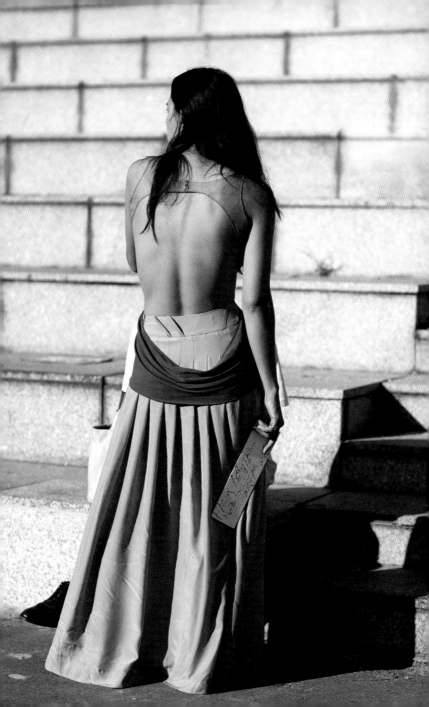

Uniquely Uniformed

I know that uniforms are meant to make everyone look, well, uniform in appearance.

However *how* a uniform is worn can say a tremendous amount about the personality of the wearer and how they feel about their profession.

I found two great examples of extreme opposites in 2010 while in Italy.

This young lady in Florence isn't about to let her uniform define her. She is, at heart, a rasta rebel and even though she is doing this job right now it is not who she will be in the future and she wants you to know that.

This gentleman in Milan, on the other hand, seems to love his chosen profession and that joy shines through in the meticulous nature in which he wears his perfectly tailored jacket and pinned silk tie. Yes, the other guys at the bar were dressed in the same uniform but none of them stood out the way this gentleman did. His attention to detail, like the perfect amount of shirt cuff showing at the jacket sleeve or the crispness of his white shirt, says he takes this job seriously and he wants you to know that.

I'm not saying that either one of these people are right or wrong in the way they dress but in these cases their 'uniforms' have actually made them quite unique.

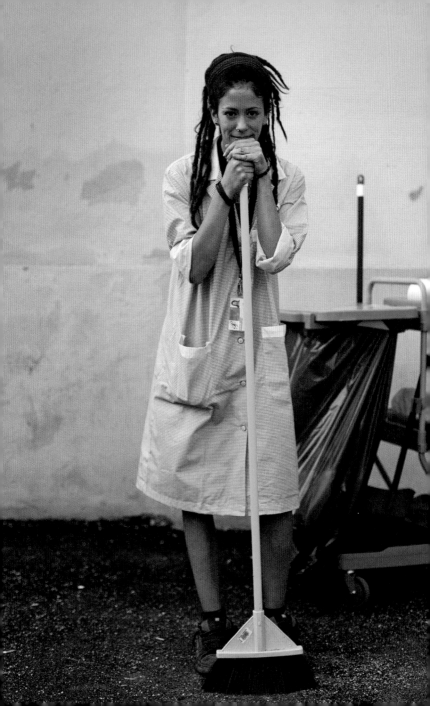

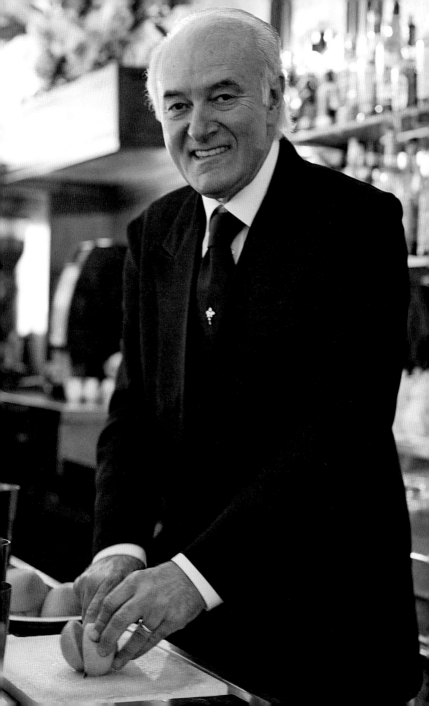

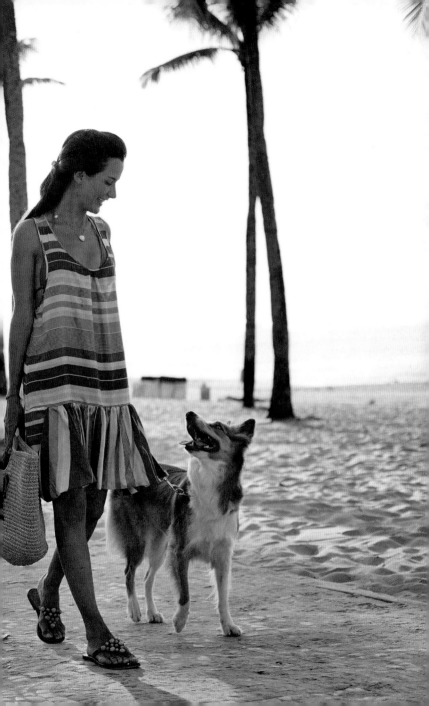

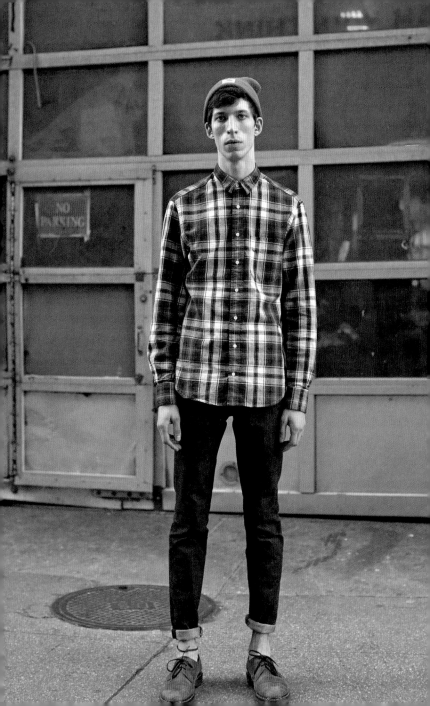

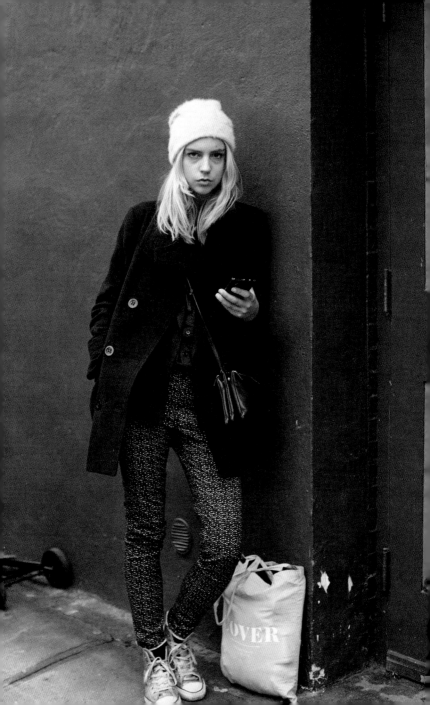

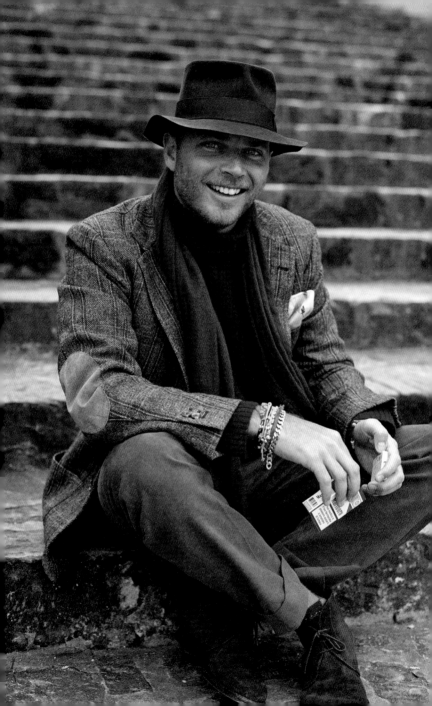

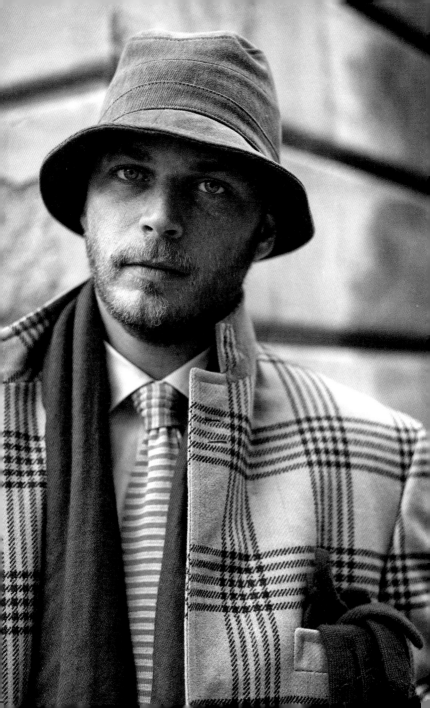

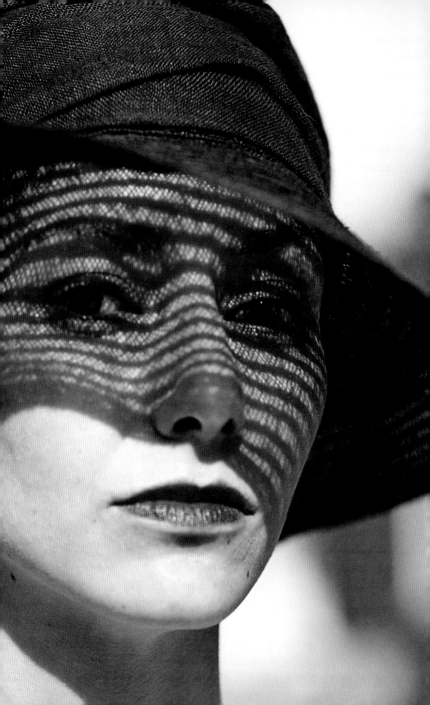

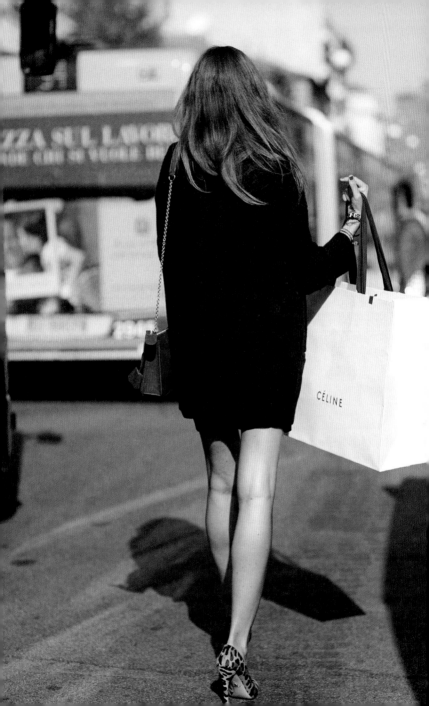

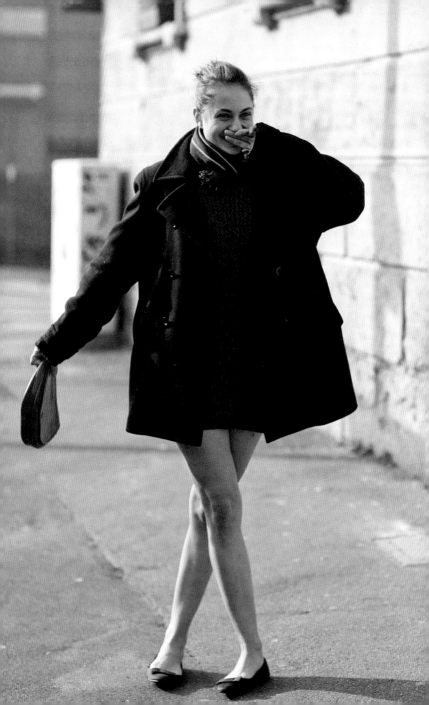

On the Street . . . Rue Saint-Honoré, Paris

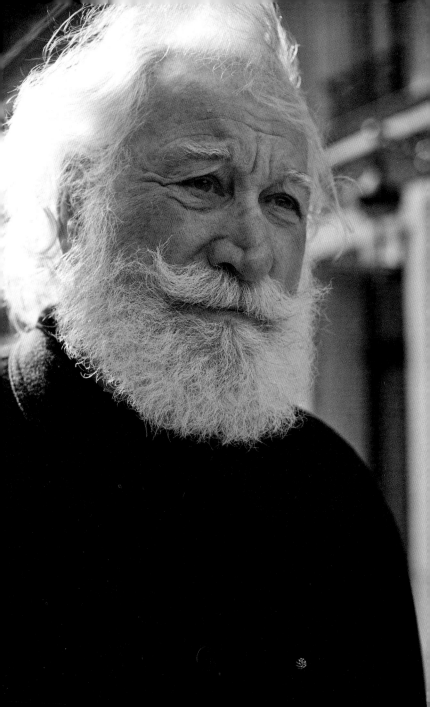

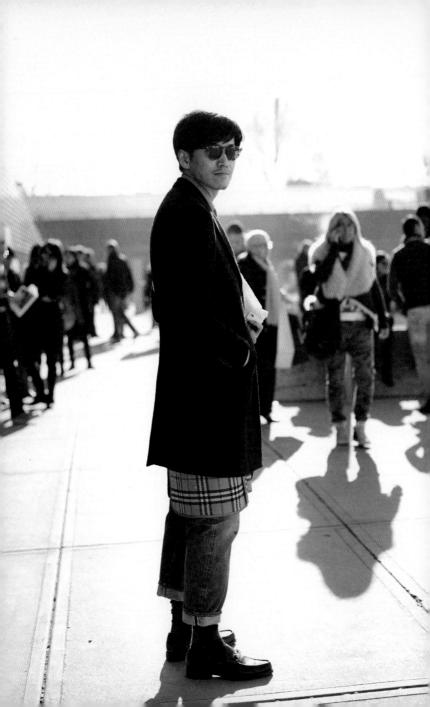

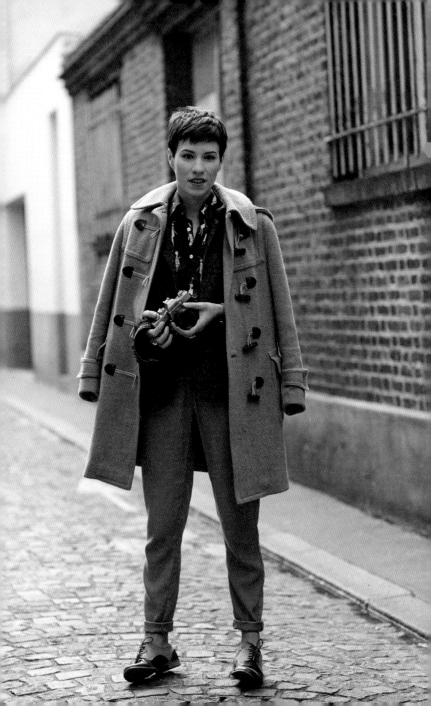

Nomads

Garance and I met a nomadic family on the edge of the Sahara during my first trip to Morocco last year.

Through our guide we asked if we could take a few photos, to which the mother kindly agreed.

What I love about this photograph is the physical relationship between mother and child.

Being a typical boy, this young gentleman spent most of the time while we were there jumping around, throwing rocks, chasing the dog and being generally (and rightfully) uninterested in our presence. That is except for one split moment when he stopped, turned to consider us and in a totally unselfconscious moment struck the exact same body posture as his mother, even half covering his face with his t-shirt just like her. A second later he was back to being a six year old.

For me, that tiny moment really captures how unconsciously we become our parents.

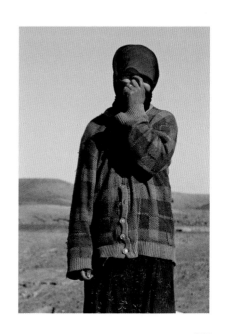

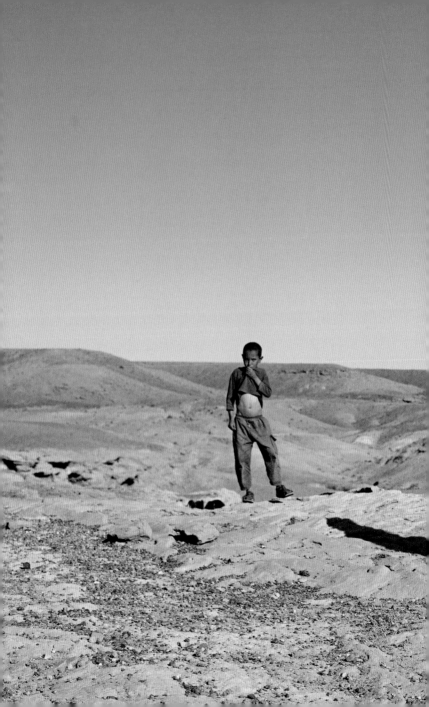

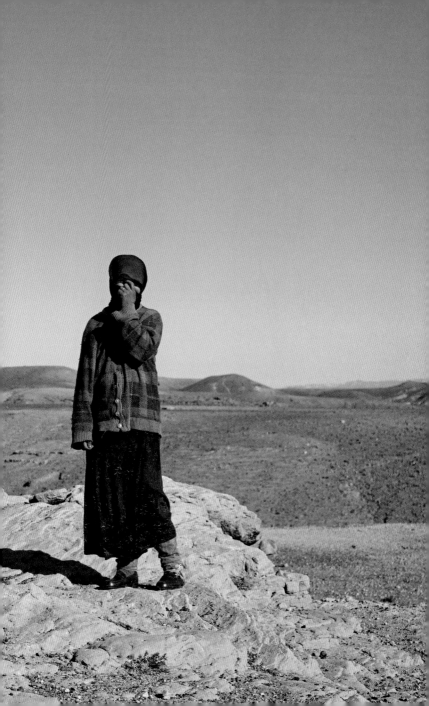

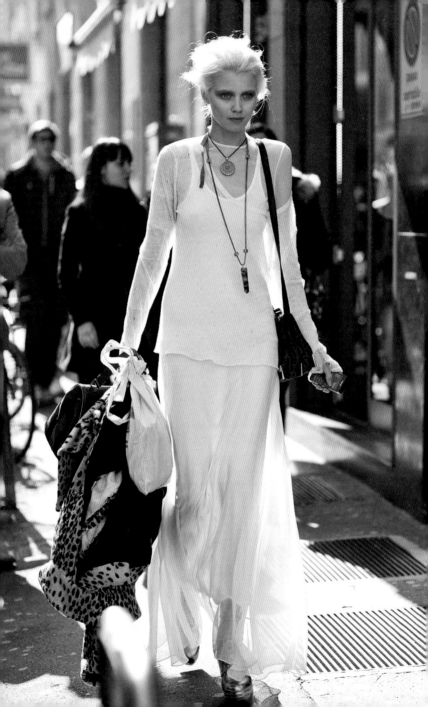

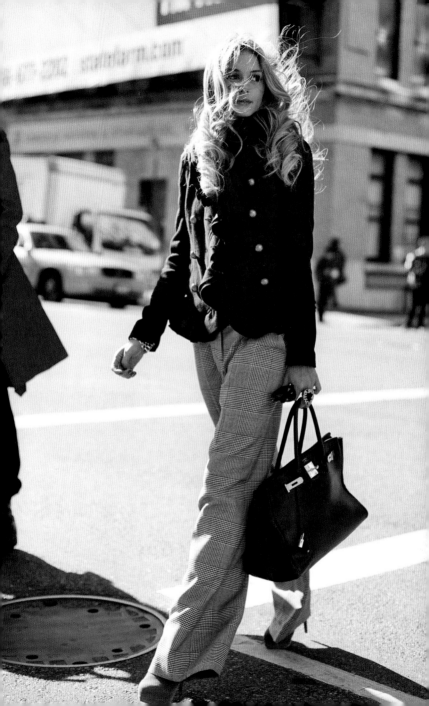

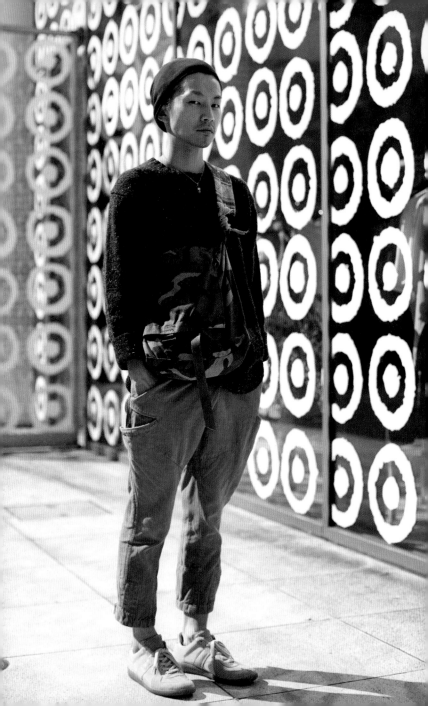

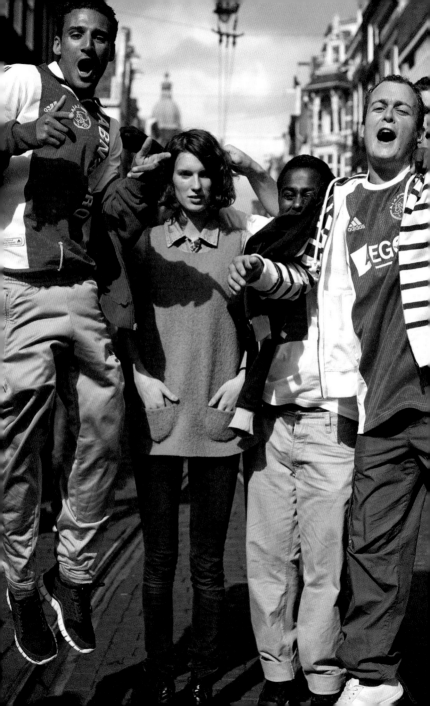

On the Street . . . Bleecker Park, New York

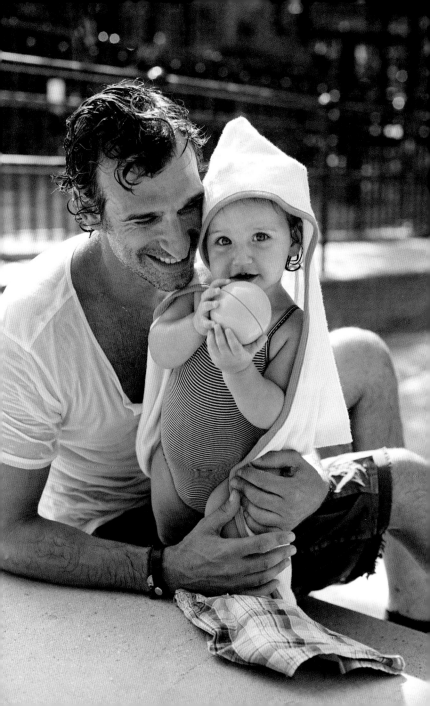

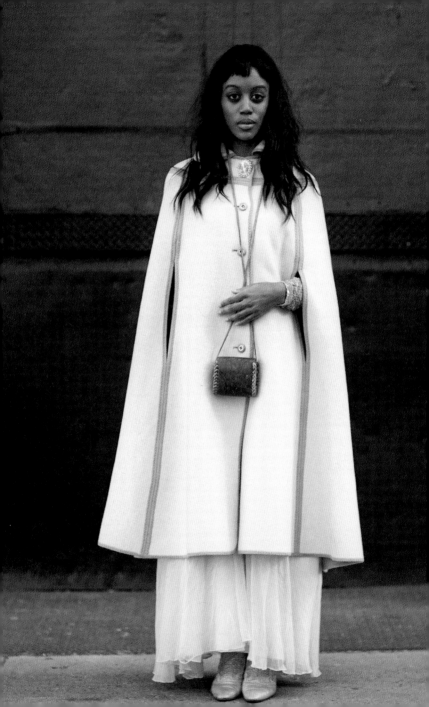

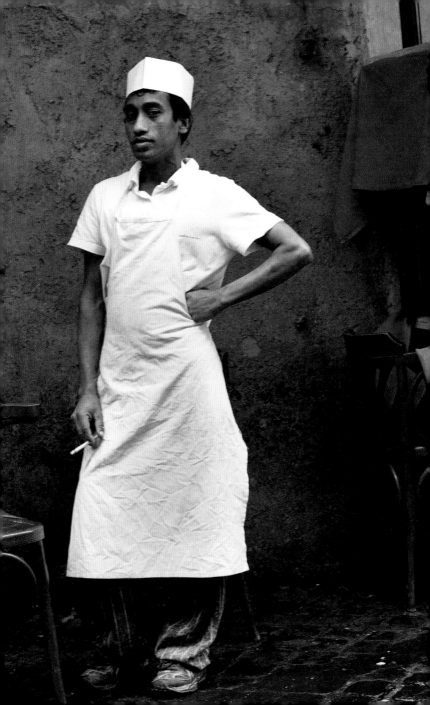

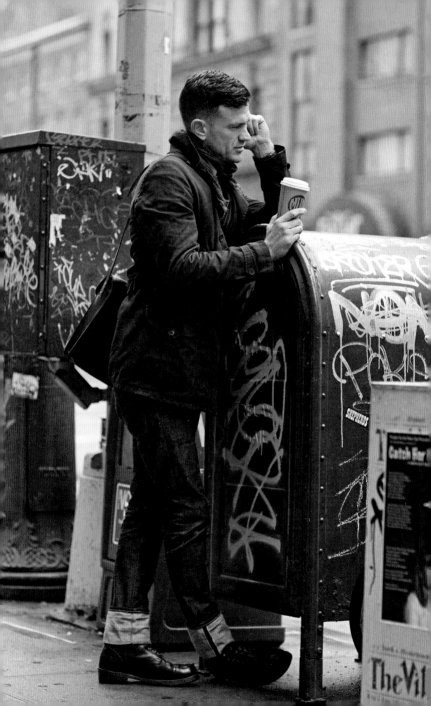

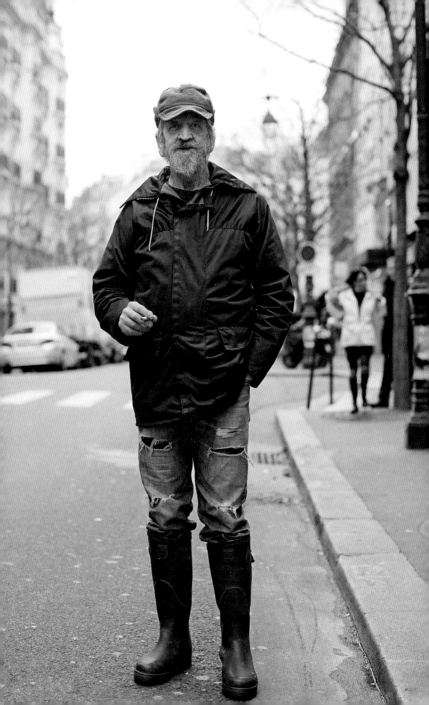

On the Street . . . Rue du Parc Royal, Paris

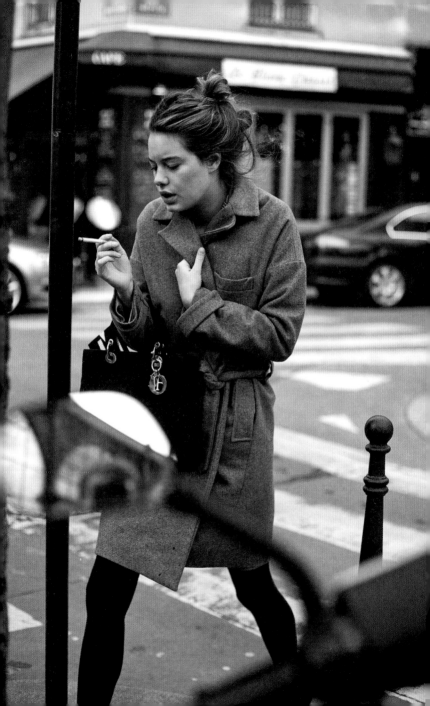

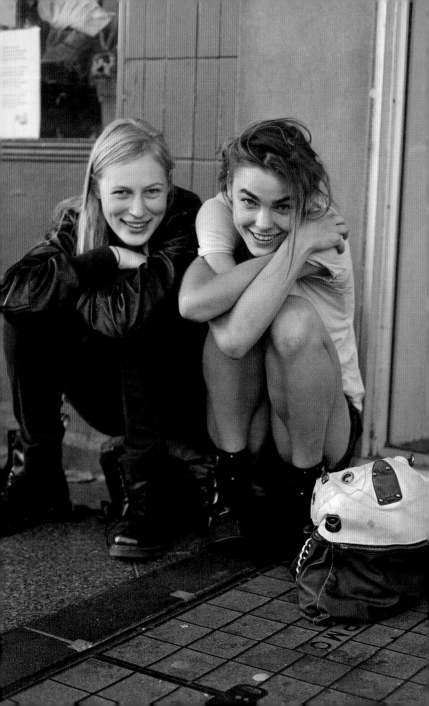

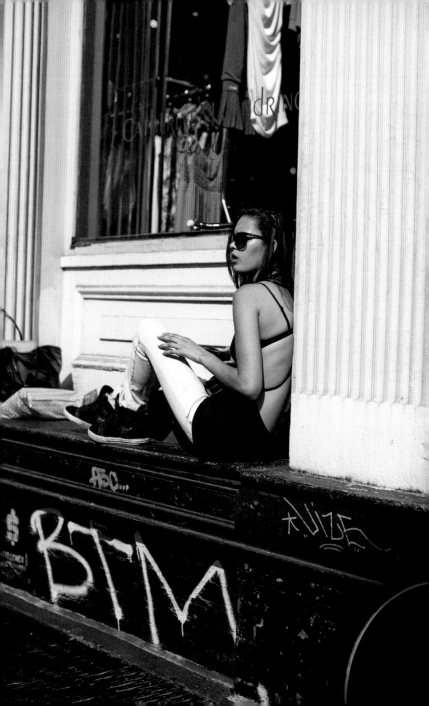

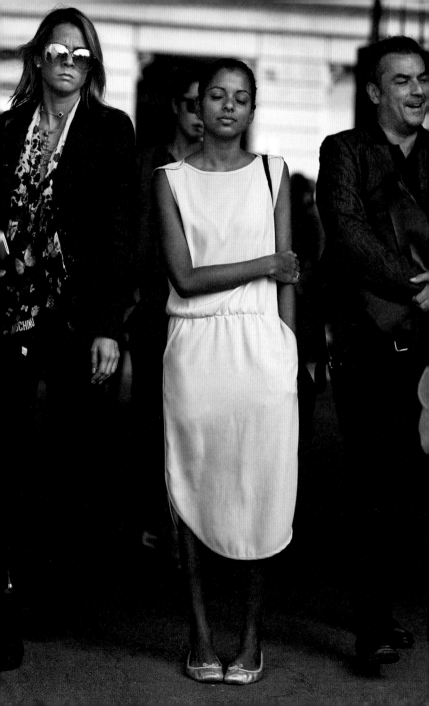

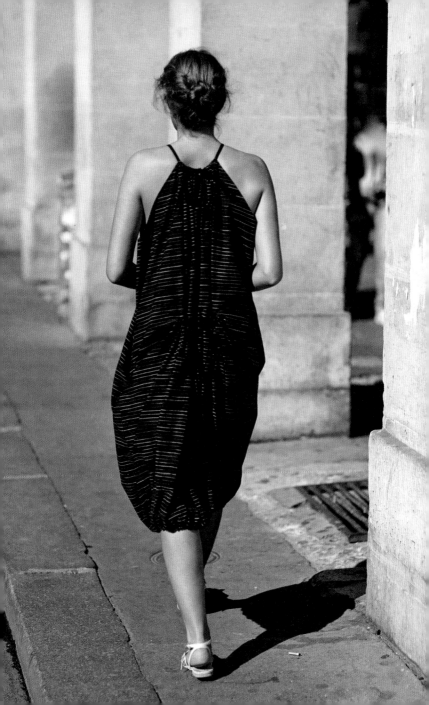

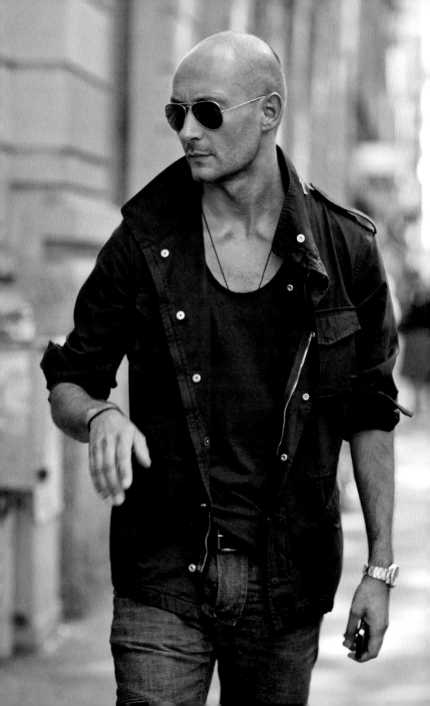

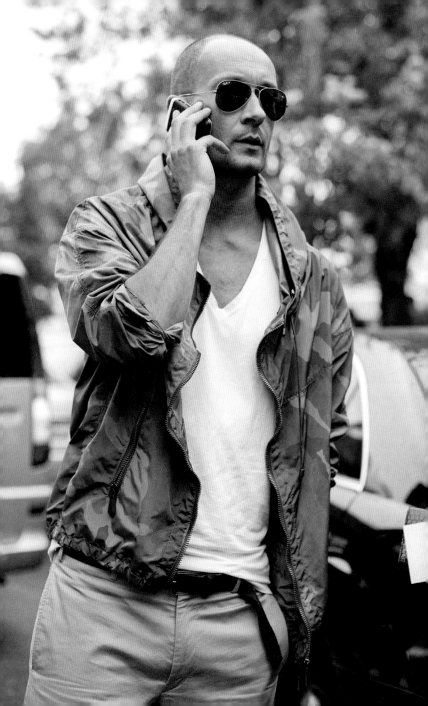

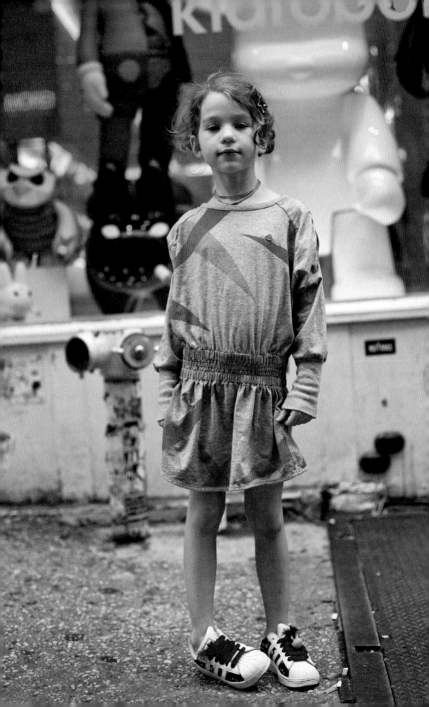

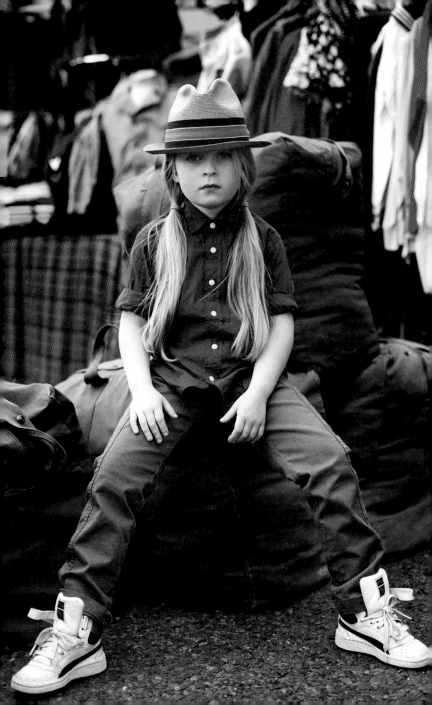

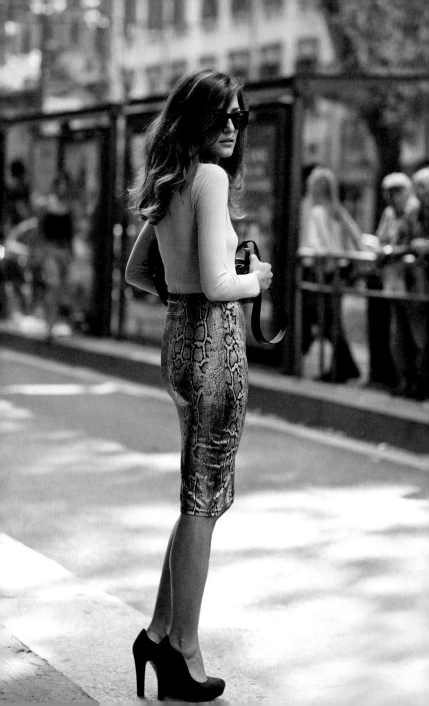

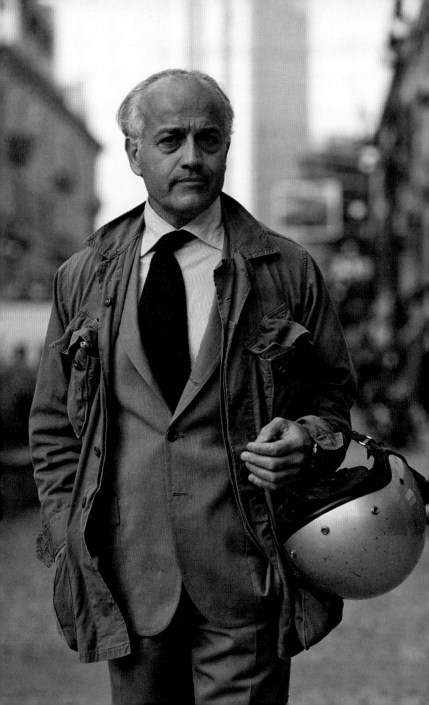

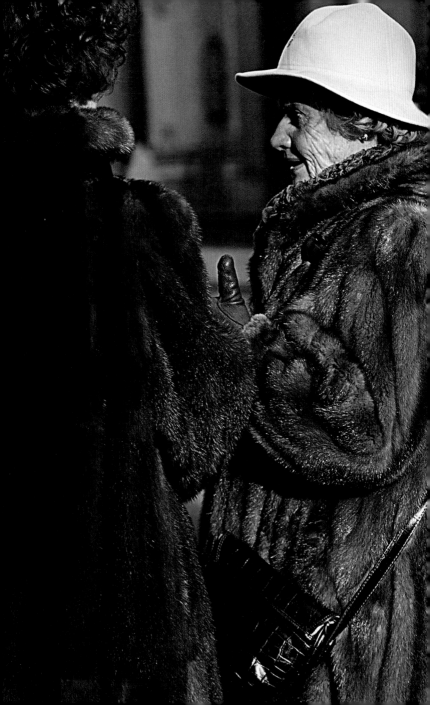

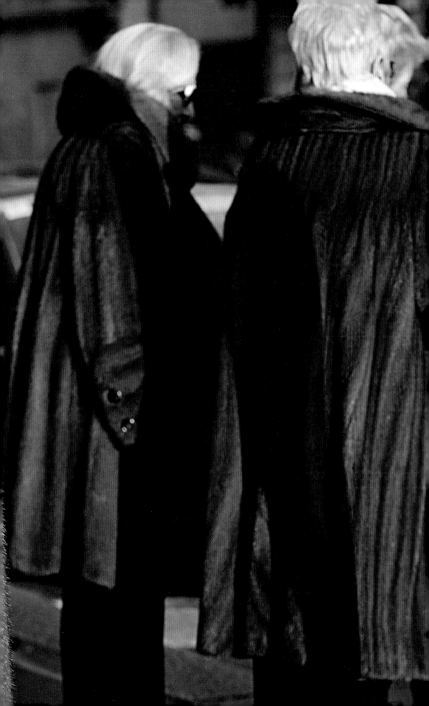

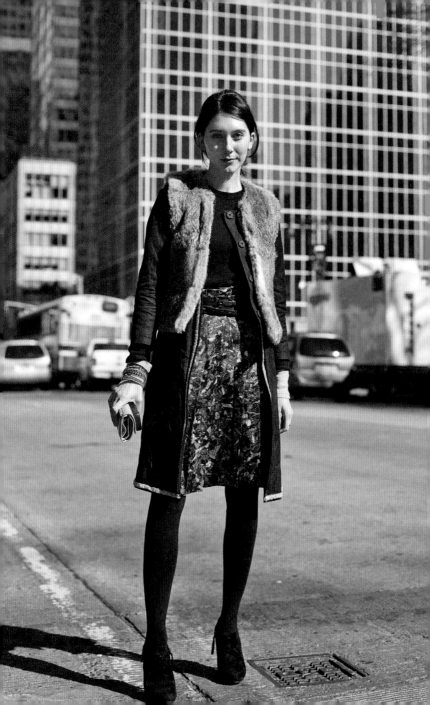

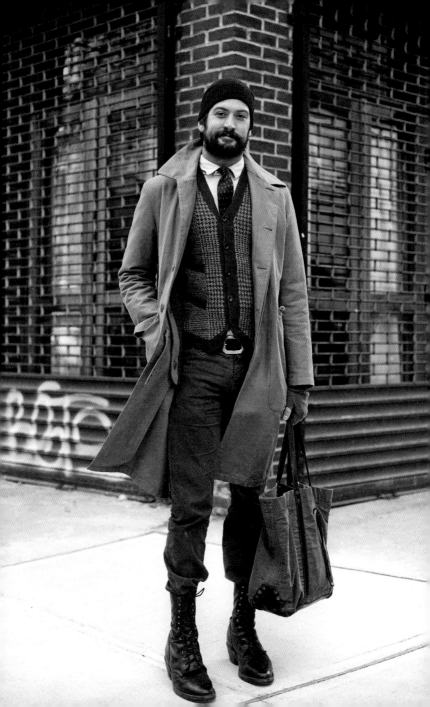

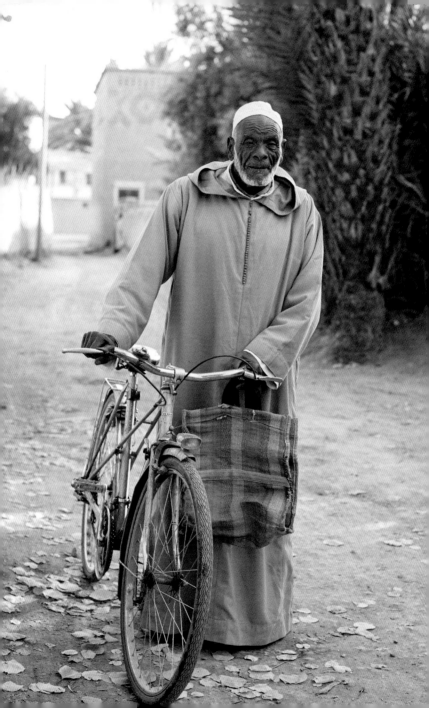

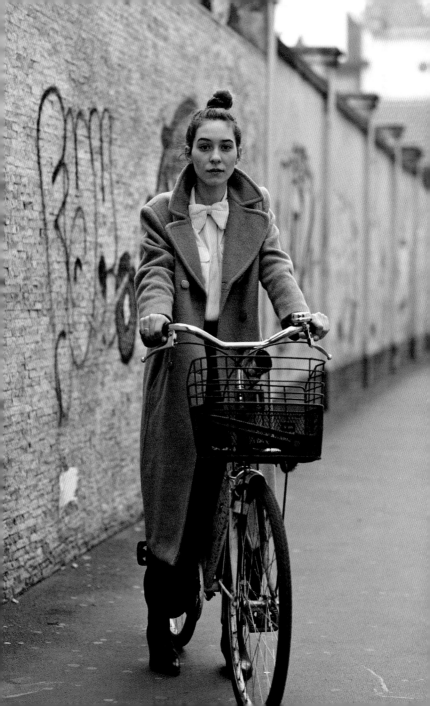

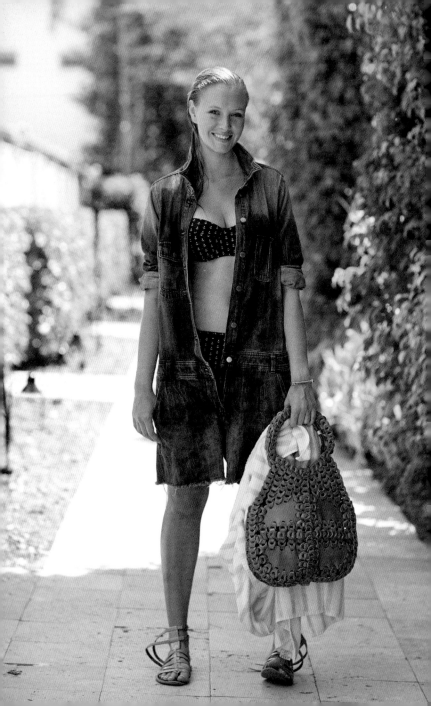

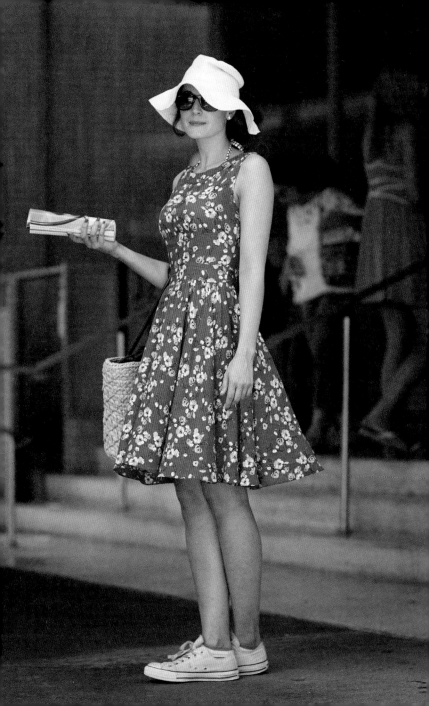

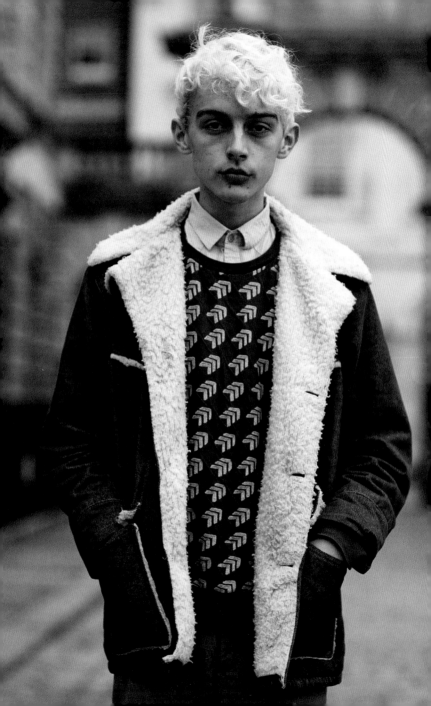

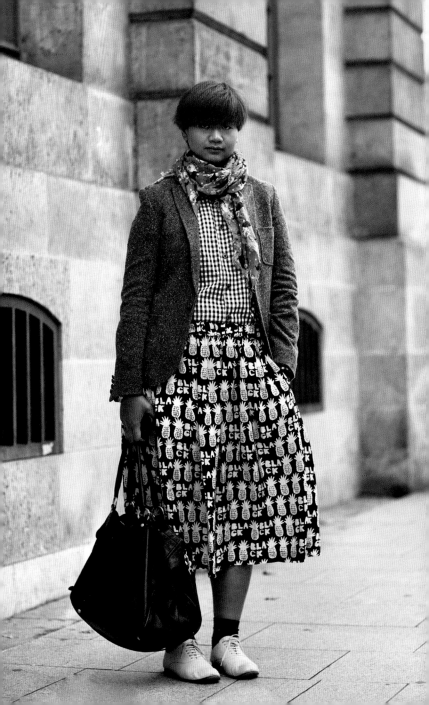

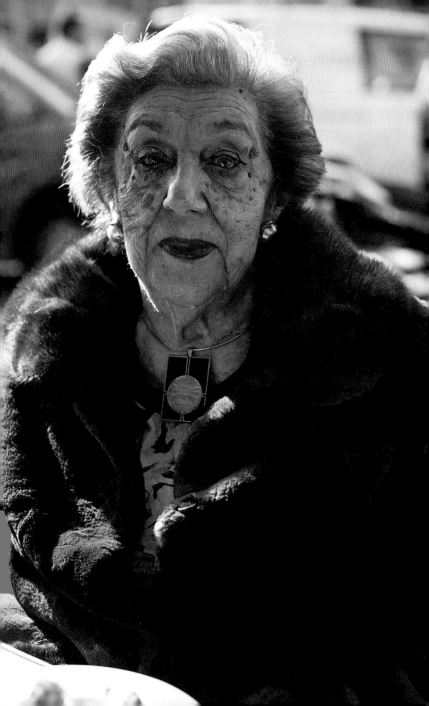

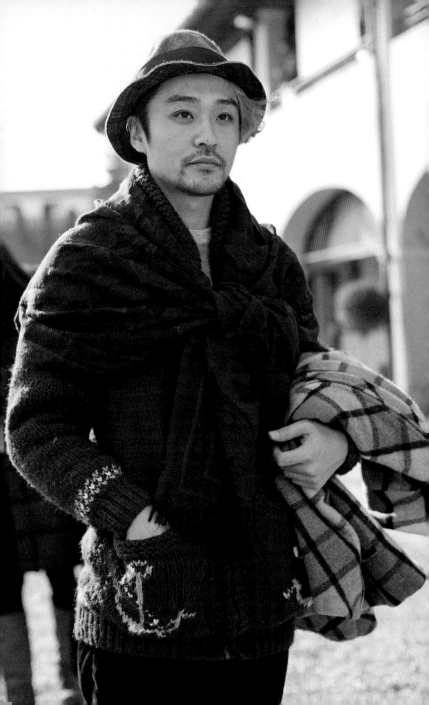

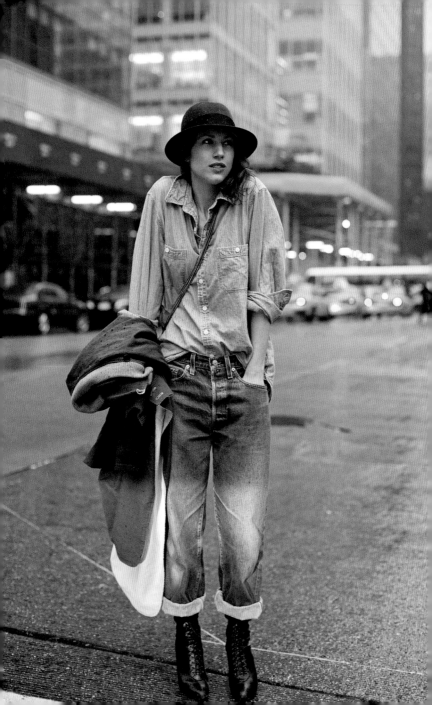

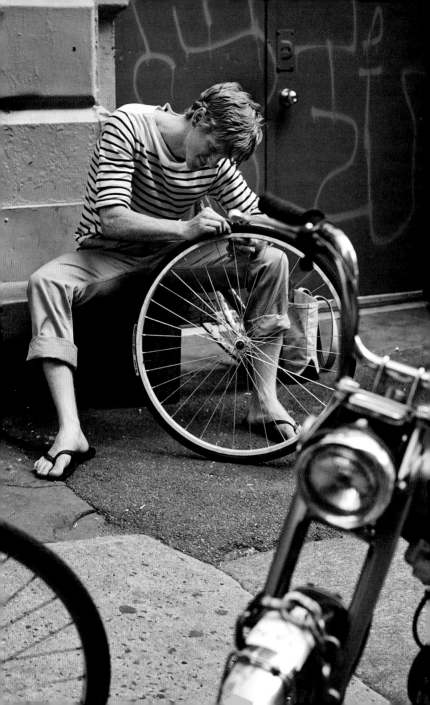

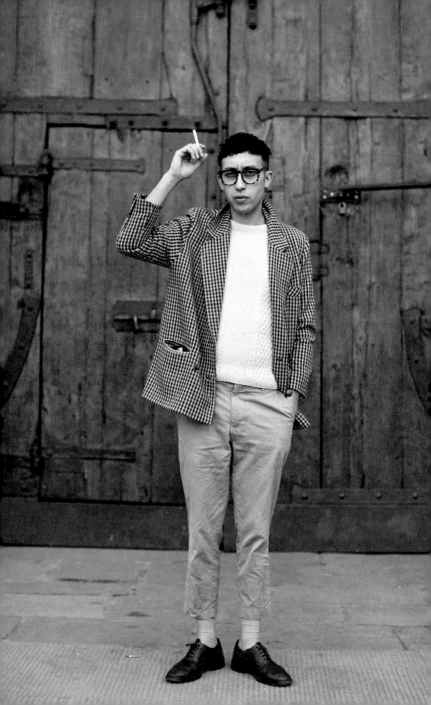

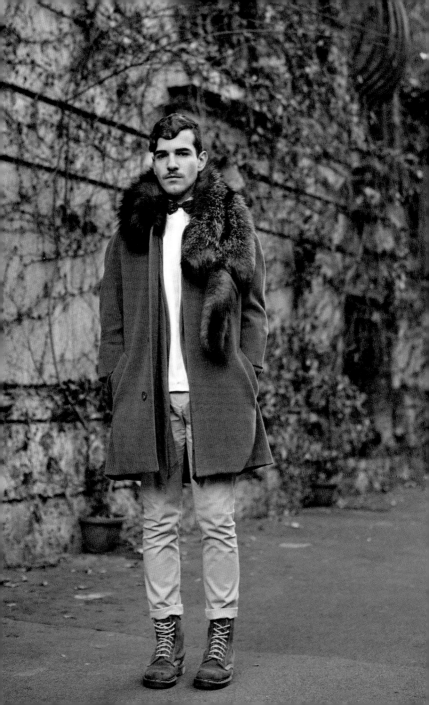

Rei Shito

There are very few people in the entire world that I'm truly curious what they will be wearing the next time I see them. Rei Shito is one of those people. She has that very special way of wearing clothes that is fearless, innocent and curious.

Even though she is very quiet and unassuming, Rei does an extremely good job at putting together seemingly random items and making them work through sheer personality.

She's like the mouse that roared.

Unlike so many young ladies I see at fashion week she never dresses to attract attention. Although I don't believe in the myth of 'effortless style' I do believe in the idea of 'passionate style'. An idea that if a person buys only the items they really, really love, even if they get dressed in a dark closet, they will come out *looking* happy.

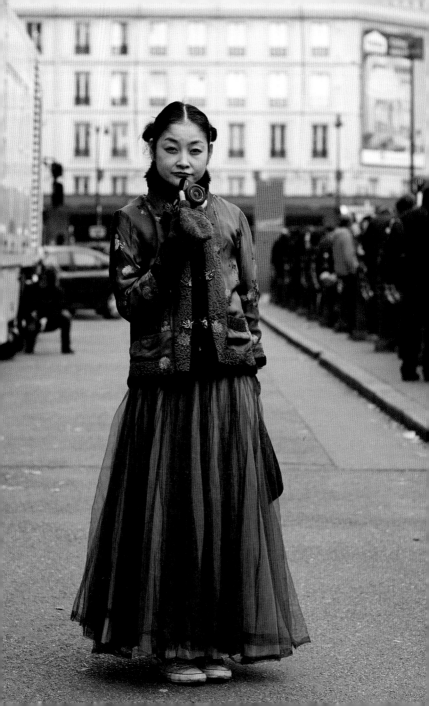

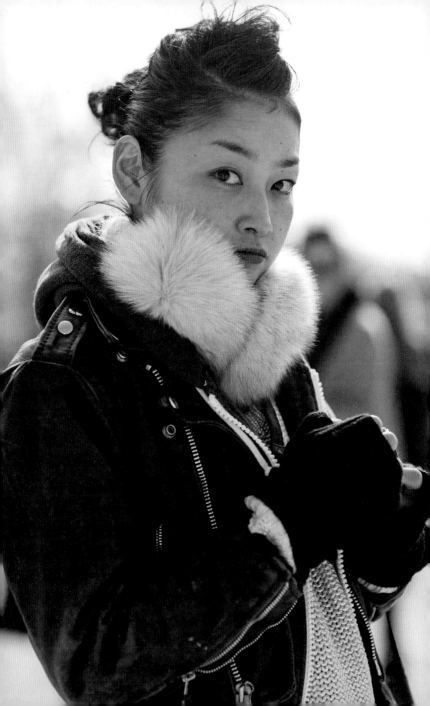

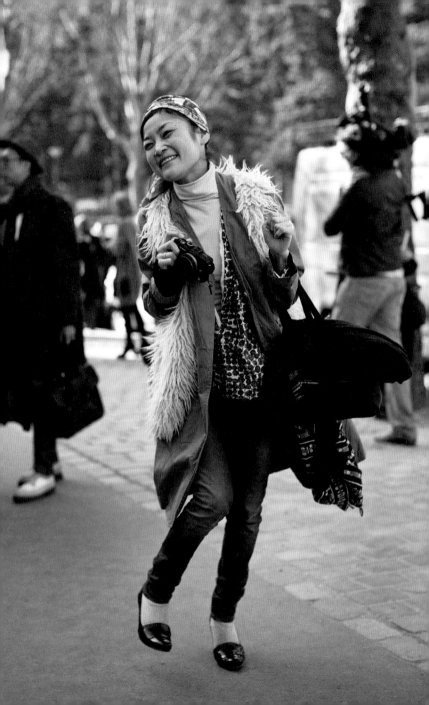

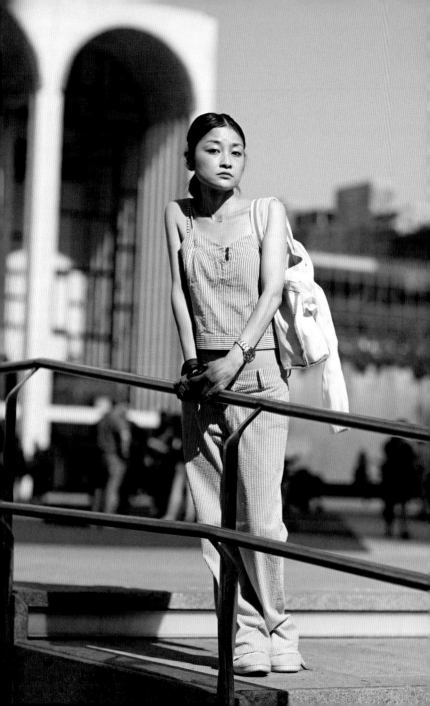

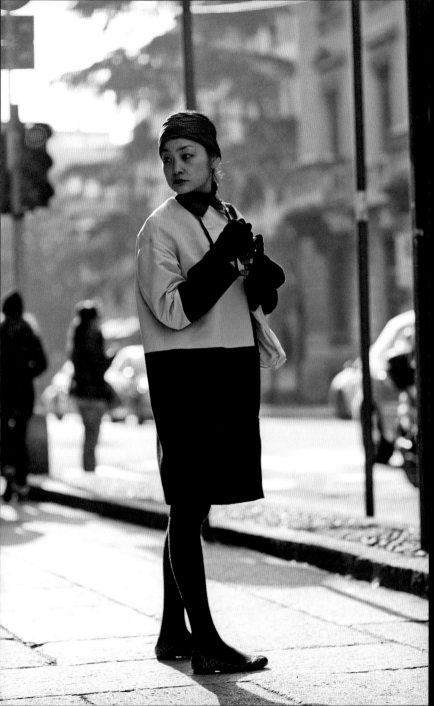

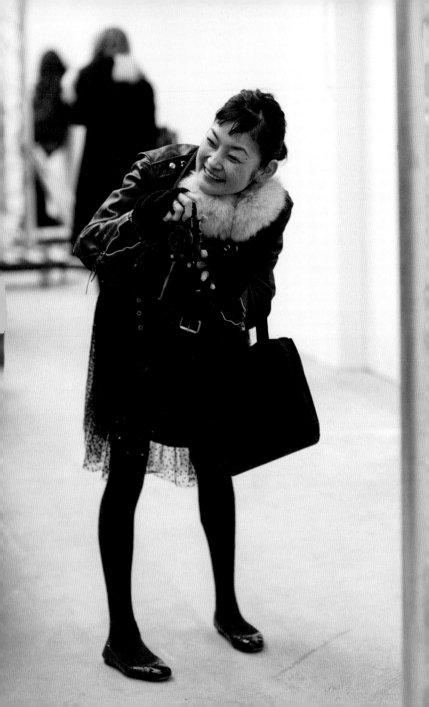

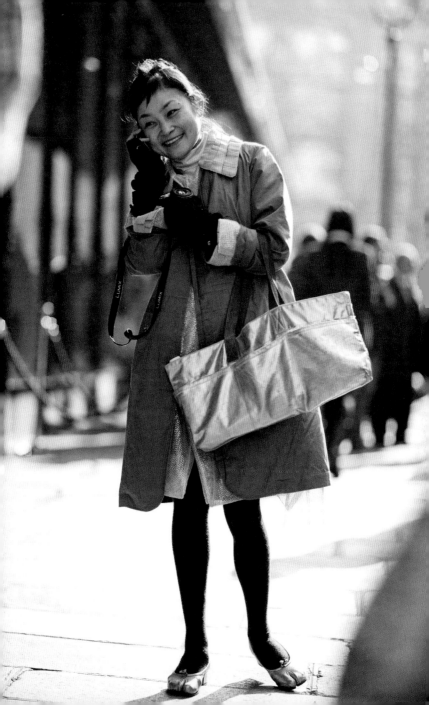

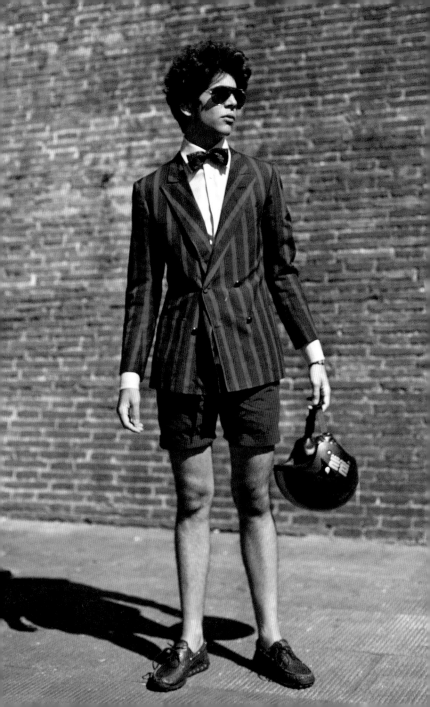

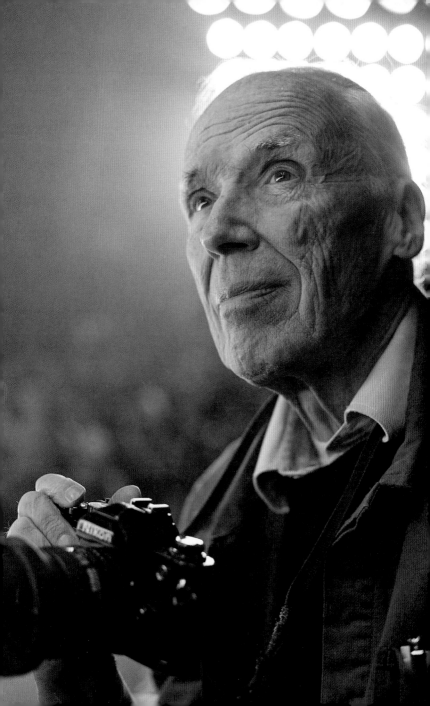

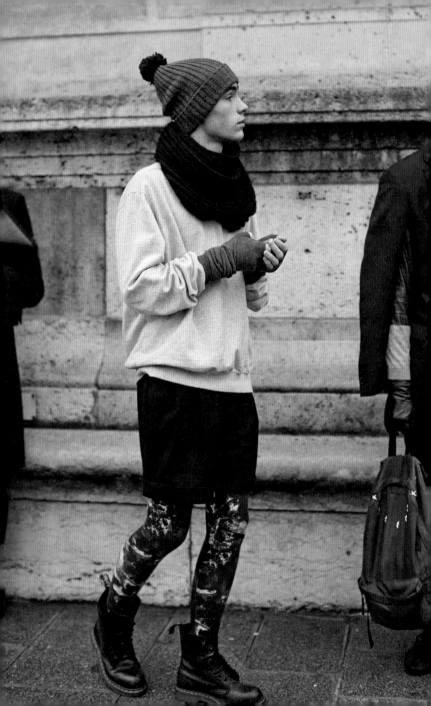

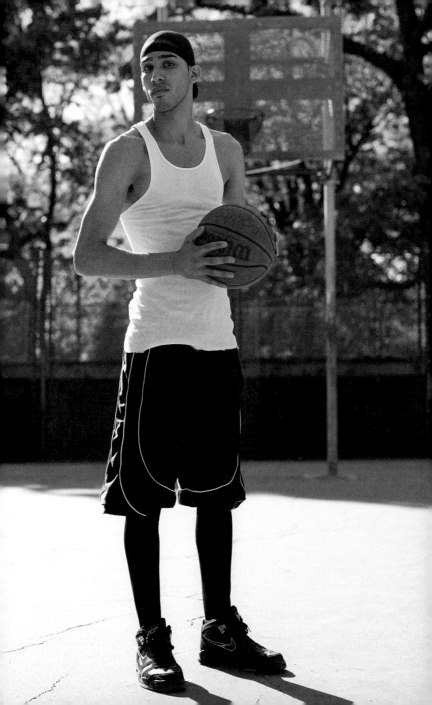

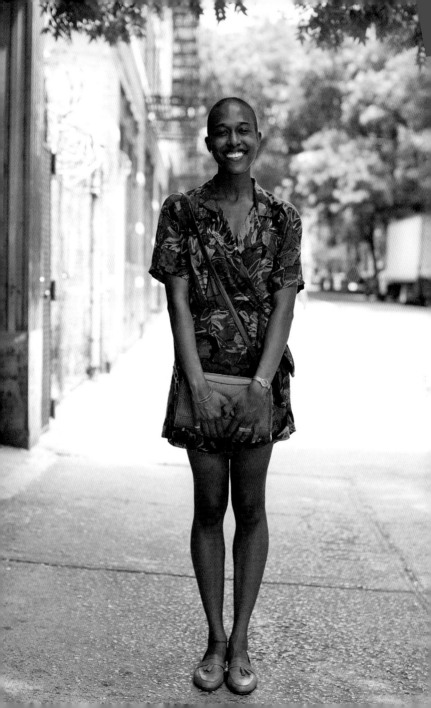

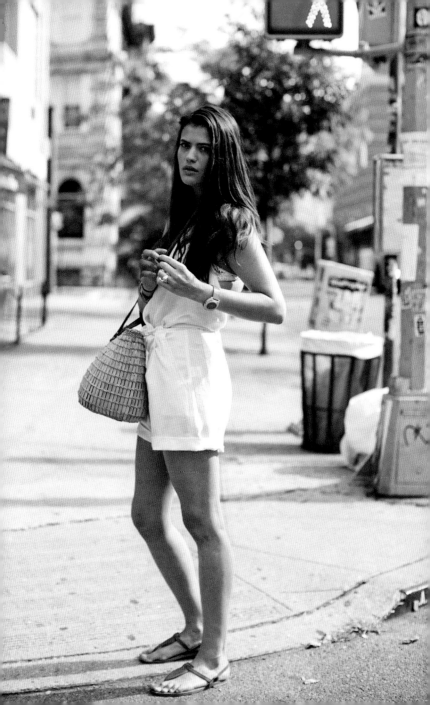

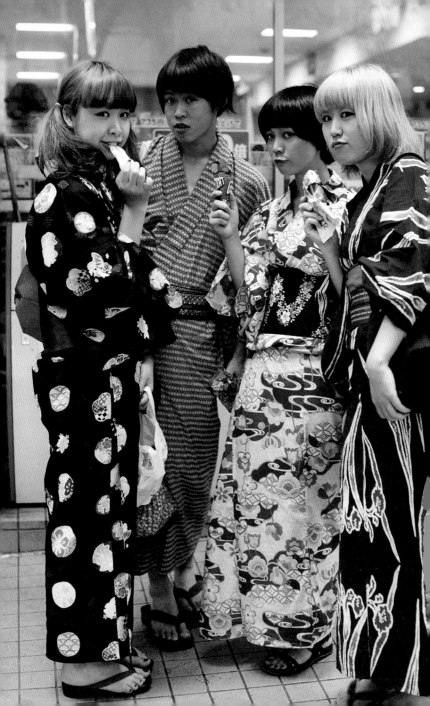

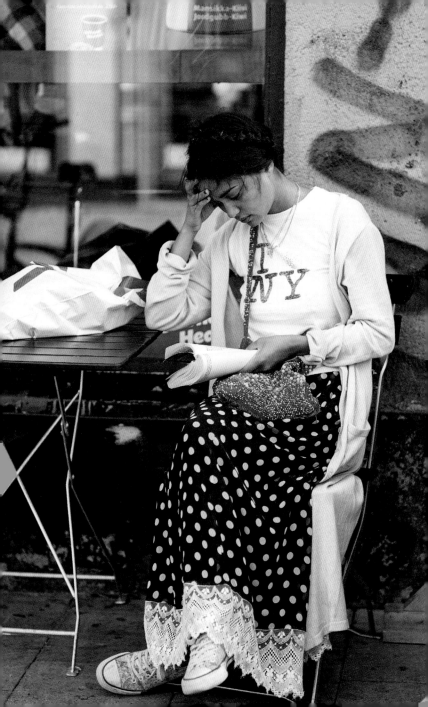

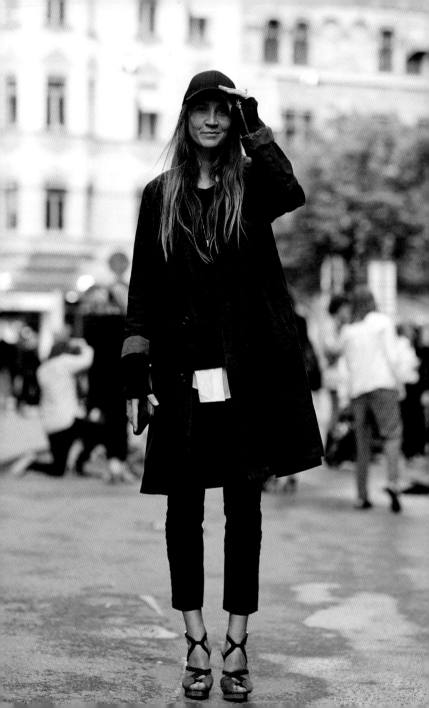

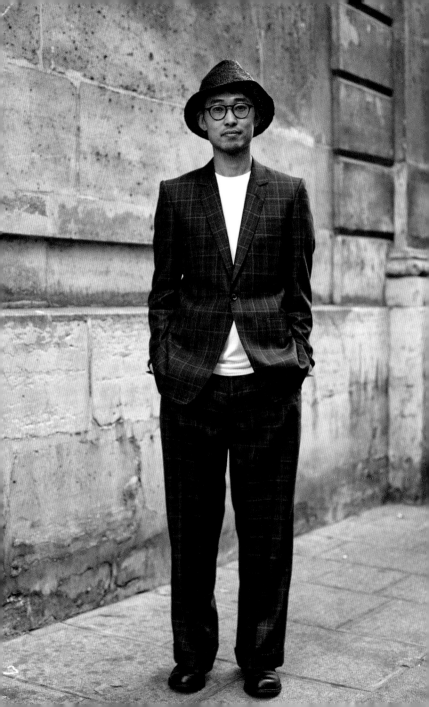

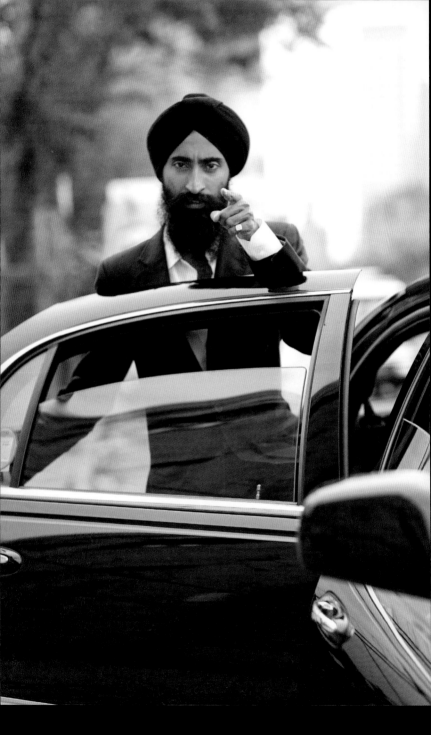

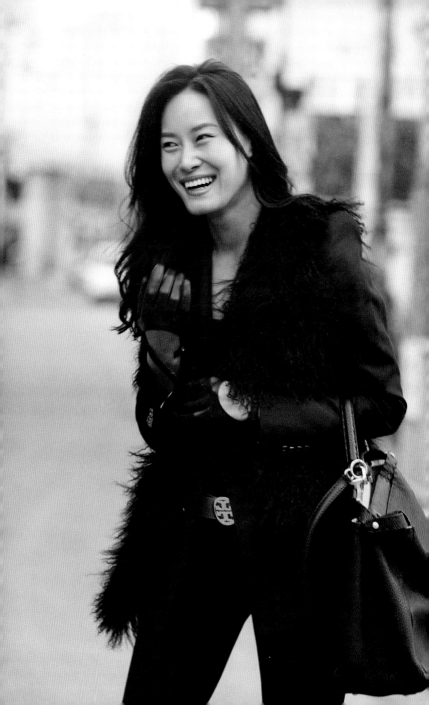

On the Street . . . Via Manzoni, Milan

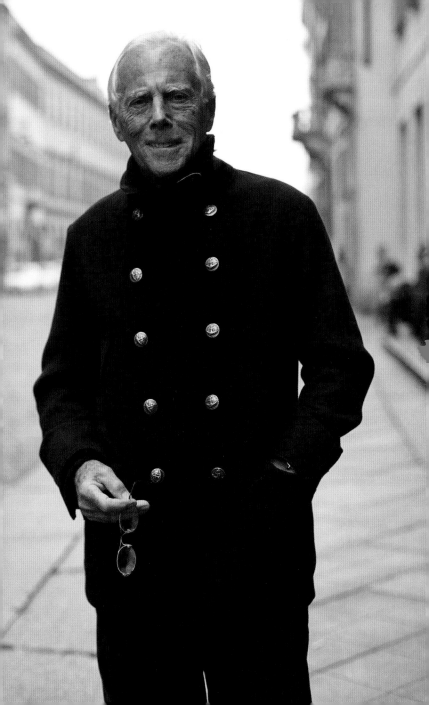

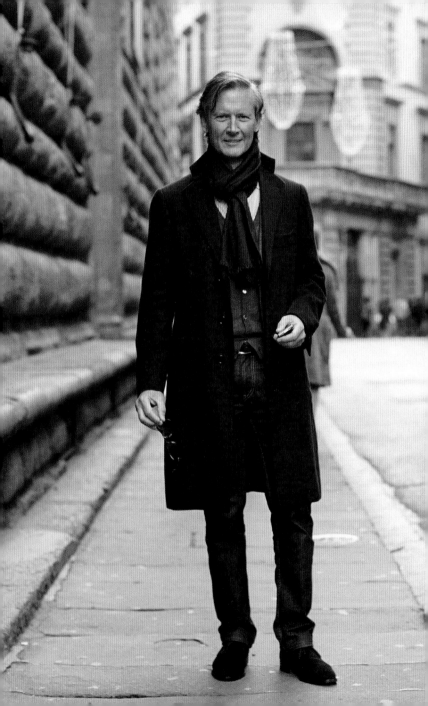

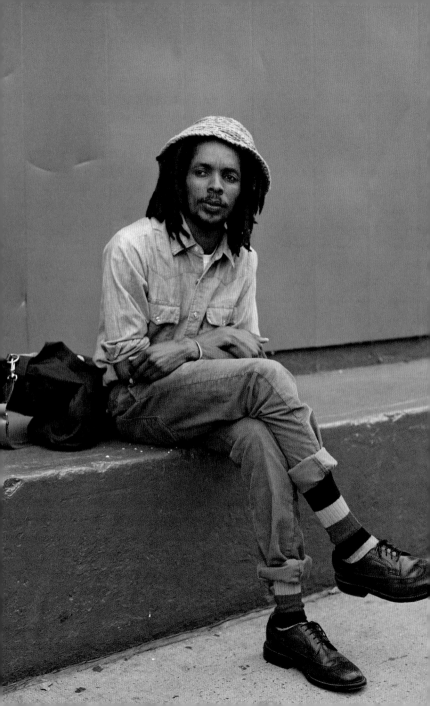

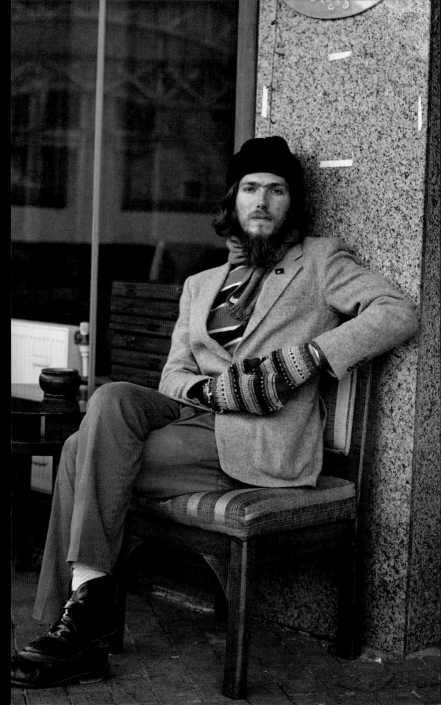

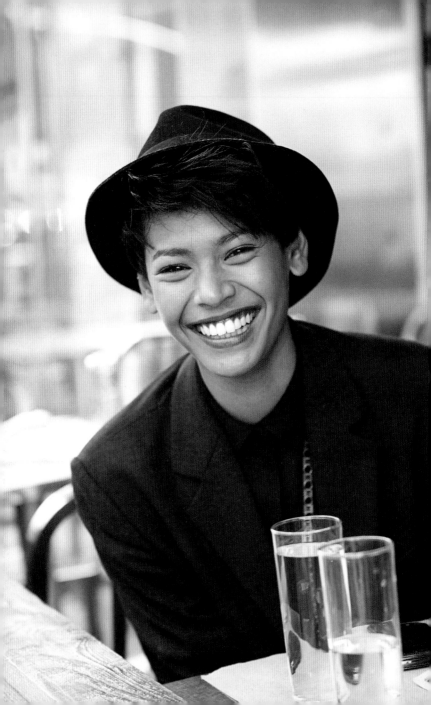

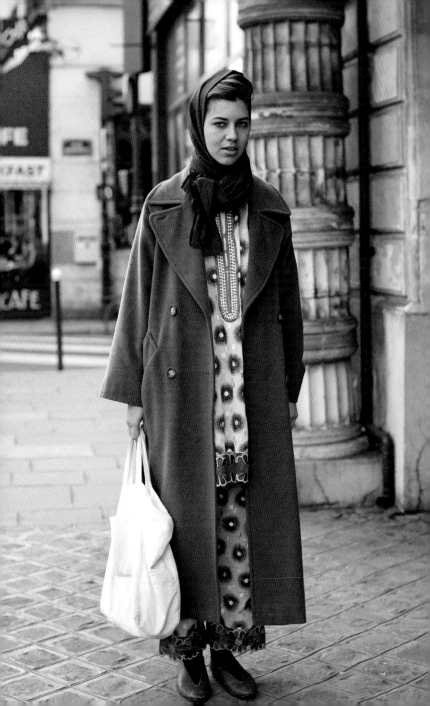

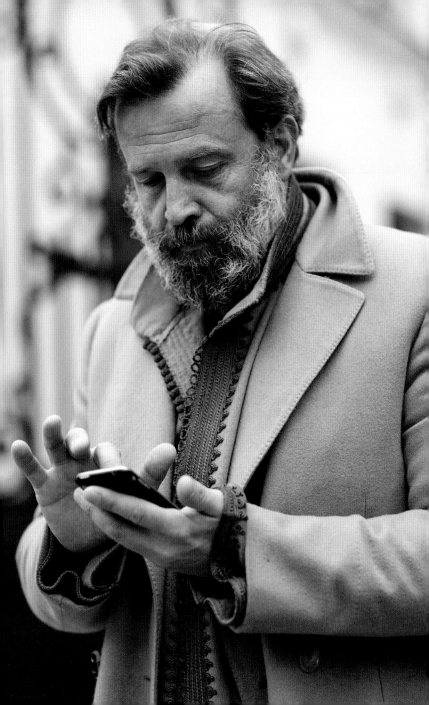

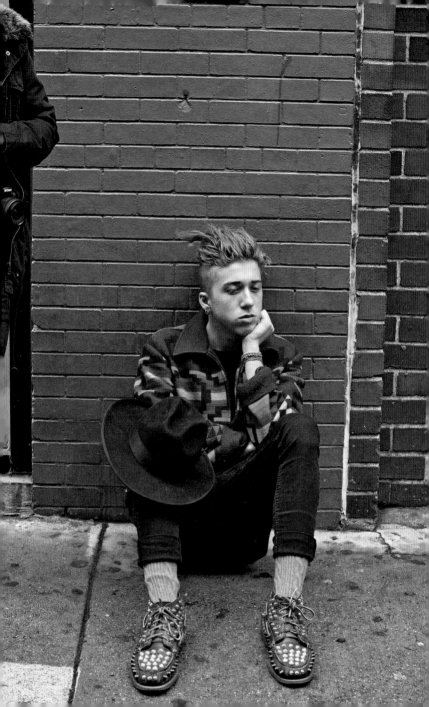

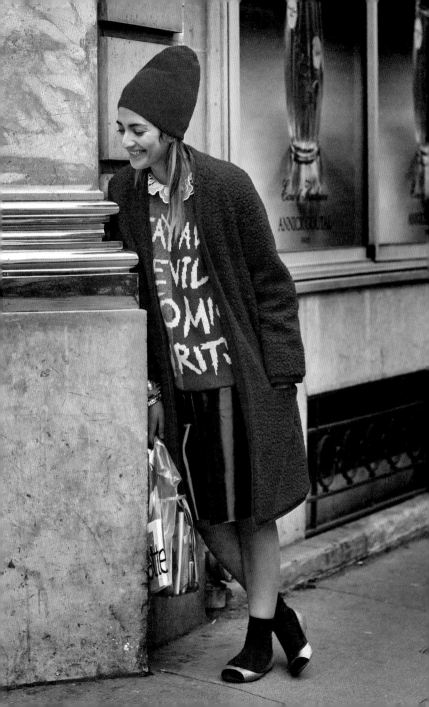

The Design Diet

This type of photo is a core reason I started The Sartorialist blog.

As a young man I learned the general rules of fashion, like horizontal stripes making a person look wider. It sounded reasonable so I blindly accepted it to the point I've never owned anything close to a striped t-shirt.

Then last January at Pitti Uomo I saw this gentleman wearing a plaid jacket with a very pronounced horizontal stripe. As opposed to making him look wider it did the exact opposite. The strategically placed stripes dropped at least ten pounds on him by emphasizing the narrowness of his waist when counterbalanced with the broadness of his shoulders.

This is real sartorial genius.

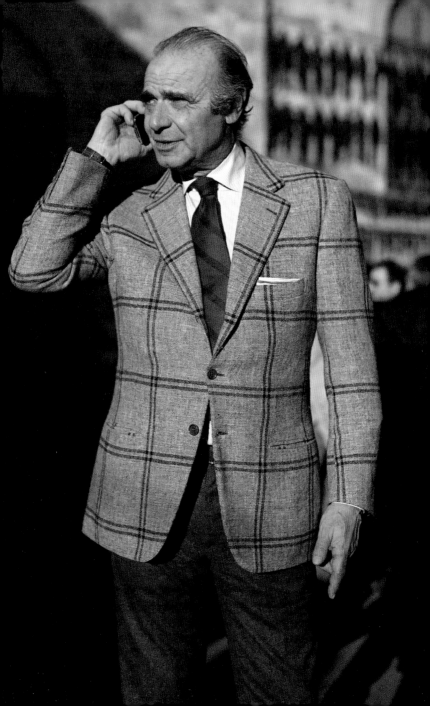

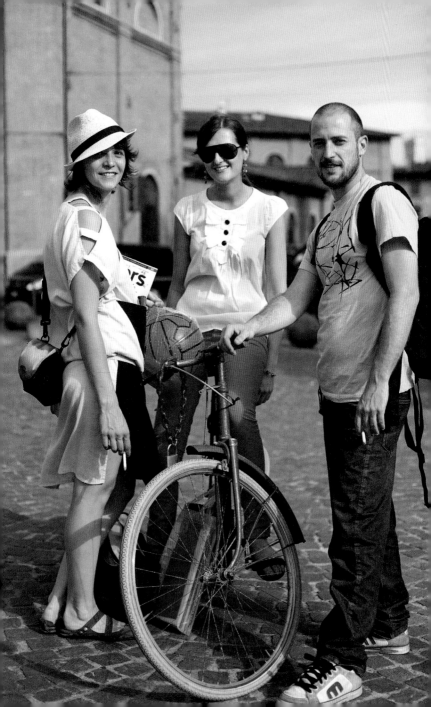

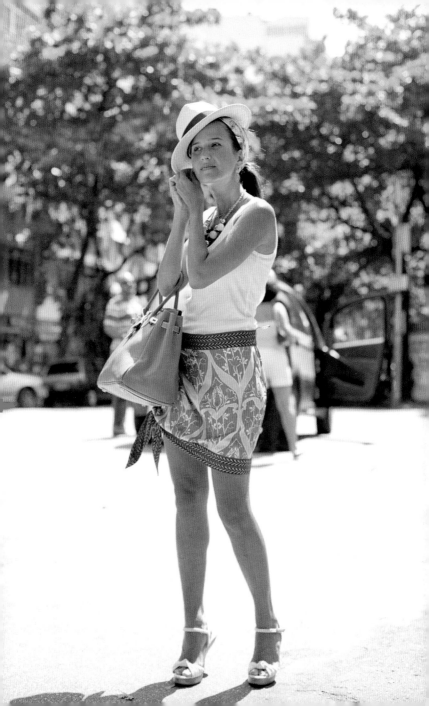

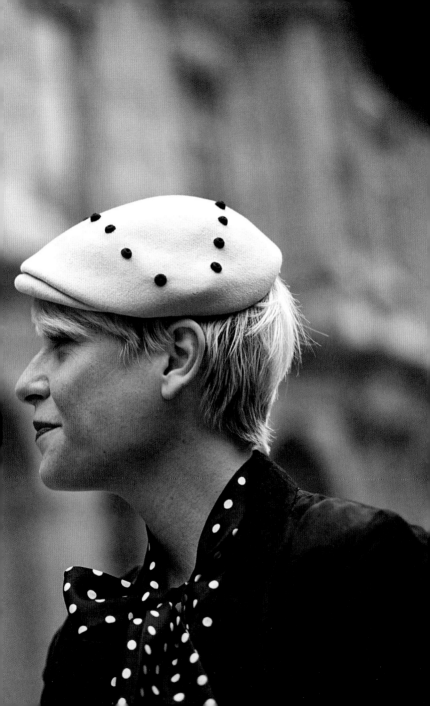

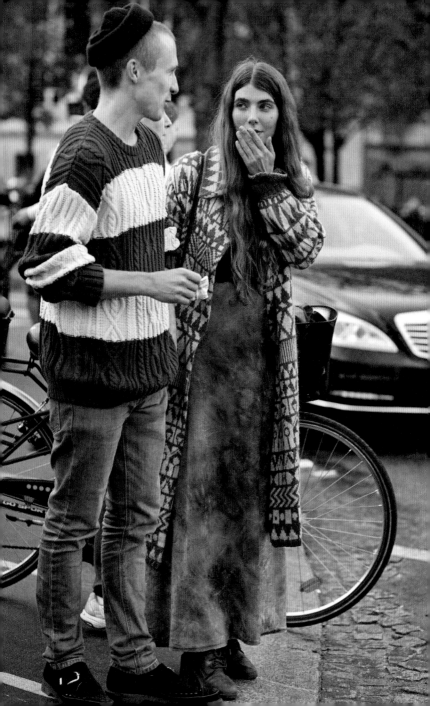

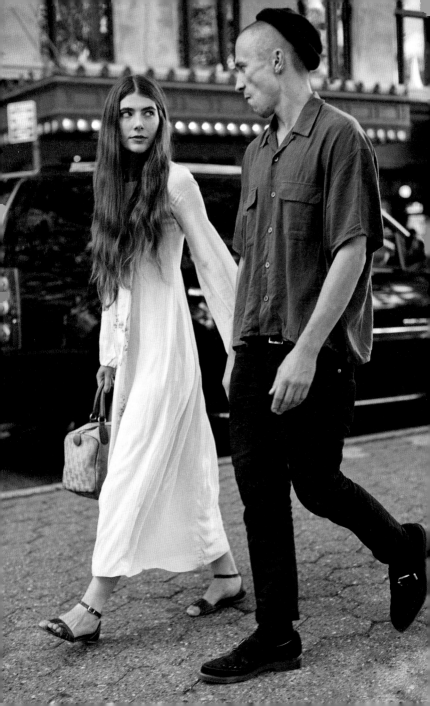

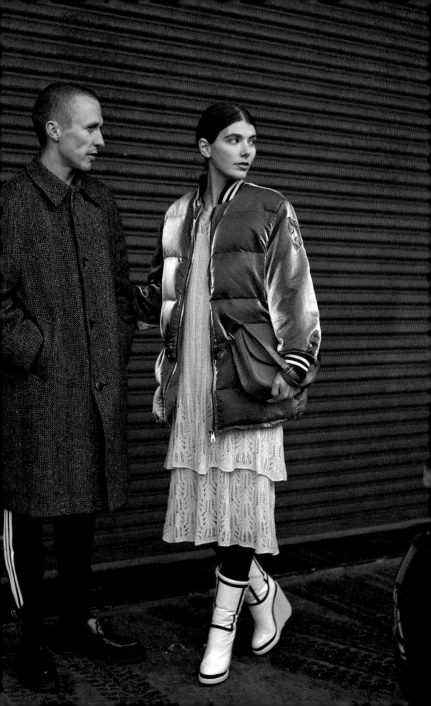

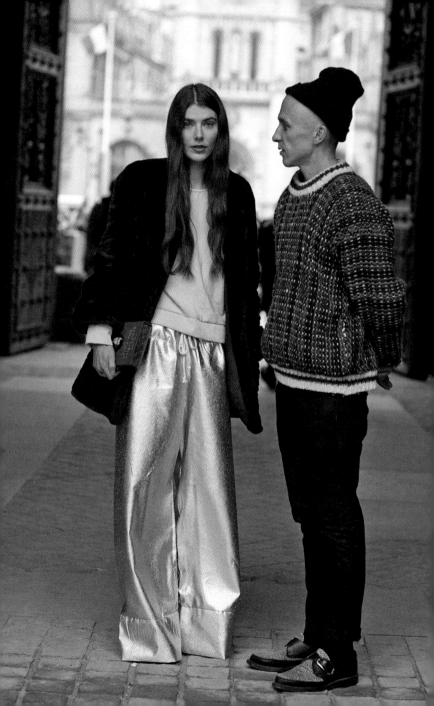

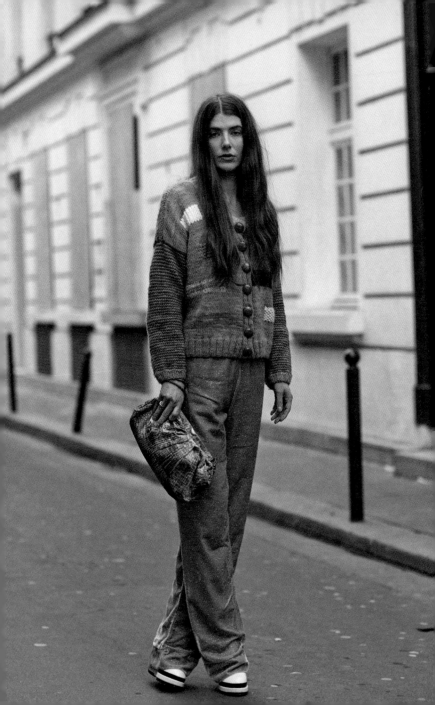

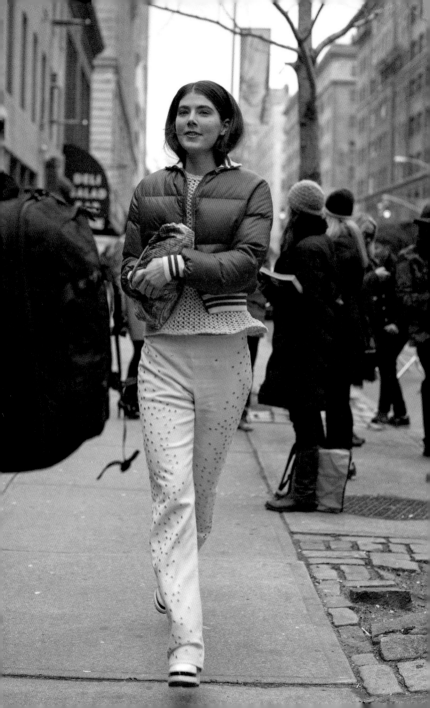

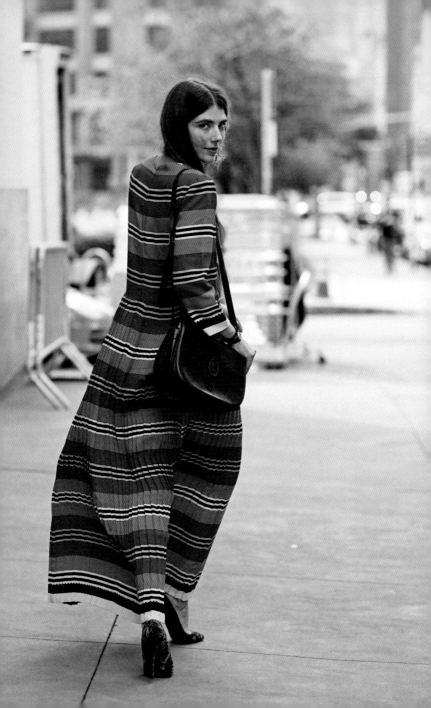

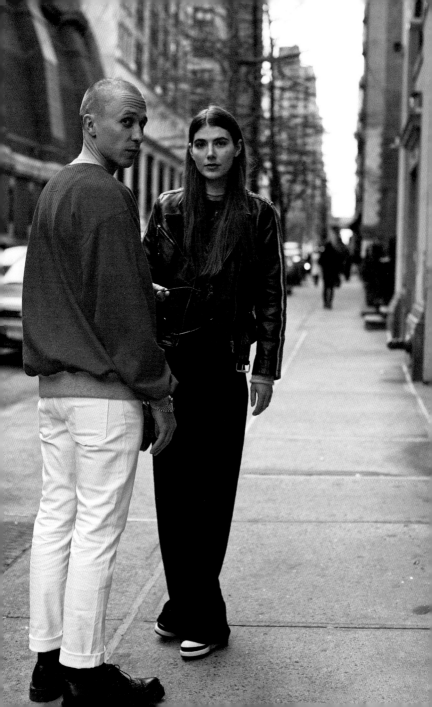

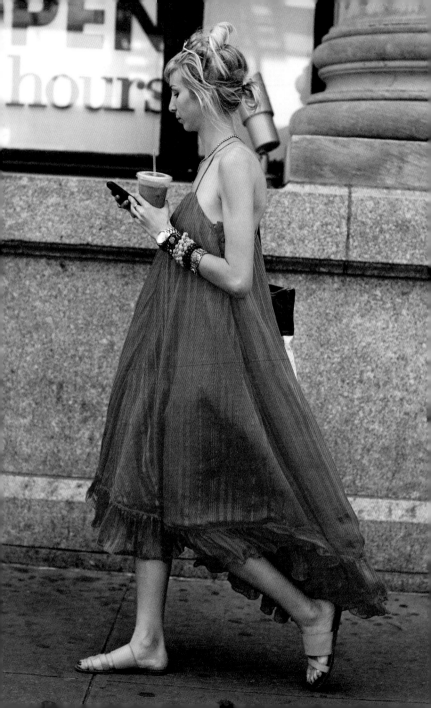

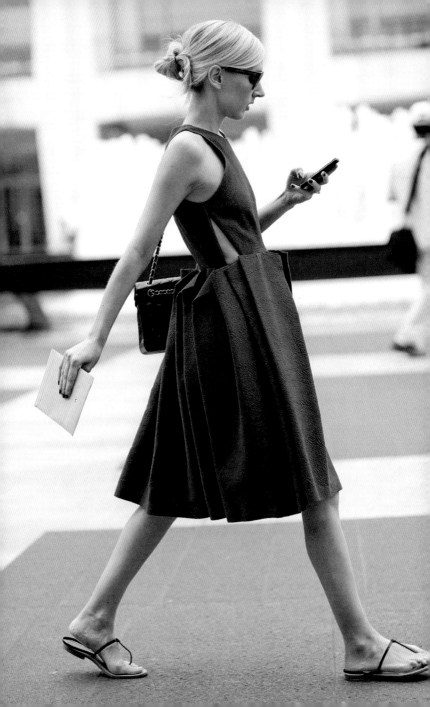

On the Runway ... Salvatore Ferragamo, Milan

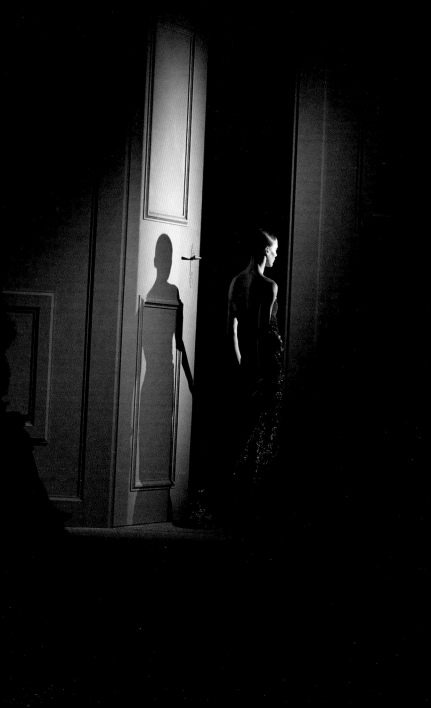

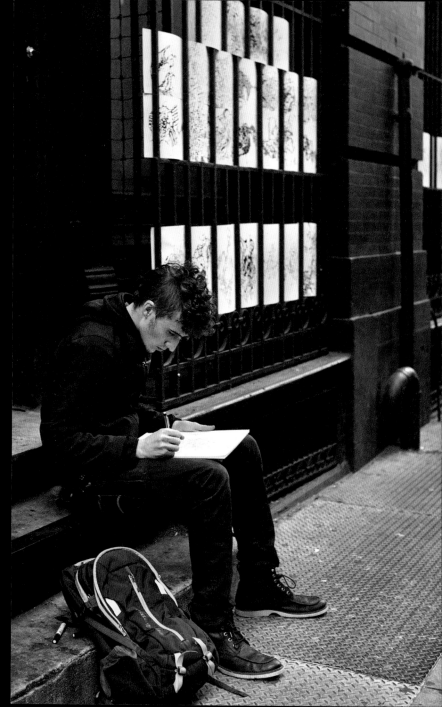

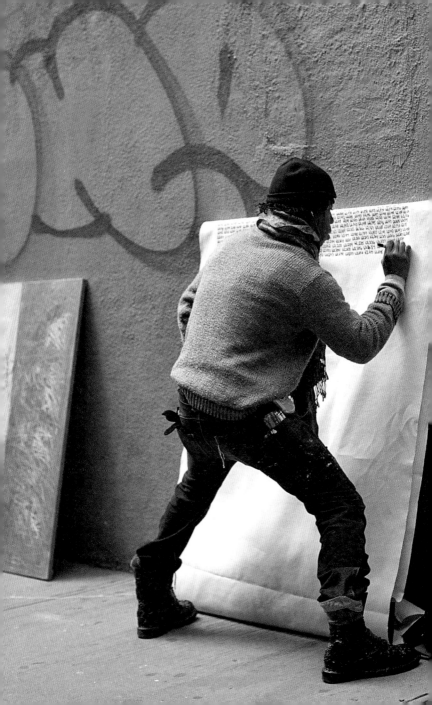

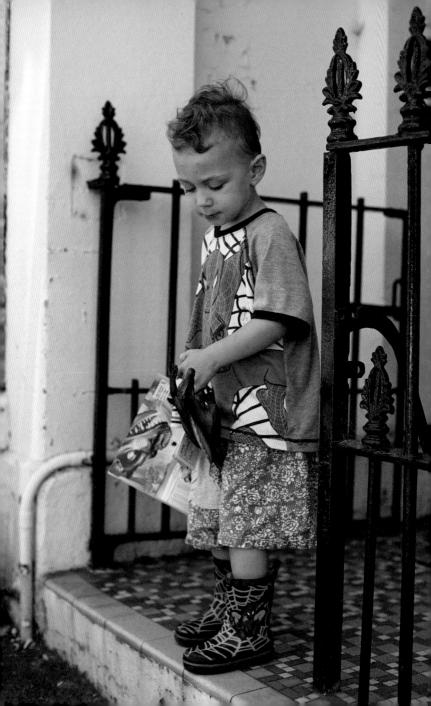

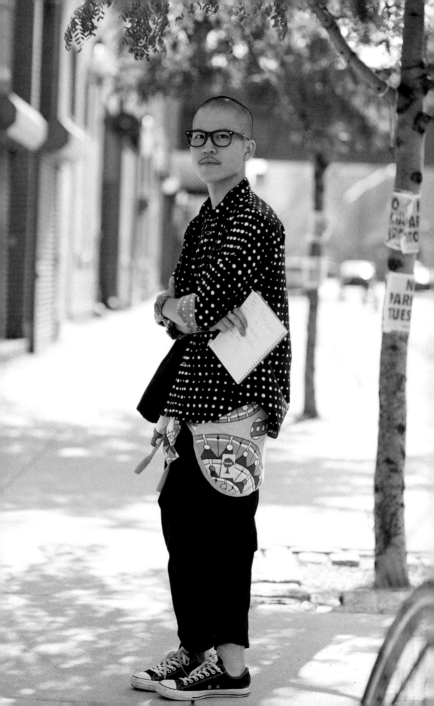

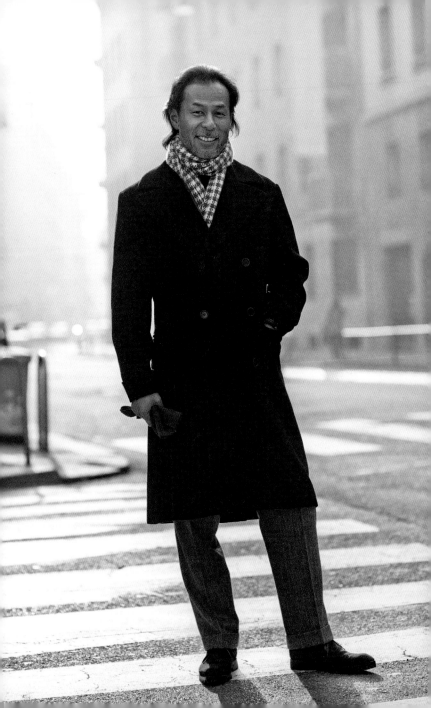

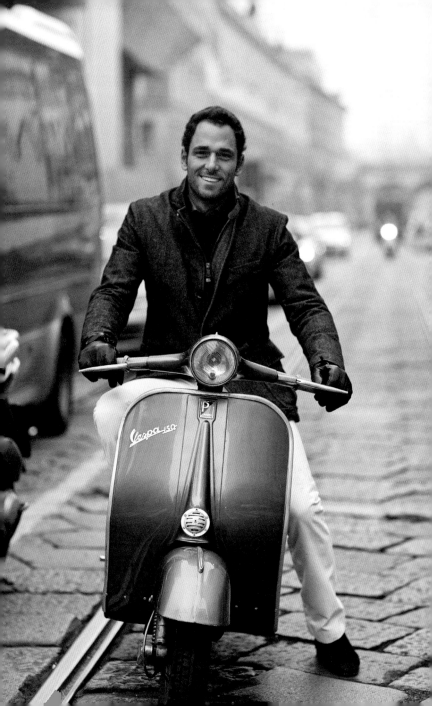

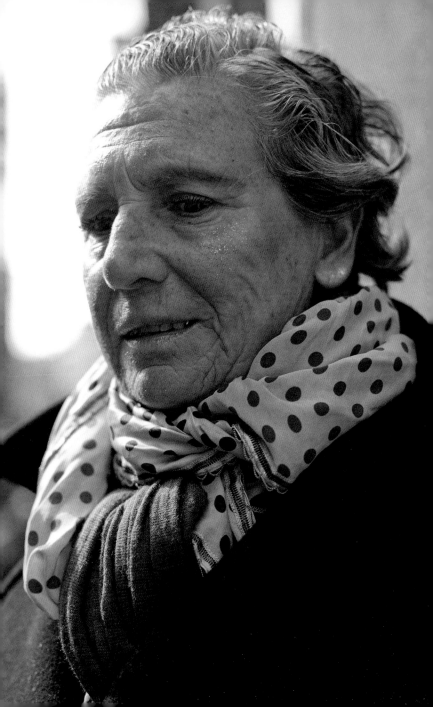

Glitter

Originally I had asked to take this woman's photograph because she had such an elegant manner and refined style.

What I didn't realize until I was working on the image later was the playfulness of her style. Notice her cheek, with just the most subtle sprinkling of glitter . . . how unexpected!

Somewhat lost in the photo is the smudge of that same glitter on her earlobes instead of earrings . . . genius!

This is the epitome of young at heart.

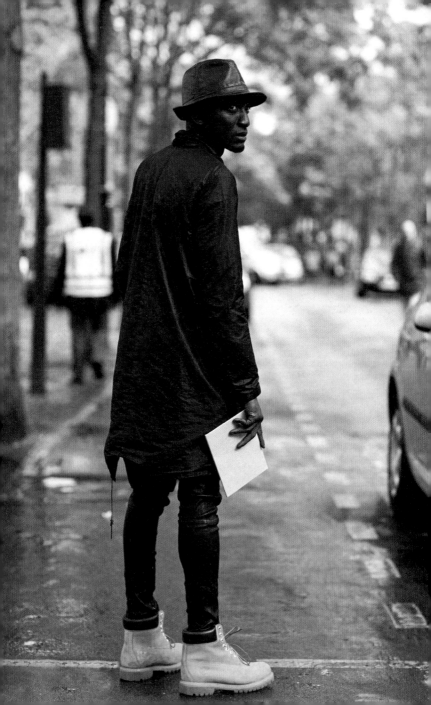

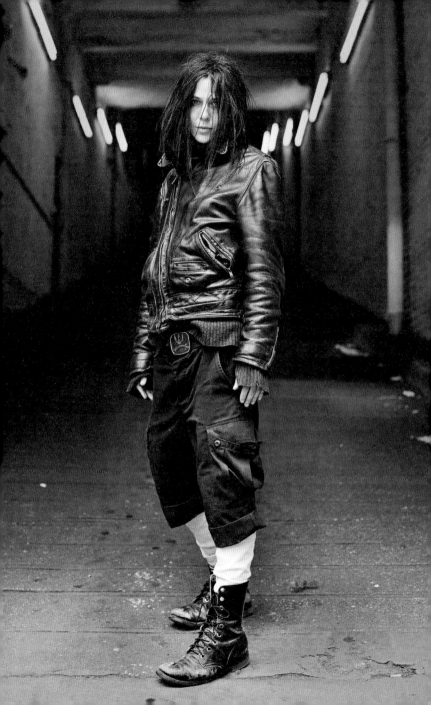

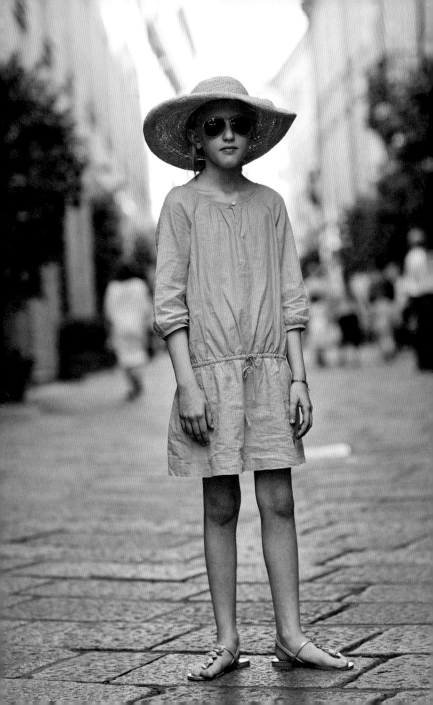

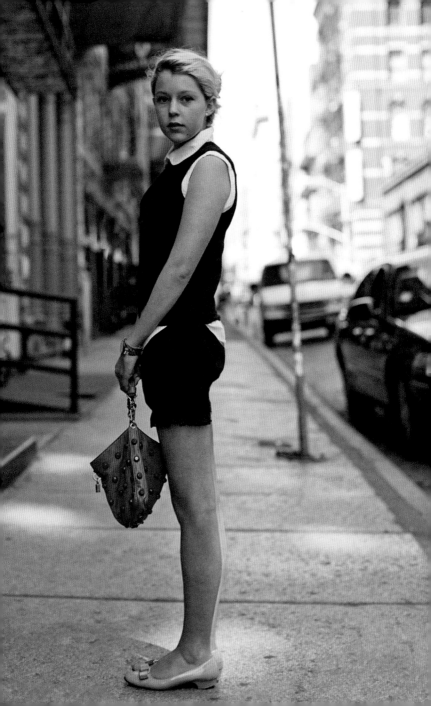

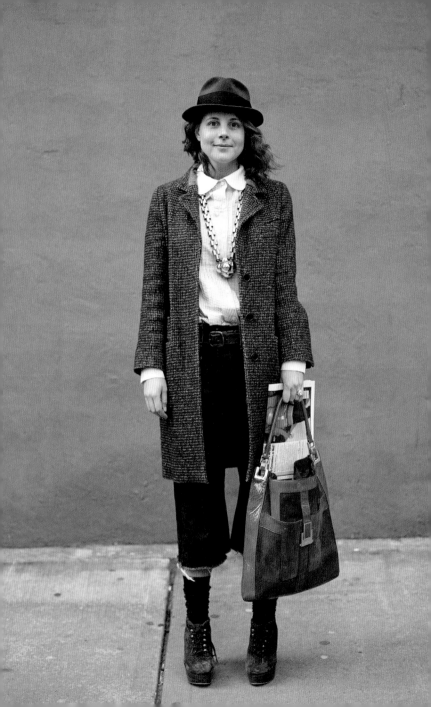

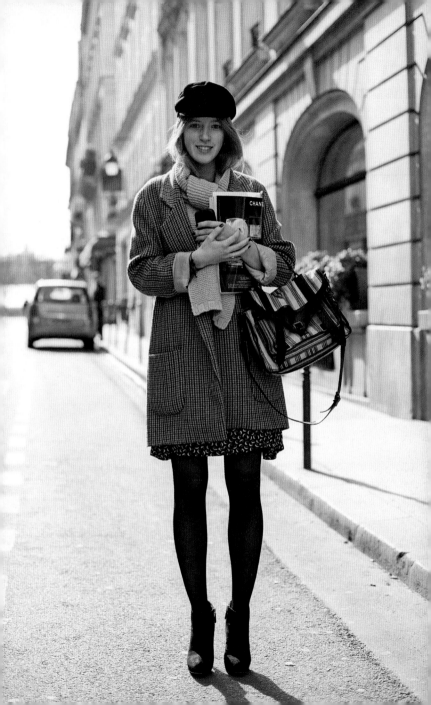

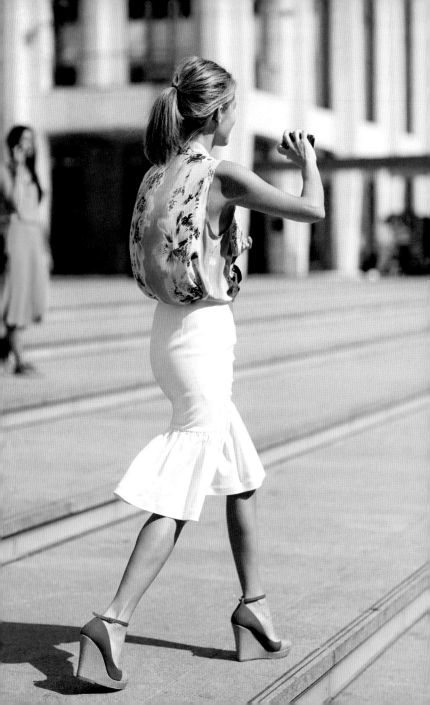

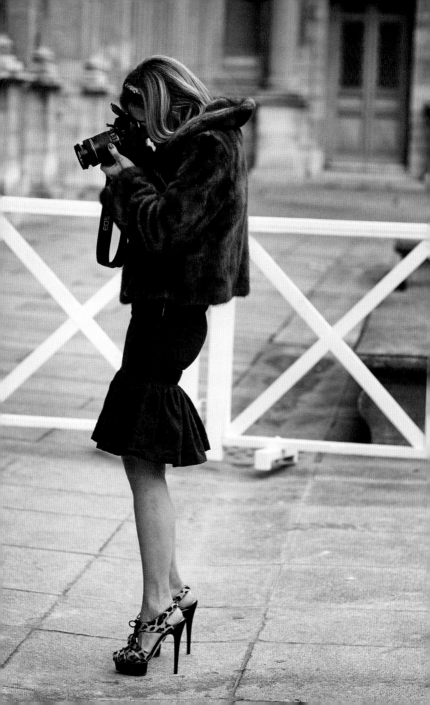

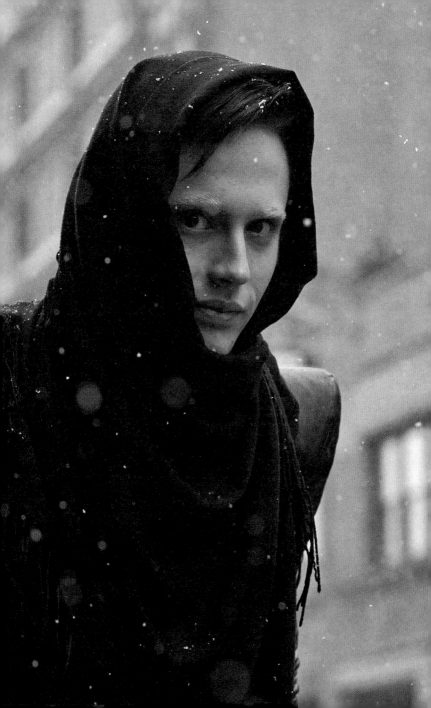

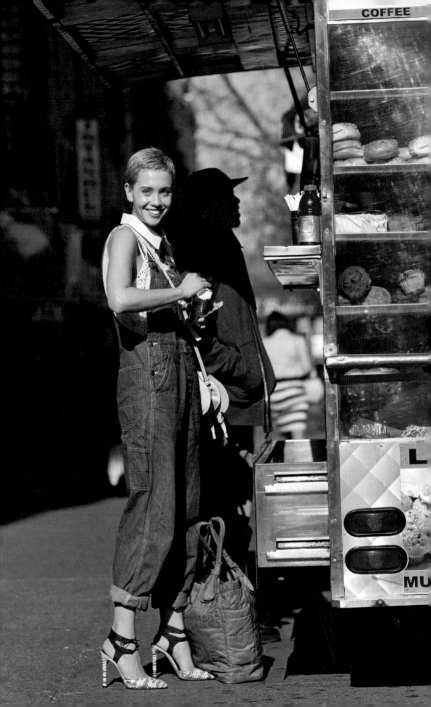

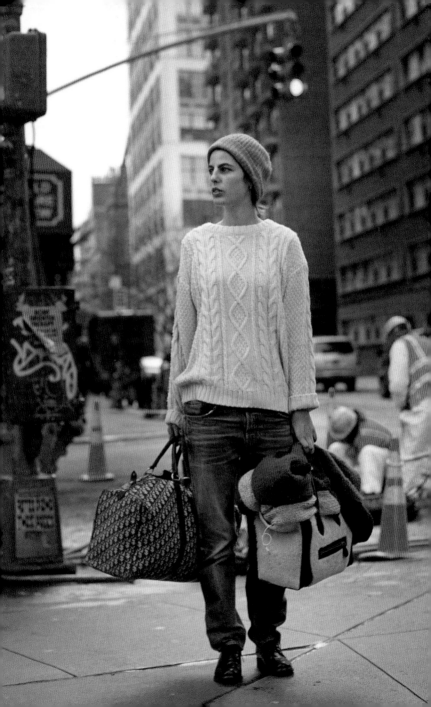

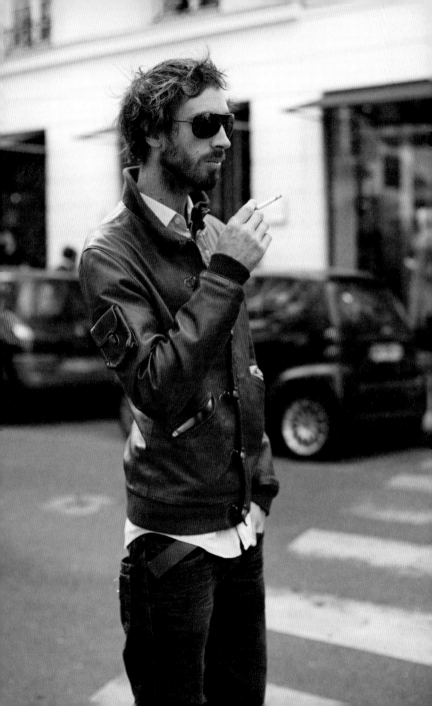

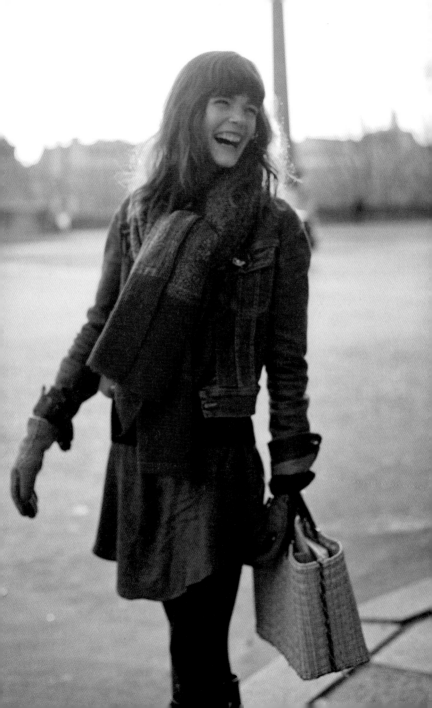

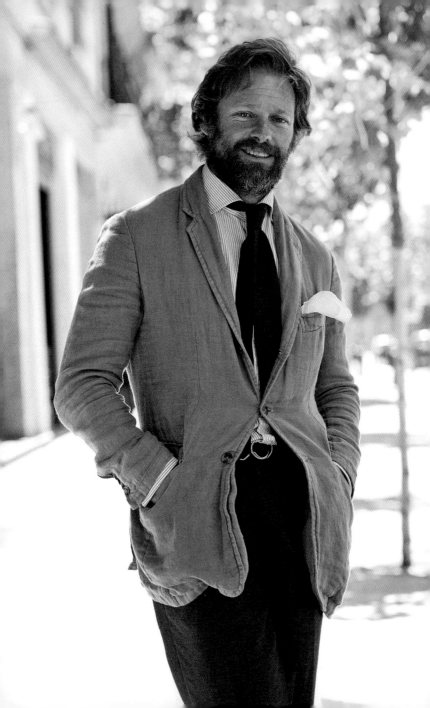

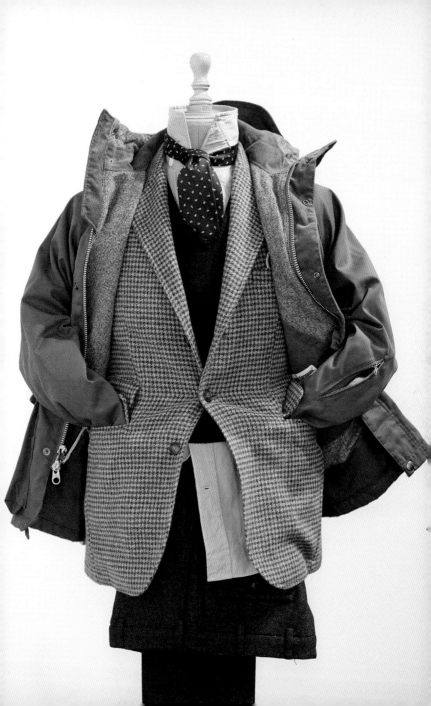

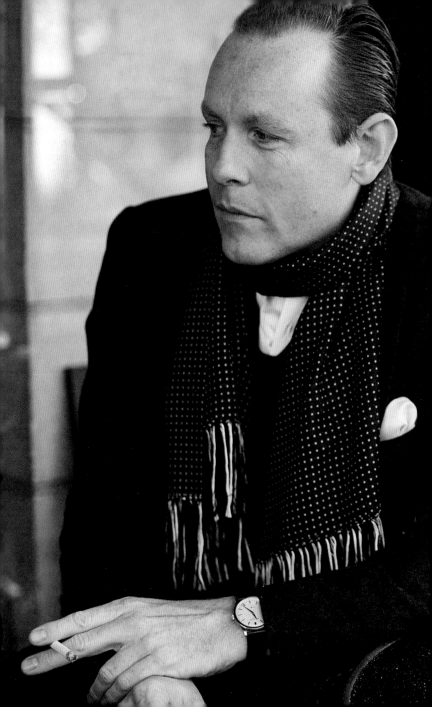

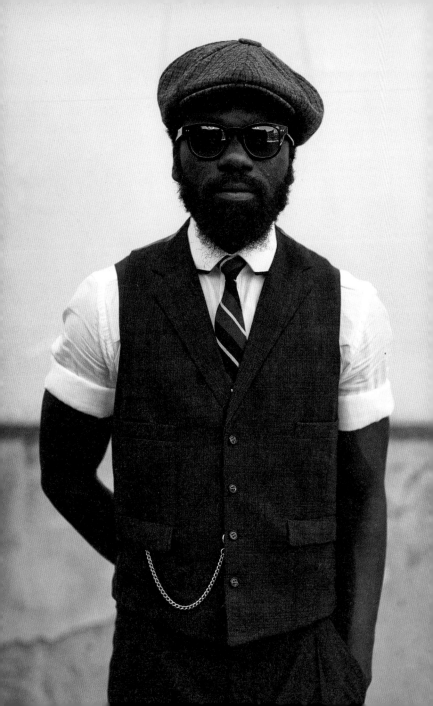

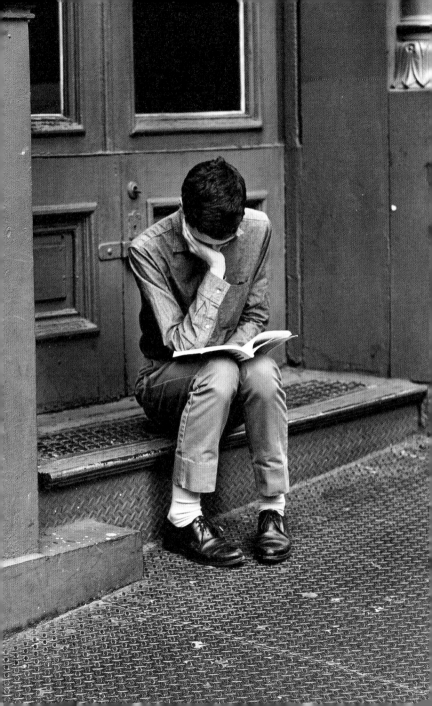

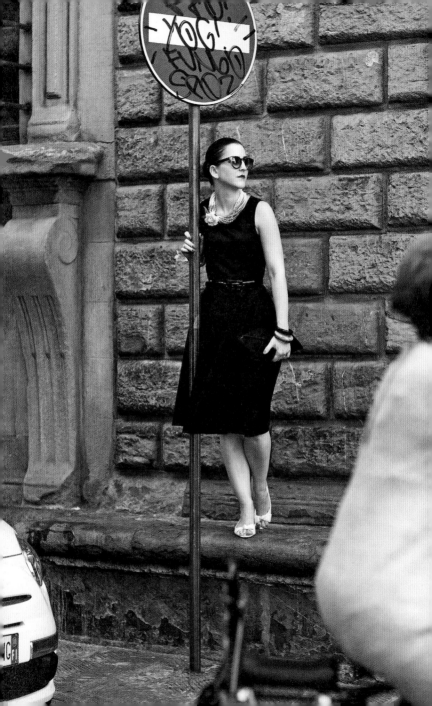

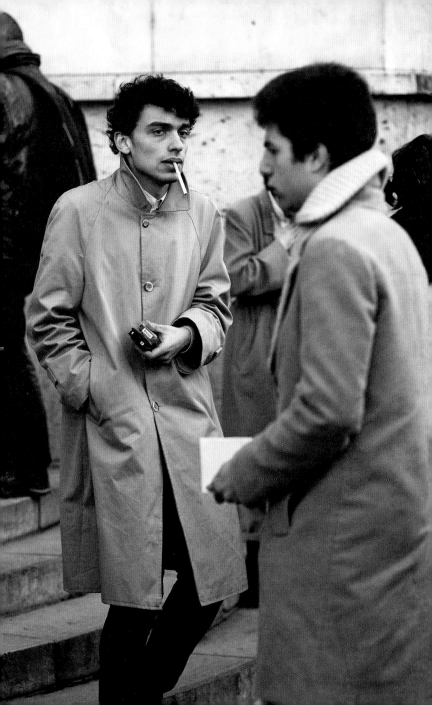

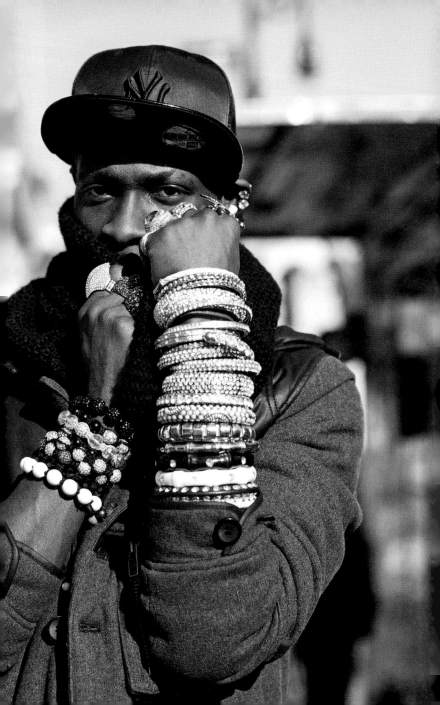

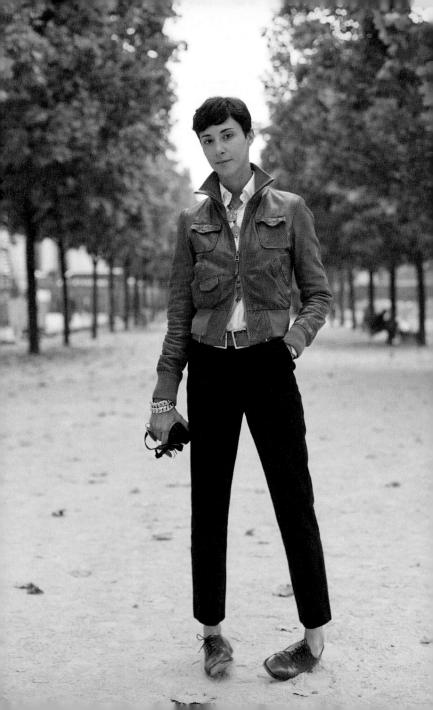

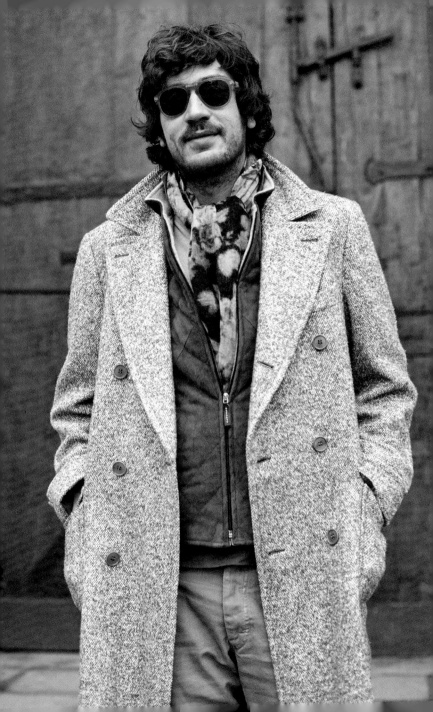

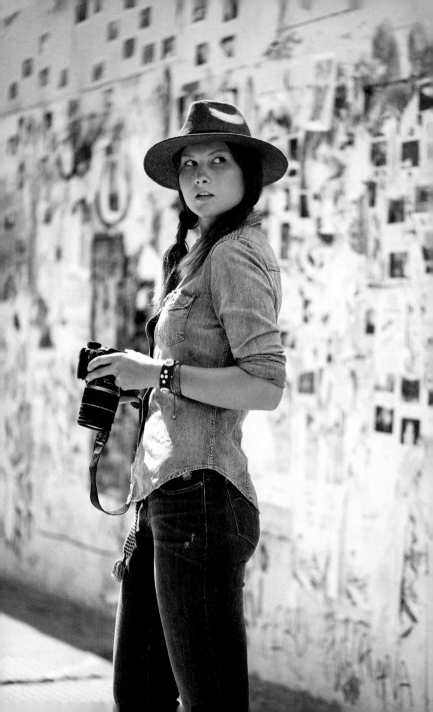

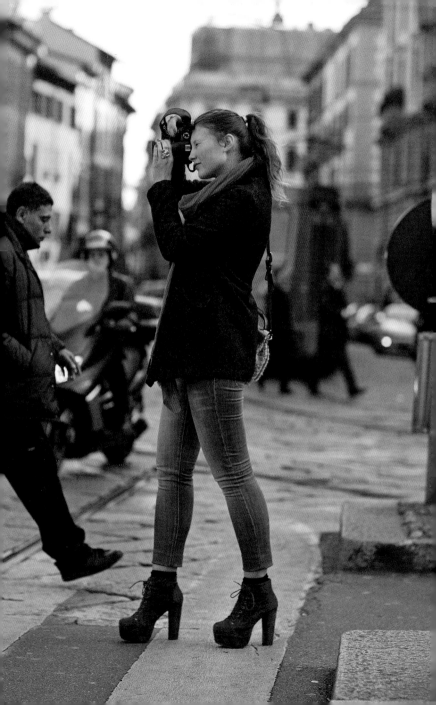

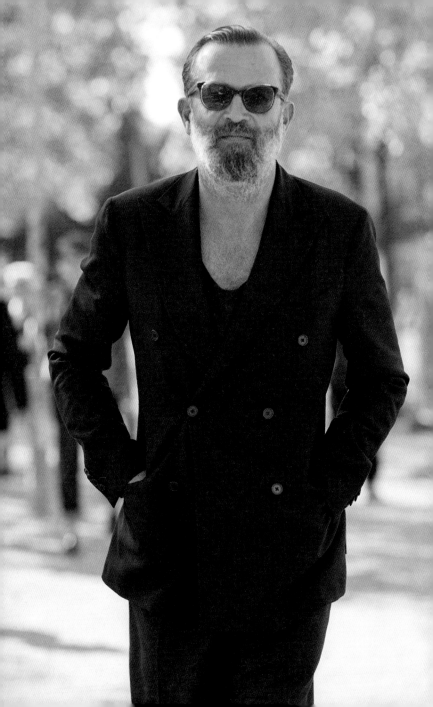

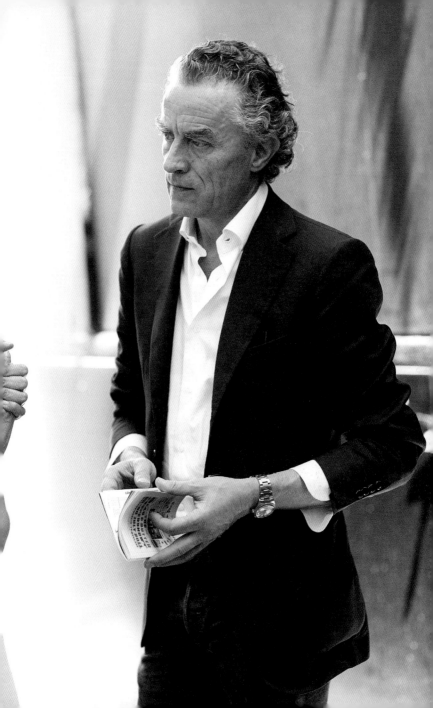

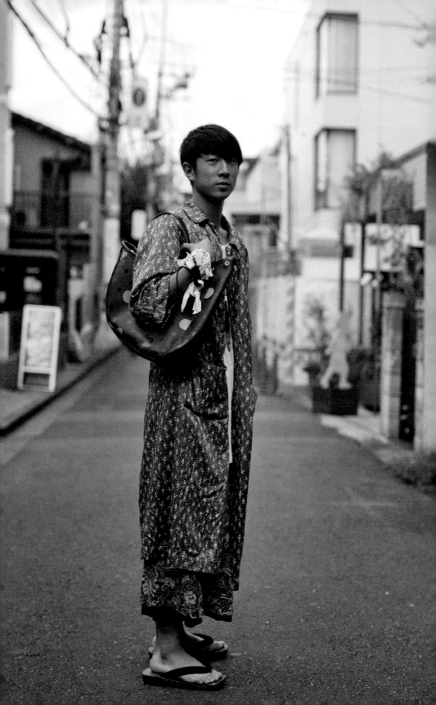

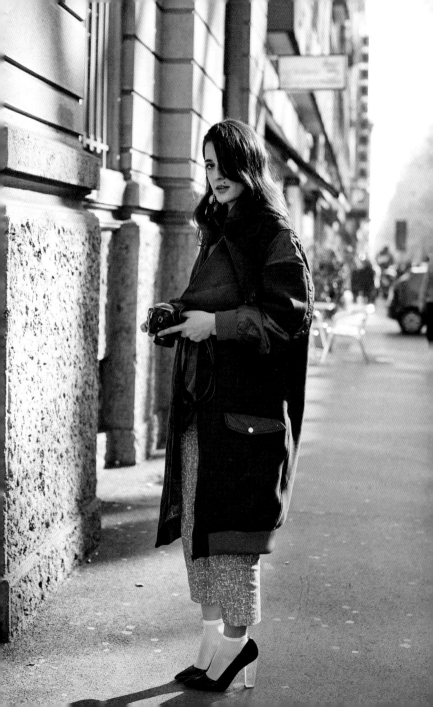

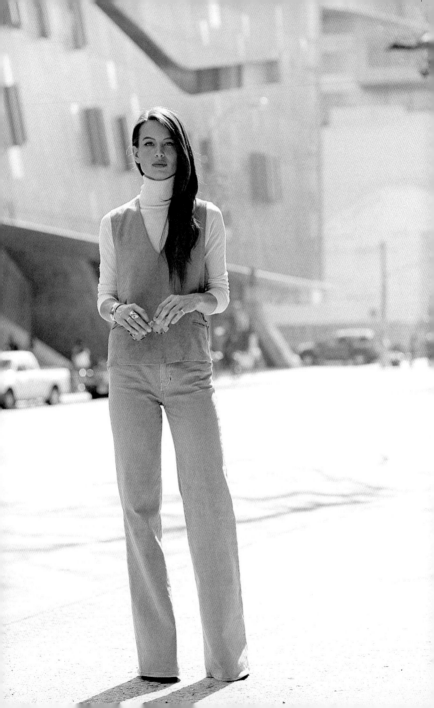

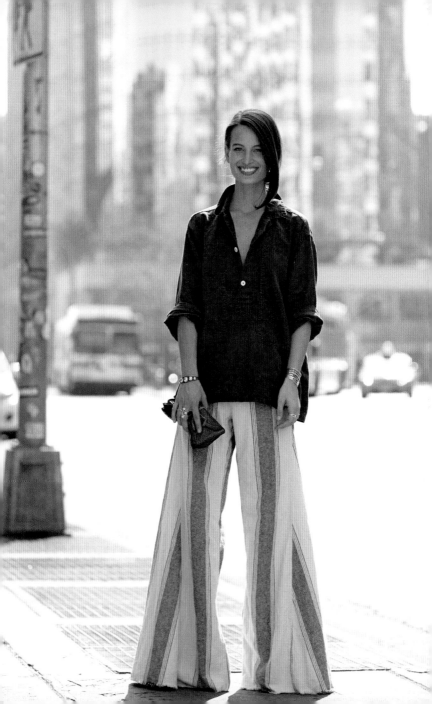

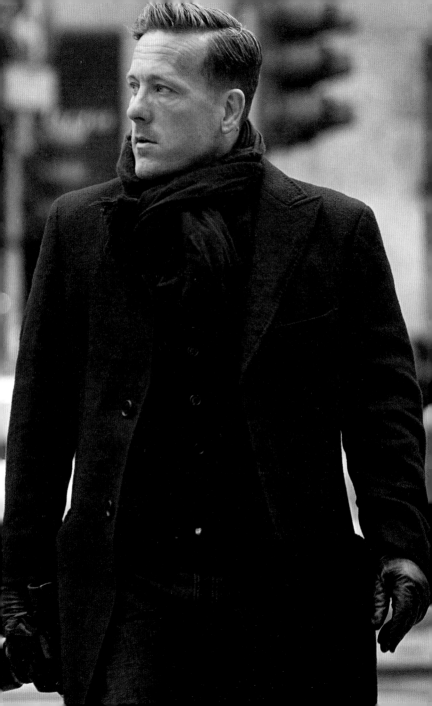

Index